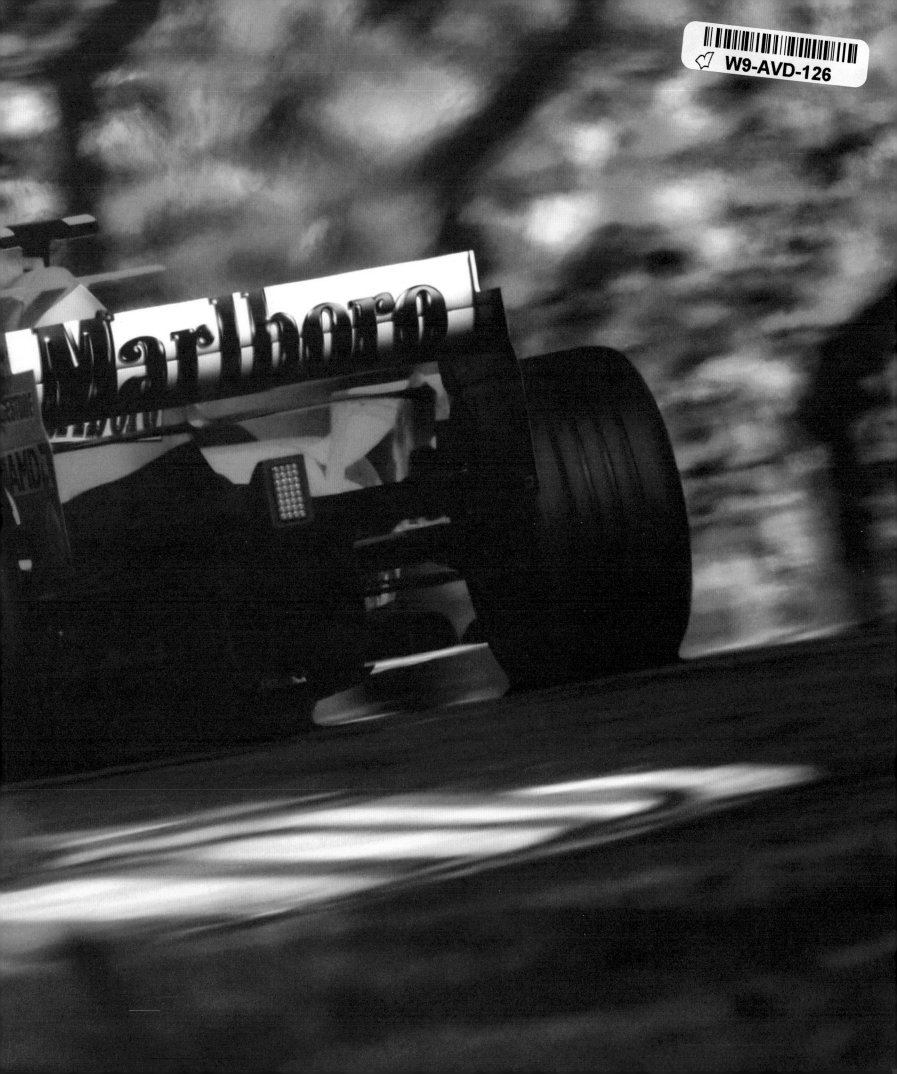

inside Ferrari

inside Ferrari

Unique behind-the-scenes photography of

the world's greatest Formula One team

PHOTOGRAPHY
Jon Nicholson

TEXT
Maurice Hamilton

FOREWORD
Jean Todt

FIREFLY BOOKS

A FIREFLY BOOK

Published by Firefly Books Ltd. 2006

First printing

Publisher Cataloging-in-Publication Data (U.S.)

Nicholson, Jon.
 Inside Ferrari / Jon Nicholson ; text [by] Maurice Hamilton.
[288] p. : col. photos. ; cm.
Includes index.
Summary: A profile of Ferrari's Formula One team with exclusive
photographs and engaging text providing a rare glimpse inside the
Ferrari factory, garage and test track.
ISBN-13: 978-1-55407-231-6
ISBN-10: 1-55407-231-X
1. Ferrari (Team). I. Hamilton, Maurice. II. Title.
796.72 dc22 GV1029.15.N52 2006

Library and Archives Canada Cataloguing in Publication

Nicholson, Jon
 Inside Ferrari / photography: Jon Nicholson ; text: Maurice Hamilton ;
foreword: Jean Todt.

Includes index.

ISBN-13: 978-1-55407-231-6
ISBN-10: 1-55407-231-X
1. Ferrari (Team). I. Hamilton, Maurice II. Title.

GV1029.15.N52 2006 796.72 C2006-902045-0

Published in the United States by
Firefly Books (U.S.) Inc.
P.O. Box 1338, Ellicott Station
Buffalo, New York 14205

Published in Canada by
Firefly Books Ltd.
66 Leek Crescent
Richmond Hill, Ontario L4B 1H1

First published in Great Britain by Mitchell Beazley,
an imprint of Octopus Publishing Group Limited,
2–4 Heron Quays, London E14 4JP

COMMISSIONING EDITOR Jon Asbury
ART DIRECTOR Tim Foster
SENIOR EDITOR Suzanne Arnold
EDITORS Miranda Harrison, John Leach
DESIGNER Ashley Western
INDEXER Alan Thatcher
PRODUCTION Jane Rogers

Colour reproduction by Bright Arts, Hong Kong
Printed and bound in China by Toppan Printing Company Ltd.

FERRARI 2003 – 2005

Where does one start to say thank you after a project like this?

It's such a long journey. At the start it's not about the pictures; it's just about being seen around the garage, being able to get out of the way, knowing when to take pictures and when not to.

Being totally accepted is the only way for me to work, to be left to get on with it and observe what is unfolding over a weekend. It's always been about people, how they interact and respond to the situations that are presented to them, individually or collectively. Sometimes, as in the USA in 2005, to be shouted at. The total disgust of the fans at the sport, watching six cars race.

The language, working with Italians. Well it all worked out: those who spoke English did, and those who didn't tried.

This team and those who work within it are great, truly professional, and totally dedicated. Probably more so than any other team. A nation is depending on them all to deliver results.

The drivers, the management, well, the whole lot of them at races and the factory all get my thanks for giving me the access to do the job.

All at Olympus, first for asking me to do their photography, but also for giving me the tools to produce the images.

The three years of this project were very difficult on a personal level. I would like to pass my thanks to the additional team sponsors, and everybody in the paddock who unreservedly gave me their support and love.

This book is for my three children, Molly, Maisy, and Sam.
With all my love.

JON NICHOLSON, SEPTEMBER 2006

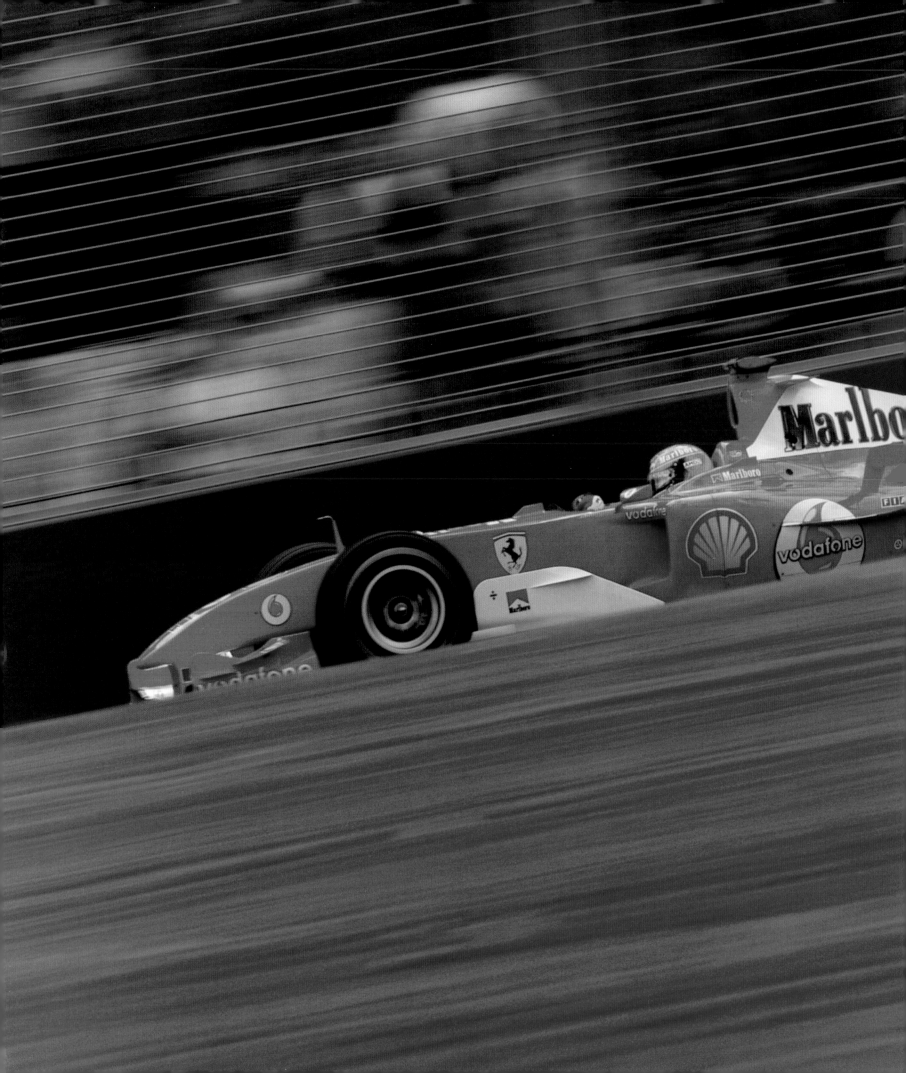

CONTENTS

FOREWORD

It is very difficult for anyone not directly involved with a Formula 1 team to fully appreciate the massive effort behind the scenes. Scuderia Ferrari Marlboro is a team in every sense. The drivers may be the public face of our F1 operation but they would not succeed without the dedication and enthusiasm of hundreds of people working for Ferrari at the factory and the racetrack, and with the support of all the technical and commercial partners.

But it is more than mere numbers. Ferrari is a family (a large one, admittedly), a close-knit community driven by an indefinable spirit and a love of the sport. This is not always obvious unless you see the team working at close quarters – which is why *Inside Ferrari* is most welcome.

This book not only takes you into the heart of our team but it also exposes what I believe to be an atmosphere and philosophy unique to Ferrari. You will not find any magic ingredients in these pages. Simply, a portrait of a great team and the wonderful people who are devoted to the Ferrari legend and who make everything possible.

JEAN TODT

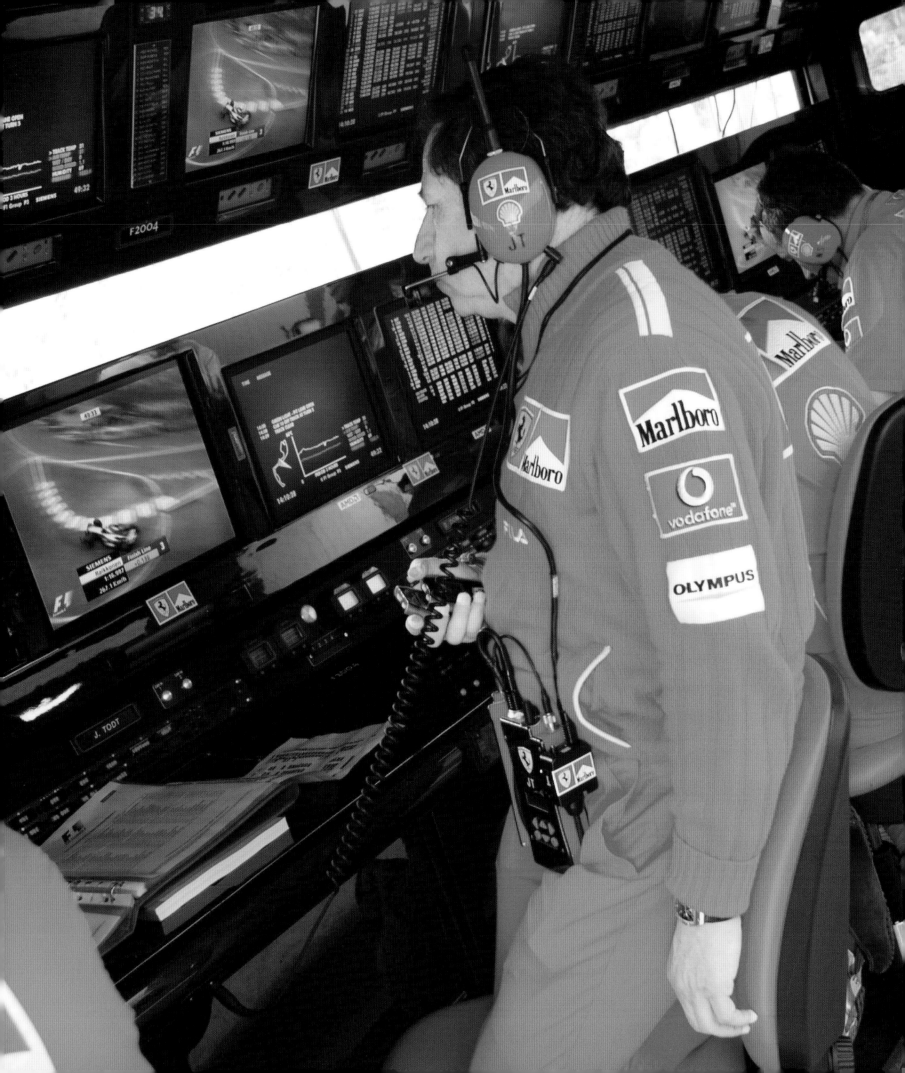

INTRODUCTION

Enzo Ferrari once described motor racing as a "great mania". Even allowing for his cunning affection for melodrama, this theatrical description sums up a fundamental value that powered Ferrari's fledgling company in the 1930s and continues to do so.

When Enzo Ferrari died at the age of 90 in 1988, it was felt the team would never be the same again. In some respects that is true, for it has been impossible to replace such an autocratic, mischievous leader who started out as the son of a humble metal worker and rose to become an icon in the world of fast cars and international motor sport.

It is also true to say that Ferrari's race team experienced more disappointment than it did success but, typically, the failures were often heroic and the victories always rich in pleasure and achievement. None of that has really changed.

The team's *modus operandi* has moved with the increasingly competitive and professional times. There may be less raw emotion on display – in public at least – because a team employing in excess of 800 employees inevitably assumes a more corporate identity. But the sense of achievement continues to motivate not just the workforce but also an entire country.

Ferrari remains a national team in everything but name. The fact that the nation in question is Italy explains the extraordinary passion fermenting beyond the factory gates, and the fervent zeal exhibited by those fortunate enough to be working within.

Motor sport is second only to football in Italy. Ferrari's progress – and sometimes the lamentable lack of it – commands the front, back, and inside pages of the national sporting daily newspaper, *La Gazzetta dello Sport*. The team is examined continually in searching detail. It is criticized for failure on behalf of a wounded nation; cherished and protected in moments of triumph.

The importance attached to Ferrari has been enhanced by the passing of time and the growth of positive statistics: more grand prix wins than any other team; the most pole positions as well as fastest laps, championship points, and constructors' championships.

No other team in the history of the sport has been around for so long, Ferrari having competed in the Formula 1 World Championship since its inception at the British Grand Prix in 1950. Naturally, Ferrari's consistent presence has bolstered the scores, but to attribute the team's success purely to longevity is to misunderstand not only the importance of those accomplishments but also the dramatic and colourful manner in which they were achieved.

Ferrari's first victory is an appropriate case in point. After the win at Silverstone in 1951, Enzo Ferrari announced, "My tears of joy were mixed with sorrow because I thought, 'Today I've killed my mother.'" He didn't mean it literally, of course. Ferrari was referring to having finally beaten his great rival, Alfa Romeo. Such a vivid expression in those straitened times said everything about the depth of his feeling for a sport that was to continue having a profound influence on his life and that of his team.

Ferrari was a true racer in the sense that he competed as a driver in the 1920s and understood the urge to win and be the best. Ideally qualified to move on and run his own team, he had an eye for the main chance and spotted the need to cater for wealthy enthusiasts who wished to race. Alfa Romeo was the name to beat and Ferrari manoeuvred himself into the position of running a second-string team of Alfa Romeos for his clients.

On 1 December 1929, he began Scuderia Ferrari by renting space within a machine tool workshop on Via Emilia in Modena. From that moment, the Ferrari name would be forever associated with this area in the Emilia Romagna region of northern Italy.

The flanks of the ruby-red cars have always carried Ferrari's emblem: a yellow shield (initially it was white) bearing the image of a prancing horse. This was not a trademark expensively devised by experts in P.R. and then confirmed by extensive market research. Rather, the acquisition of this simple but effective motif involved a typical degree of drama and emotion.

In 1923, Ferrari had won a race at Savenna and was savouring his moment of victory. He was approached by a complete stranger carrying the prancing horse symbol, previously seen on the fighter flown by Francesco Baracca, a World War I ace who had shot down 35 enemy aircraft before his death in 1918. His family, sensing a similar aura of bravery, skill, and fortitude surrounding Ferrari's victory against more powerful opposition, presented the winner with Baracca's emblem. They had chosen wisely. Thanks to the efforts

of its new custodian, the *Cavallino Rampante* was destined to become one of the world's most famous images .

Scuderia Ferrari quickly became not just a small autonomous division of Alfa Romeo but a team so successful that it attracted top drivers rather than mere gifted amateurs. In 1935, Ferrari scored a memorable victory in the German Grand Prix thanks to an incredible drive by Tazio Nuvolari – then aged 43 – at the wheel of a three-year-old Alfa Romeo against frontline opposition from the favourites, Mercedes-Benz and Auto Union. It was a typically dramatic outcome that would accompany Ferrari's clever footwork away from the racetrack.

Nuvolari's success merely served to sharpen Enzo Ferrari's already acute sense of independence. Rows with the Alfa Romeo management became more frequent to the point when, in 1939, there was a parting of the ways. It was no coincidence that Ferrari was already working on building and racing his own cars, an adept piece of commercial positioning which would characterize his shrewd dealings with rivals and the sport's administrators during the next 50 years.

But, first, the intervention of World War II saw Ferrari keep his company in business by manufacturing machine tools and moving to a new factory on farmland adjoining the Via Abetone in the small town of Maranello. This was to become the most famous address in the world of motor sport, if not the entire automotive industry.

Recognition and respect would take a major step forward in 1951 when Ferrari finally brought an end to Alfa Romeo's domination during that landmark British Grand Prix. It was to be the first of

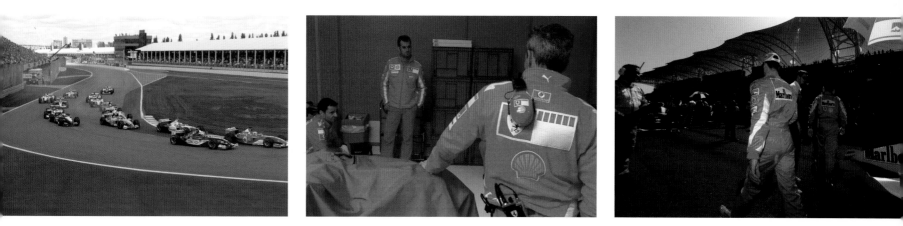

more than 180 wins in Formula 1 and the beginning of a sporting relationship that would travel through a powerful range of emotions as Scuderia Ferrari won 14 constructors' championships and the same number of drivers' titles.

The most recent run of success has arguably been the best and certainly the most unrelenting during not only Ferrari's history but also that of Formula 1. Five championships in succession for Michael Schumacher is a statistic that will be difficult, if not impossible, to beat. The only downside to sustained achievement at the top is the height of the inevitable fall. But Ferrari has been there before. Previous experience has shown that the pain of failure is more than balanced out by the pleasure of success in one of the most fiercely contested sporting arenas. And the frustration is also worth enduring if it comes with the knowledge that a return to success is just around the corner.

That was the case when Ferrari narrowly missed the driver's title in 1951, only to win it for the next two years. In 1955, Juan Manuel Fangio, driving a Ferrari, scored one of his five world championships. Three years later, Mike Hawthorn became the first Englishman to wear the champion's crown, an honour that was enhanced in the eyes of motor sport aficionados by his driving for the Italian team rather than a British outfit that lacked Ferrari's charisma.

Much of the team's post-war aura had been created by its success in sports car racing, a series second only to F1 in terms of international prestige at the time. And success on the track led to a demand for Ferrari cars on the public roads, the surge of potential buyers being of little interest to Enzo Ferrari, who saw the sale of his exotic sports cars merely as a means to an end; namely, the funding of his racing programme.

In the 1960s, a bid by Ford to buy Ferrari was rebuffed, thereby setting the stage for intense rivalry in the Le Mans 24 Hours and automatically massaging the Ferrari legend even more when the little firm in Maranello repeatedly managed to humble the giant from Detroit. This achievement was to complement two more F1 championships, won by an American (Phil Hill, 1961) and an Englishman (John Surtees, 1964). Then there was nothing for ten years. Ferrari tended not to do things by halves.

During that period, Fiat bought 40 percent of the sports car business but, significantly, Enzo Ferrari kept control of his beloved motor sport department. Work needed to be done as the pace of competition accelerated.

The arrival of Niki Lauda in 1974 coincided with the first appearance of Luca di Montezemolo, a bright young lawyer who would play a major part in maintaining the Ferrari legend, not least because he had the ear of Mr Ferrari and acted in an even-handed way as the boss's liaison man at the track.

Lauda came close to taking the title in 1974, secured it the following year, almost died in a fiery crash in 1976, but came back six weeks later, only to lose the championship to James Hunt at the final race. And so the drama and glory of the Ferrari legend continued. But it was not to last for long.

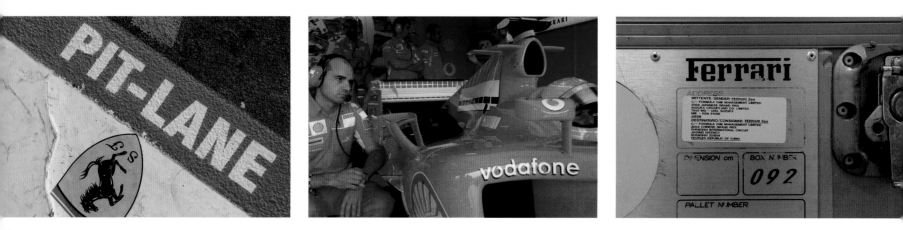

When Jody Scheckter became world champion in 1979, it marked the beginning of a drought lasting 21 years. Ferrari won the odd race, but not even the huge honour of a visit by His Holiness the Pope in 1988 would bring the blessing of a championship.

When Enzo Ferrari passed away in the same year, his cars would finish first and second at Monza less than a month later. The result was totally out of keeping with the team's faltering progress that year, and yet it created the feeling that the spirit of Ferrari lived on. No one doubted it, least of all the intensely loyal *tifosi* clinging to the spectator fencing. But they knew as well as anyone that their beloved team needed new direction.

A significant date in terms of Ferrari's sporting future was 16 August 1995. A press release announced that Michael Schumacher would join the team the following year. Jean Todt was already in office as sporting director and the final pieces of the jigsaw followed soon after with the arrival of Ross Brawn and Rory Byrne, both of whom had worked with Schumacher in his championship days at Benetton. Now the necessary transformation could begin.

It took time. Along the way, the near misses in 1998 and 1999 again massaged the myth and increased the sense of anticipation. When the result finally came with Schumacher's championship in 2000, it was more than champagne that flowed from the hub of the Ferrari empire. This was not merely the celebration of success for a local business. A nation's sense of relief was palpable as the chapel bells pealed long and loud and traffic ground to a halt in Maranello.

But there was to be no resting on laurels. With the millstone removed after two decades, now the team could get really get into its stride. Todt had marshalled a highly organized and slick fighting force within a company that makes every part of the F1 machine, including the engine. The evocative red cars you see on the track are merely the end product of a massive effort behind the scenes. Some of it is private and top secret; much of it has never been seen by anyone outside the team. Until now.

Join us on this incredible journey and witness the inner workings of a sporting icon through the privileged lens of Jon Nicholson. Come *Inside Ferrari*. The sport may have changed beyond recognition since Ferrari's first championship victory in 1951 but the "great mania" remains. Enzo Ferrari would not have wanted it any other way. This book tells you why.

FACTORY

THE SENTIMENTAL HEART OF FERRARI
This is the farmhouse on the original Maranello
site bought by Enzo Ferrari. Mr Ferrari used the
farmhouse increasingly as his base while the factory
and the racing team expanded. When the adjacent
land was converted to the Fiorano test track in the
late 1970s, the farmhouse stood at its heart. After
his death in 1988, Enzo Ferrari's elegant *pied-à-terre*
remained in use. It has been an occasional base
for Michael Schumacher but, essentially, it is a
reminder of the past while, at the same time, the
bright red paintwork symbolizes the continuing
propagation all around of the Ferrari legend.

The Via Abetone Inferiore splits Ferrari in two. On one side, the production plant; on the other, the racing team. Both are in the town of Maranello, and are united by a predominance of that glorious shade of bright red and a shared belief that speed and drama are the essential ingredients of a Ferrari car.

The racing department needs the sale of road cars to help the team survive: the production Ferraris feed off the image and technology flowing from their thoroughbred namesake. If the Ferrari symbol is a prancing horse, then the racers are the rampant stallions and the showroom stock the proud progenies. Drive a Ferrari road car and you not only feel the engineering excellence but, above all, you experience the tradition and emotion that seems to have been hand-stitched into the leather coachwork. It is priceless and it is not an optional extra.

This is no production line churning out robotically created products. Each car is rolled forward as and when the job is done and deemed ready for the next stage. Waiting to tend it with gentle care will be predominantly local men and women, many of them from a generation of "Ferrari families" proud to be associated with the legend which is receiving just as much love and devotion in the racing department across the road.

Their work clothes are the same shade and carry the exact same Prancing Horse symbol as the racing overalls seen in 17 countries around the globe. Production staff may never be fortunate enough to venture into the hallowed precincts of the pit lane, but pictures of Formula 1 cars and their drivers on the workbenches demonstrate that there is only one team that matters in this part of the world. Maranello and its *Cavallino Rampante* brings a new and more respectable meaning to the expression "one-horse town".

The racing division is known as the *Gestione Sportiva*. A good translation, although by no means literal, would be "Formula Ferrari". Here, more than 800 people focus on getting two cars to the grid at each of the 18 grands prix. That may seem an excessively large workforce until you realize that everything is made in-house. And that includes the engine. While the majority of F1 teams rely on "engine partners" for their power supply, the Ferrari forge will produce about 100 cylinder blocks for the race engine division each year.

That has always been the way at Maranello, the throaty but mellifluous sound of 12-cylinder Ferrari engines having left a magical impression on grateful race fans across the decades. The V12 may have been Ferrari's trademark on and off for 50 years, but the team has manufactured and raced just about every type of engine. In 2005, it was a V10. In 2006 and beyond, it is a V8. Whatever the configuration, the Ferrari engine department, led by Paolo Martinelli,

Ferrari's symbol is a prancing horse; the racers are the rampant stallions, and the showroom stock, the progeny.

will strive to maintain a reliability record that, since the millennium, has had no equal. By having every department more or less under the same roof, the bond between the engine and the rest of the car is seamless. The chassis is created from carbon fibre, carefully layered and cooked in a massive oven to produce a driver cell so strong that it can withstand massive stress in the event of an accident.

Then comes the bodywork that is more than merely red and arguably the fastest trademark in the world. A wind tunnel allows the aerodynamicists to craft wings and undertrays, flicks and curves, all designed to harness the passage of air to maximum effect and help force the car onto the track.

The latest wind tunnel is a work of art in itself. Designed by Renzo Piano – the man responsible for Osaka International Airport among other globally recognized structures – it possesses an exterior as aesthetic as the interior is functional. Anywhere else and it is only what goes on inside the tunnel that matters. At Ferrari, Piano's work sums up the attention to detail and pursuit of perfection.

It is the same with the Nuova Logistica building. Elsewhere, this would be a factory warehouse with a lorry park alongside. But not at Ferrari. The gleaming floor inside the aluminium-clad, curved exterior creates a positive first impression, one that is enhanced rather than devalued by having the massive articulated trucks drive across it.

The race team is supported by a veritable armada of vehicles, ranging from trucks to carry cars and spares, to mobile bases for technicians and their electronic monitoring equipment. This already formidable fleet is further enlarged by the inevitable but important headquarters for catering, management, and media.

When in Maranello, however, the team management can eat and entertain in the Cavallino restaurant directly opposite the factory gates or the Montana half a mile down the road. The latter is a home from home, bedecked with Ferrari memorabilia reflecting the passage of time and the great names that have driven for the team.

Each driver is embraced by the locals as if one of their own. It could hardly be otherwise when the priest of Maranello, the late Don Erio Belloi, used to ring the chapel bells to signal victory – even if it was won in Australia at some unearthly hour, Maranello time.

The mood, though, is predominantly one of reverence. The local streets are named after Ferrari's heroes – Ascari, Musso, Nuvolari, Villeneuve – and the area inside the Fiorano test track has a special significance. Here stands the former farmhouse in which Enzo Ferrari once lived. Immaculately presented, the three-storey building has its shutters and doors painted but one colour; bright red. It could hardly be anything else in a town where the Ferrari factory provides the lifeblood, the pleasure, and, occasionally, the heartache. It is part of a legend that is Ferrari and Maranello.

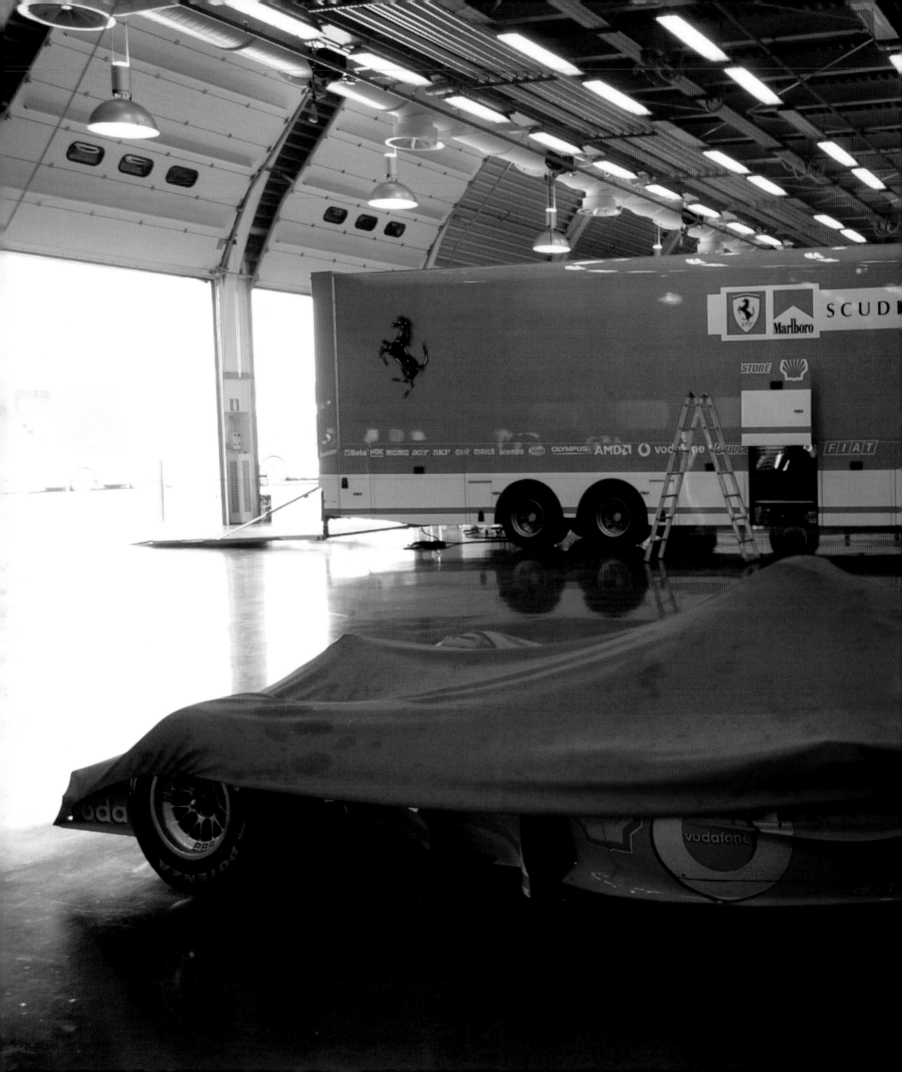

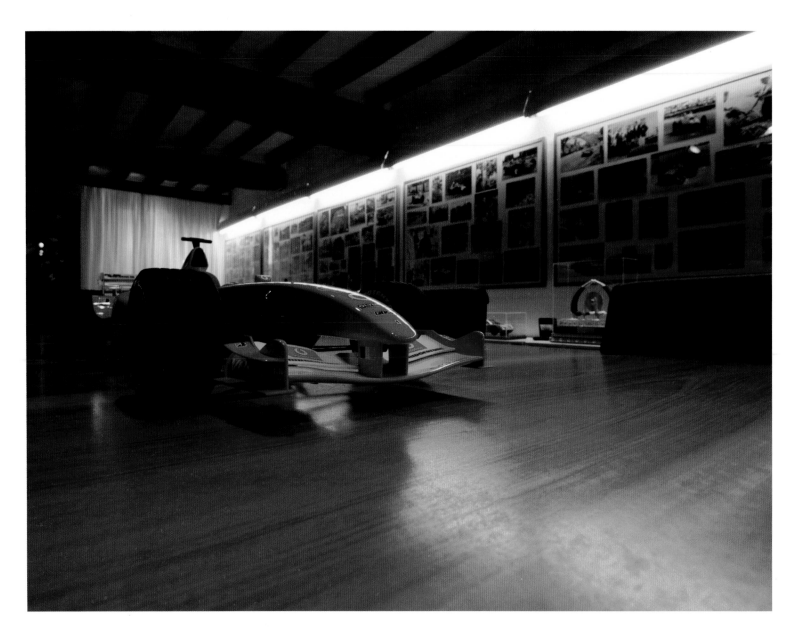

Previous page

WHEELS WITHIN WHEELS
The imaginative architecture of
the Nuova Logistica building can
be appreciated from within its
immaculate interior. A Formula 1
car, ready for action, is dwarfed
by one of the transporters that
will carry it to the next race or
test session. Few F1 teams enjoy
such space and splendour,
a far cry from the traditional
habit of loading a truck by
backing it to the rear door
of a crowded workshop.

MEETING WITH THE PAST
In this meeting room within the
farmhouse, the model F1 car
from recent years provides a
counterpoint to black and white
pictures illustrating five decades
of Ferrari's sporting heritage.

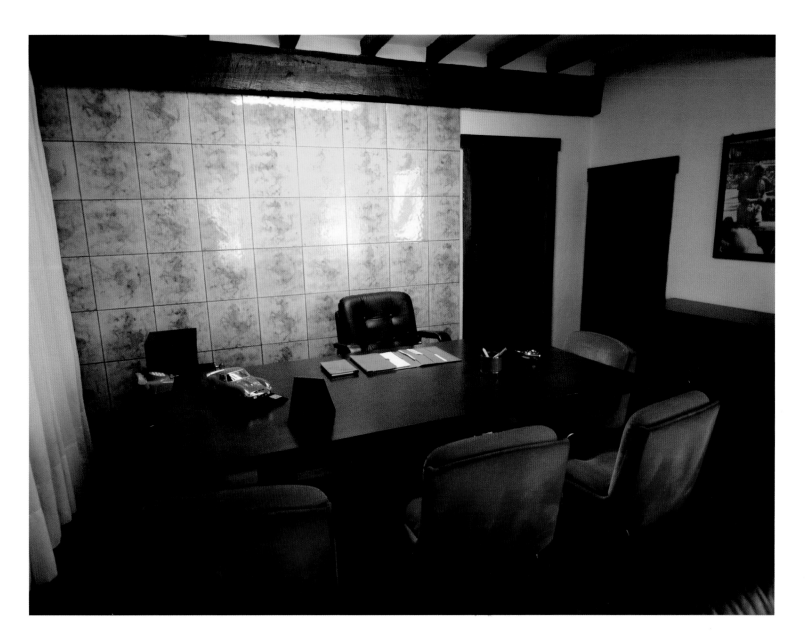

THE CENTRE OF POWER
The office used by Enzo Ferrari
in the farmhouse exudes efficient
simplicity. The Prancing Horse
symbol is never far away, while
the yellow tiles symbolize the
ceramic industry endemic to
this region of northern Italy.

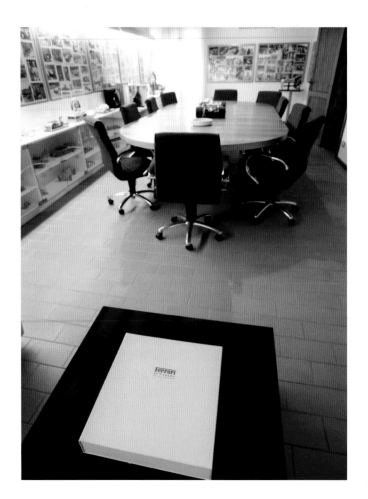

MOVING WITH THE TIMES
The farmhouse meeting room (above) mixes photographic memories of the past with samples of Ferrari merchandising; a useful and novel source of income for a team that, under Enzo Ferrari's reign, shunned such commercialism. Mr Ferrari wantonly scrapped F1 cars that today would be worth a fortune.

MELODIOUS MERGER
Two great sounds were united when Fender produced one of its classic guitars in the colours of a car maker famous for generating a different, but equally distinctive, sound. The red Fender is on display in the farmhouse (right).

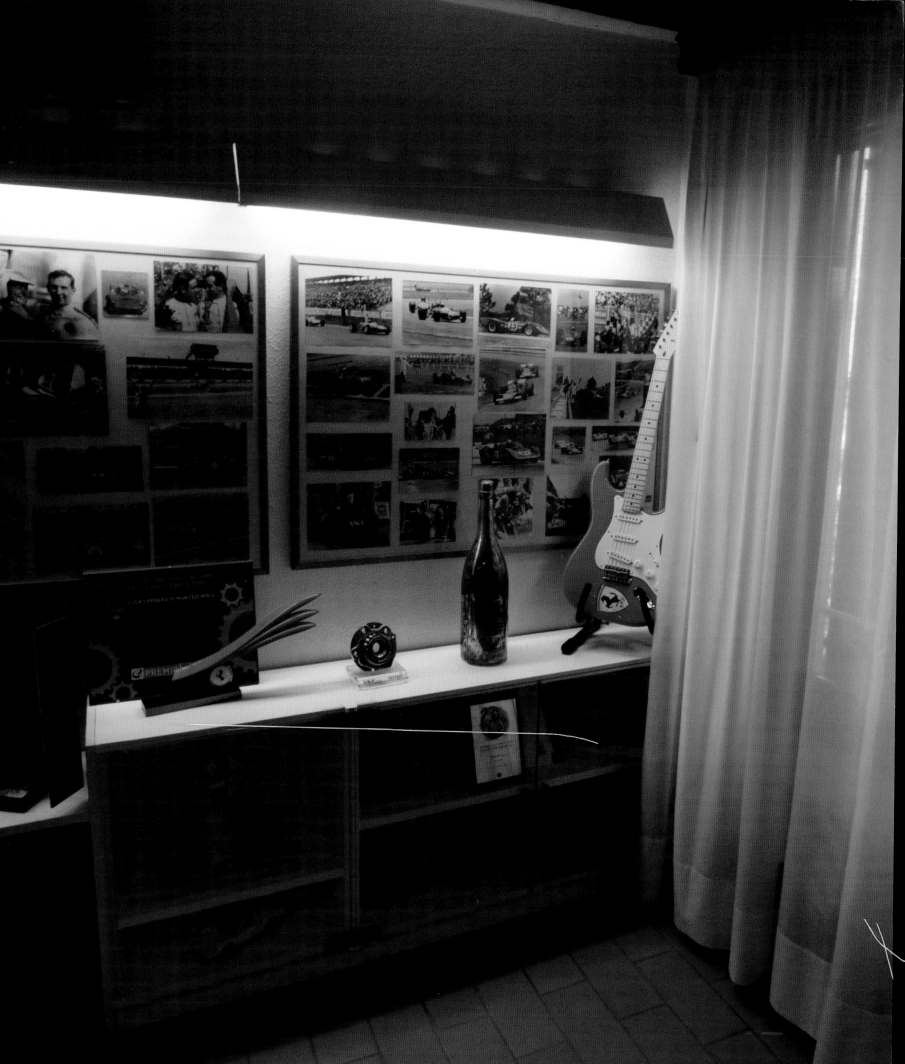

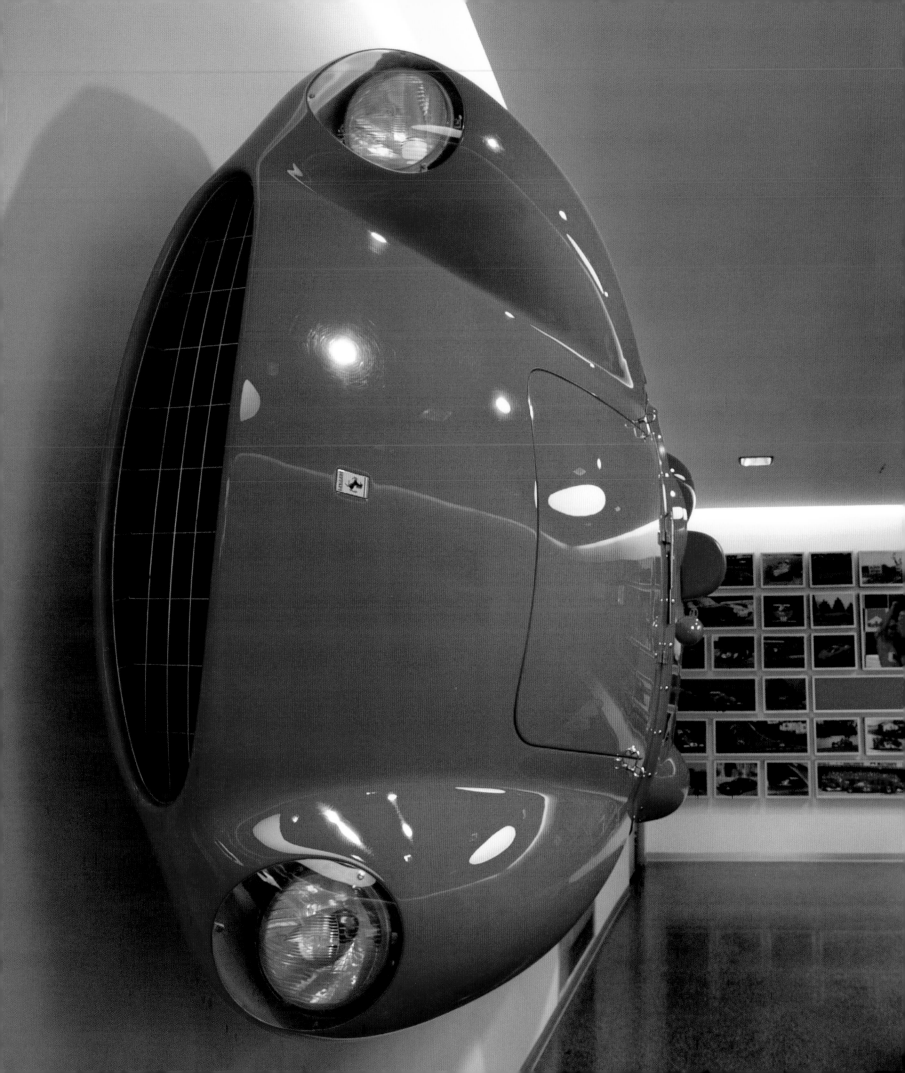

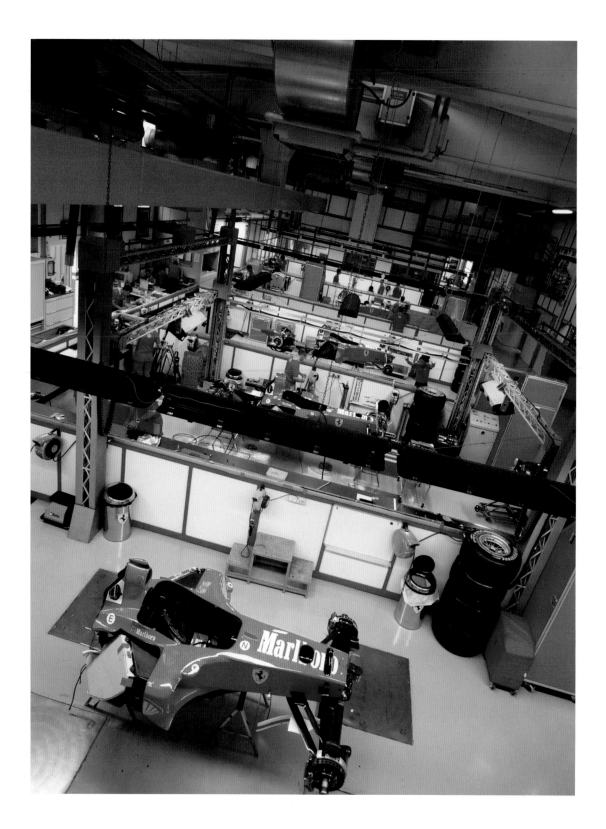

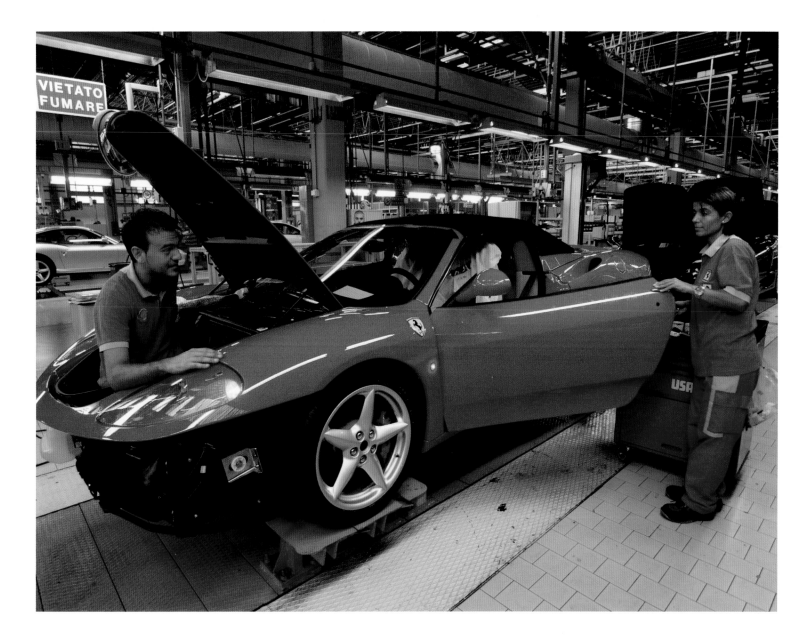

SAME COLOUR; SAME LOVING CARE

There may be different functions for the cars being prepared in the racing department (left) and the production plant (above), but they all carry the Prancing Horse symbol. A spare chassis, minus engine and transmission, sits in the foreground of the race shop. Beyond, three cars are being prepared for the next grand prix. Across the Via Abetone, a 360 Spider sits on the production line and will be rolled forward only when the intricate installation jobs are complete.

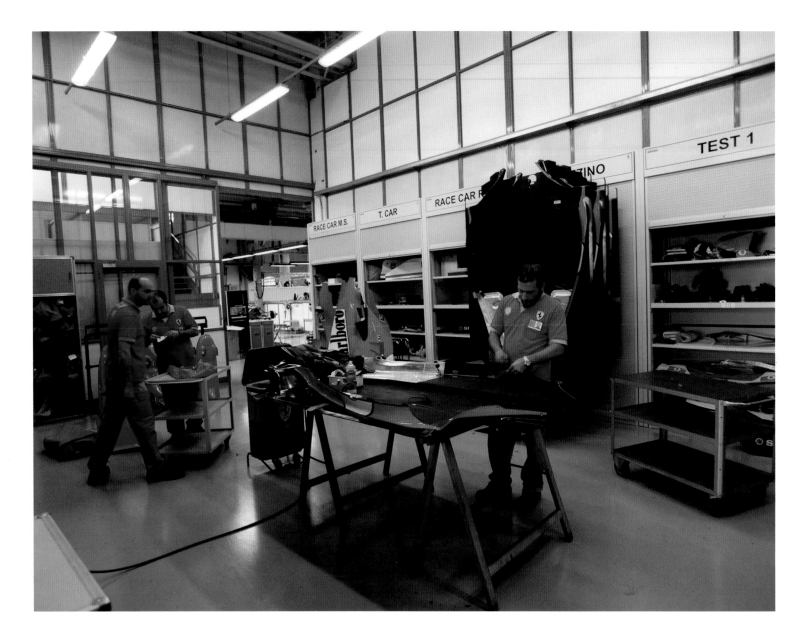

TWO DIVISIONS UNITED IN SPIRIT
Coachwork leather is trimmed in the
factory (right), an allegiance with the
race team clearly prominent around the
workbench. Materials used in the race
department are more functional as
floors for F1 cars are inspected (above)
in the pre-loading final check area.
Either way, racing clearly remains at
the company's core.

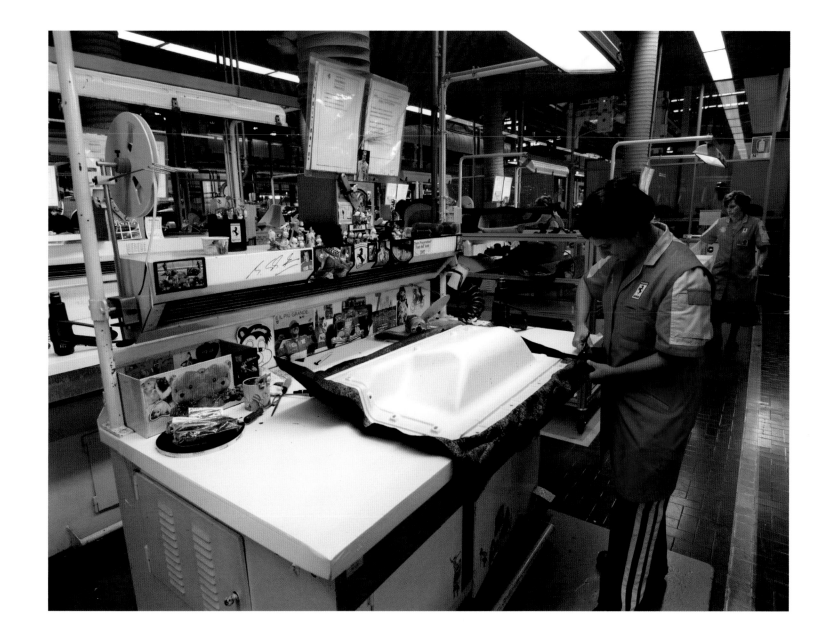

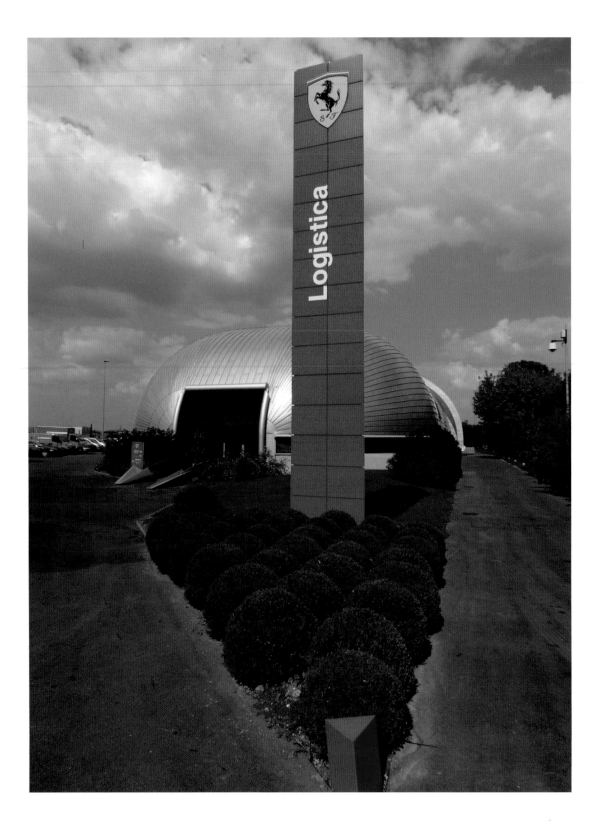

DEPARTURE POINT

The space and elegance of the Nuova Logistica building (left and right) are immediately evident. They become even more apparent when a fully prepared race car is pushed toward the waiting fleet of trucks and motor homes (below right). These will travel to the next grand prix.

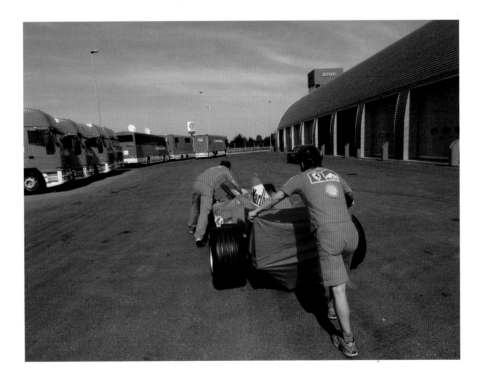

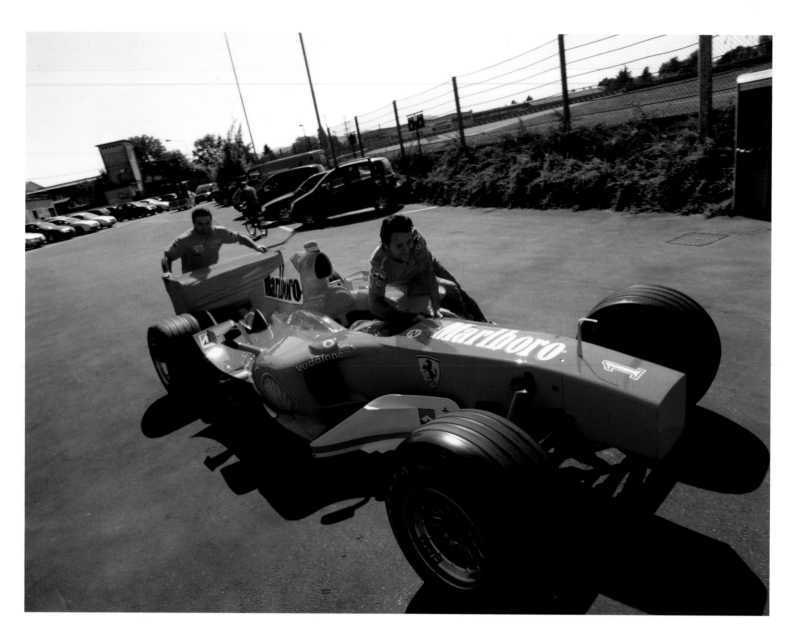

DRESSED FOR TRAVEL
In readiness for loading, with its
engine silent, an F1 car looks
unusual without its nose cone.

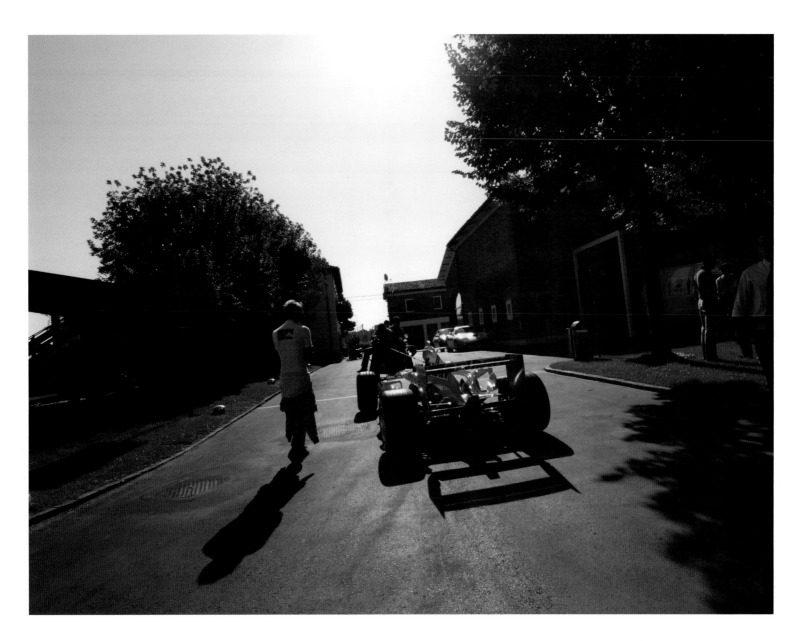

FINISHED – FOR THE MOMENT
Long shadows signal the end of a pre-race installation run at Fiorano. Luca Badoer, his work in the cockpit finished, walks alongside the car as it is taken to the Nuova Logistica building. Each car receives a final shakedown to ensure everything is at least functioning normally after the last rebuild in the workshop. The team has been working until the last minute. Badoer's pensive mood and the general lack of anticipation suggests that a difficult weekend lies ahead at the next grand prix.

HOME FROM HOME
The Montana restaurant, tucked out of sight but not far from the factory, provides a bolt hole for the team. The family atmosphere of the restaurant was summed up by Michael Schumacher when he referred to the owner, Rosella, as "my second mother".

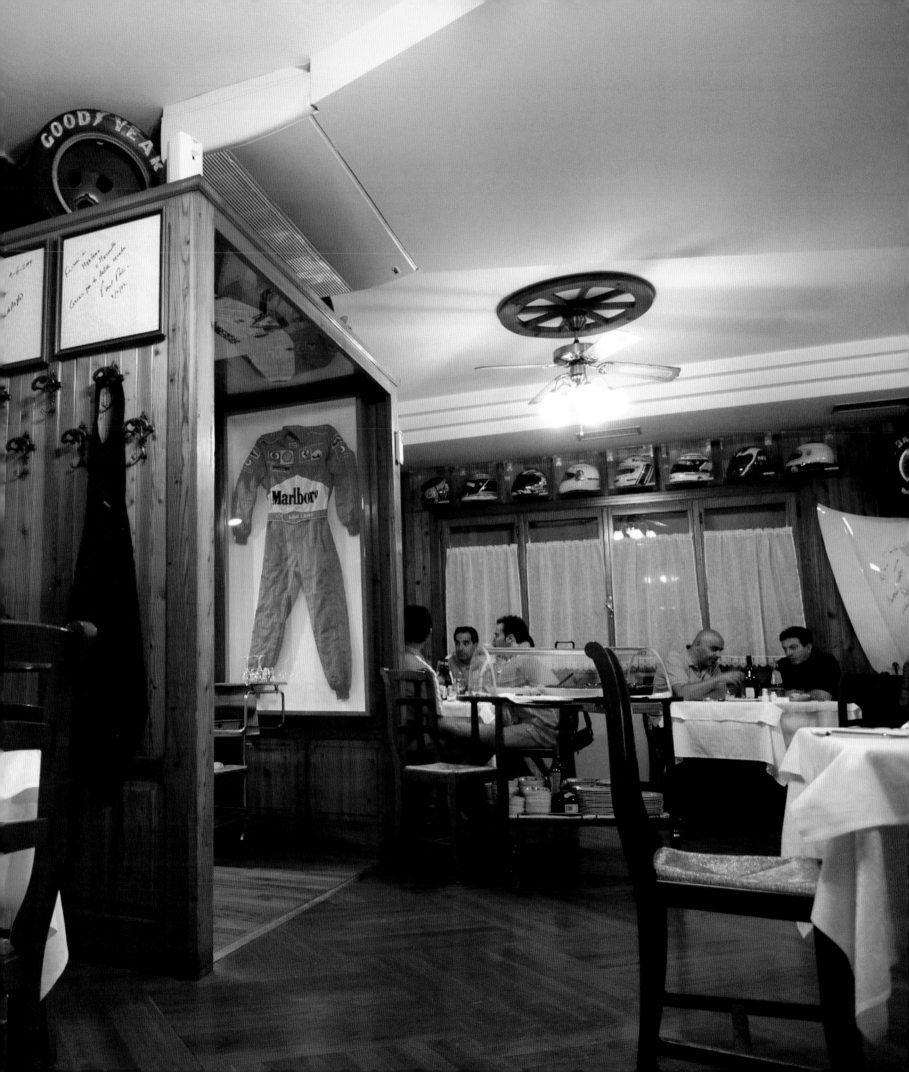

HAVE RACING TEAM; WILL TRAVEL

Packing everything necessary for a grand prix weekend demands attention to detail so that nothing gets left behind (left). A Formula 1 car, covered and ready for travel (below), looks lost within the Nuova Logistica building. Designed for easy shipment on aircraft, the red-painted box units (below) are taken to the long-haul races. The team brings at least 20 tonnes of freight to each grand prix, all of which is taken by road to the races in Europe. Everything is neatly packed and wrapped. Items for the pit wall platform are ready for loading (below right).

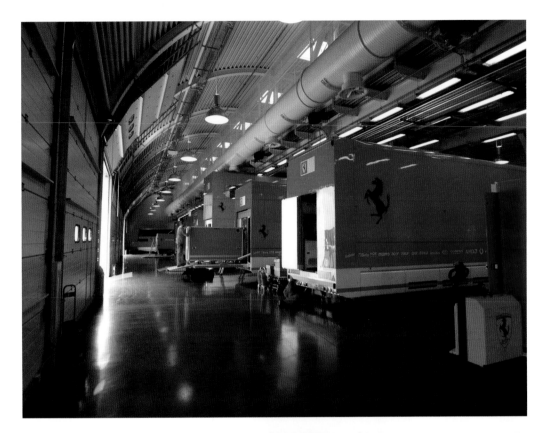

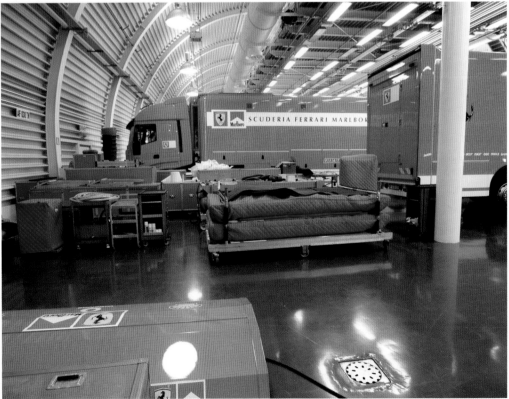

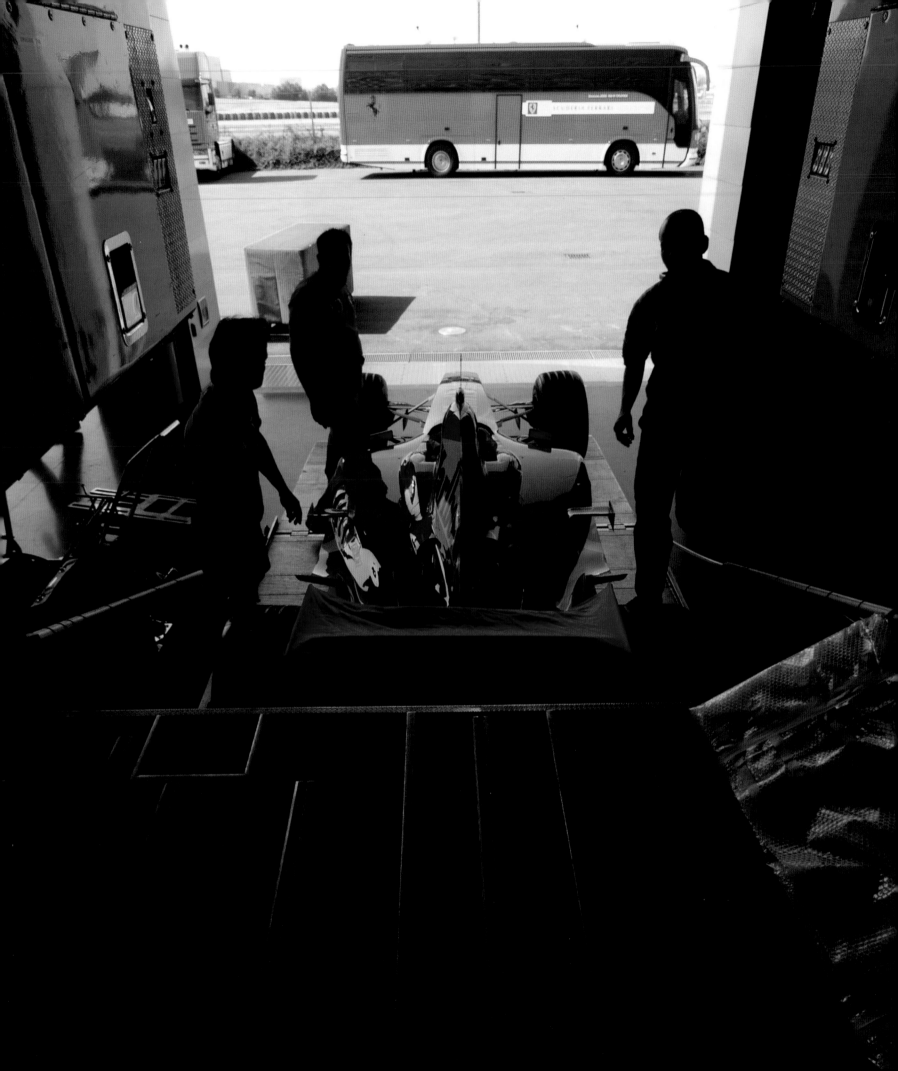

NO ROOM TO SPARE

Not a single square centimetre is wasted as a Formula 1 car is loaded and stowed on the upper deck of a transporter. Lockers are built into every available space. Beyond the truck sits the motor home (left) that provides a base for Ferrari's media operation at the races.

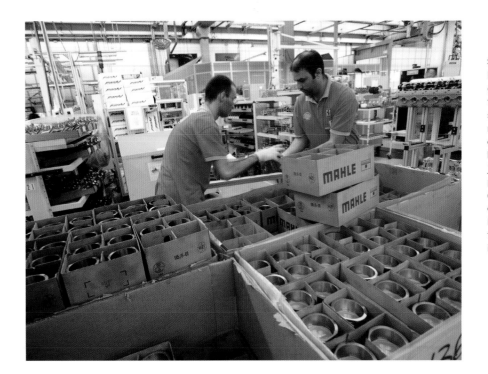

STAFF ONLY
Ferrari fans the world over would give anything to gain admission to the factory. Staff go through security at the main gate (right), ready for a day's work within one of the most hallowed automotive headquarters in the world. The job is treated accordingly, as pistons are handled with care (left) prior to assembly in the engine plant. An engine (below left), complete with gearbox and transmission, is pushed neatly into place, ready for installation.

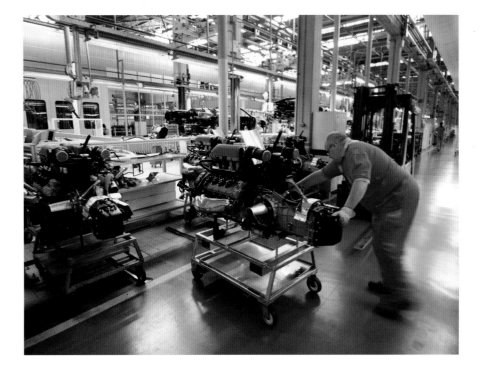

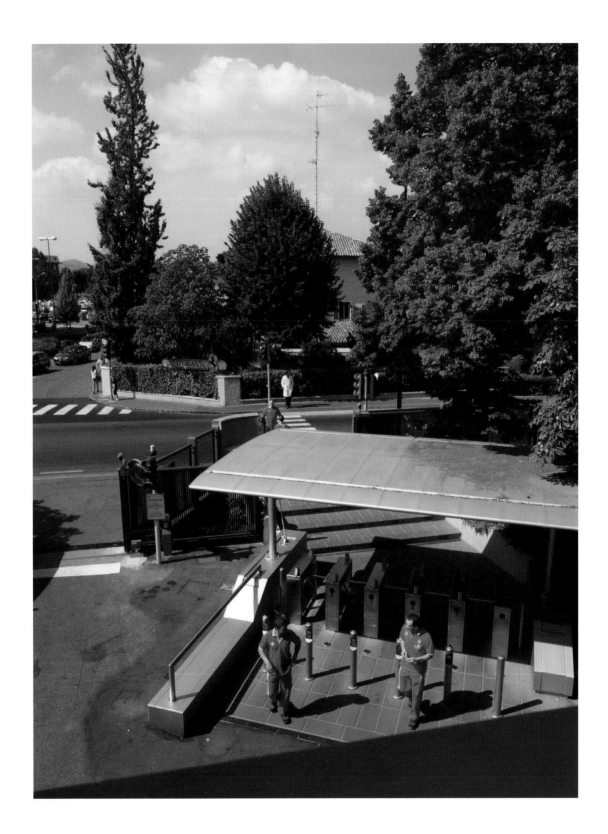

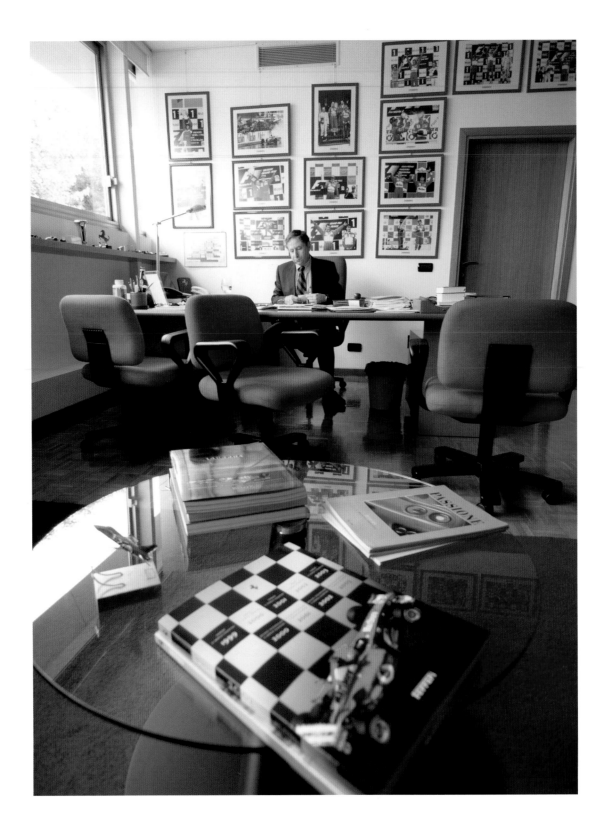

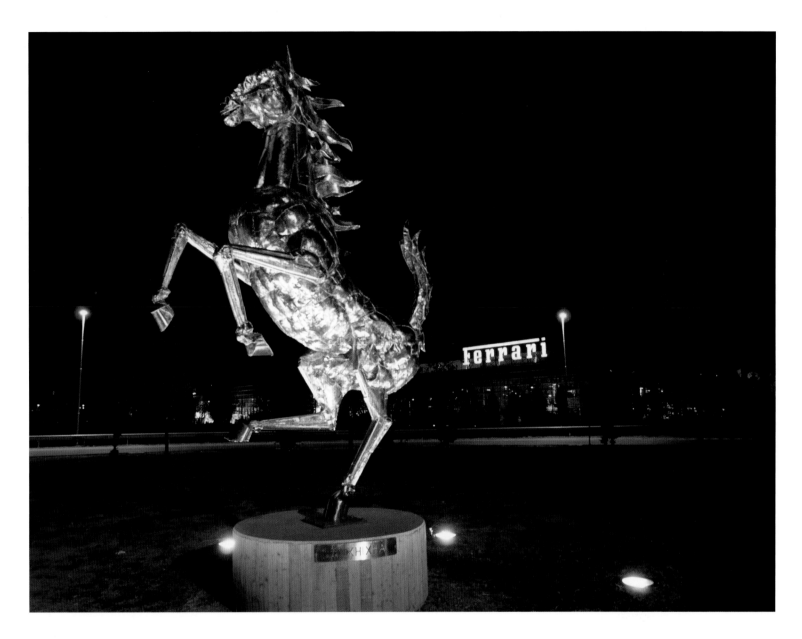

SURROUNDED BY SUCCESS
Jean Todt, general manager at
Ferrari, sits at his desk in the
Gestione Sportiva (left). The walls
display evidence of the many
victories that have come to the
team since his arrival in 1993.

ONE HORSE TOWN
The Prancing Horse symbol
in the middle of a roundabout
symbolizes how much Ferrari
and Maranello have become
irrevocably linked during the
past five decades.

TESTING

ROUND AND ROUND AND ROUND
A major part of Ferrari's relentless test schedule concerns tyre development, an essential link in the chain. Bridgestone and Ferrari work closely together to produce tyres that will combine with the car to provide consistent performance on the variety of surfaces encountered during the racing season. Ferrari will regularly spend three or four days in succession pounding around a test track.

The comparison between a grand prix weekend and a test session is stark. It is as if someone has pressed the mute button. It's true that a single Formula 1 car going flat out can create enough noise to waken the dead. But, during a test, you can listen to its progress for the entire length of the circuit. That's the difference. When a grand prix practice session is under way with 20 cars constantly coming and going, the assault on the senses is so powerful it is difficult to distinguish anything in the midst of this barrage of sound. During a test session, you can hear every gear change, every beat of the engine, every cough of a mechanic waiting in the garage, every clatter of a spanner. After the full-on values of a race meeting, a test session is spooky, surreal, almost serene.

And yet the work being carried out is just as intense as a race weekend: arguably more so because much progress needs to be made. Designers and engineers can only learn and speculate a limited amount from work in the wind tunnel and on computer simulations. There is no substitute for the information coming from the seat of the driver's pants and the effect of his efforts on tyres and the myriad parts that make up a Formula 1 car.

A test session is exactly that: a test. It is routine, repetitive, sometimes tedious, always lengthy. But it is essential if the team is to arrive fully prepared for the next grand prix.

Ferrari is unique in having a test track on its doorstep. Enzo Ferrari was well ahead of his time in 1979 when he had the Fiorano circuit built on land abutting his farmhouse temporary residence and the race headquarters. A crossover in the layout allowed 3km (1.86 miles) to be squeezed into the available space. There was very little problem with planning permission or noise abatement. Quite the contrary, in fact. If you live in Maranello, you also live Ferrari. You embrace the opportunity to actually see the latest F1 car being given some stick. The sound draws locals to the perimeter fence. Bikes are tossed in hedges, trucks straddle pavements, cars double park. If a Ferrari is testing then it invariably means there is something "new". Even if nothing is immediately obvious to the casual observer, the sight of the latest car amounts to an audition for friends. The feeling seems to be, "Ferrari is getting ready to go racing again – for me".

Because Fiorano has its limitations, Ferrari also owns the Mugello track in Tuscany, and carries out further work during official F1 test sessions at tracks such as the Circuit de Catalunya in Barcelona and the Monza Autodrome. But, wherever the venue, the routine is always the same. Work, work, and more work; lap after relentless lap; try this, try that; always looking for that elusive tenth of a second.

The immediate plus point on arrival at the test track is the absence of queues, the security guard glad to relieve the boredom by

You can hear every gear change, every engine beat, every clatter of a spanner.

receiving a bona fide visitor. This curious feeling of turning up on the wrong day is exacerbated by the acres of empty car parks, ghostly grandstands, and locked shops and cafés.

But, once inside the paddock, the Ferrari enclave looks familiar. As many as six spotless red transporters and half that number of Bridgestone trucks are parked side by side at the back of the garages. The catering vehicle and management quarters complete the home-from-home feeling as the team gets down to business in preparation for a 9am start.

The day ahead may be long, but there is usually much to be done. It could be a series of lengthy runs to check tyre performance; it might be the need to put miles on a new engine modification or try back-to-back reaction from the driver to old and new aerodynamic parts. It might simply be a shake-down (known as a *collaudo*) to ensure there are no leaks and everything is running as it should prior to departure for a race.

Whatever the reason for a test, it will prompt the appearance of as many as 50 personnel if Ferrari is running two cars – as it frequently does. One driver could be focussing on tyres; the other on aerodynamics and handling. Backing them up will be rows of technicians and engineers studying graphs and read-outs on laptops, the information being beamed directly from the moving car to antennae erected at the back of the garages.

Every pulse and movement of the car is measured by sensors attached to it, like monitors on a patient in intensive care. Except that the centre of attention in this case is in loud and rude health, the Ferrari being in need only of the fine tuning necessary to gain the smallest of edges in a business measured by mere tenths of a second on a lap of around 5km (3 miles).

The driver's role in all of this is beyond the obvious. He does not merely drive the car at speed. He has to do it consistently, to within a tenth of a second, for lap after lap. The test driver has to be able to build up to racing speed from the moment the test starts, and maintain it for most of the day if necessary.

True, there may be lengthy periods when the driver must cool his heels as the mechanics replace a damaged part or fit a different one for comparison purposes. But, if everything runs as it should, it could be that a test driver will complete more than a grand prix distance between 9am and 5pm. And then have to do it again the following day. And the day after that.

At no point must his lap time drop off through tiredness or boredom. The team will learn nothing if the car is not being extended as it will be during the course of a 320km (200-mile) race. Routine and boring it may be, but testing is absolutely vital to success on race day. There is, in every sense, no time to lose and everything to gain.

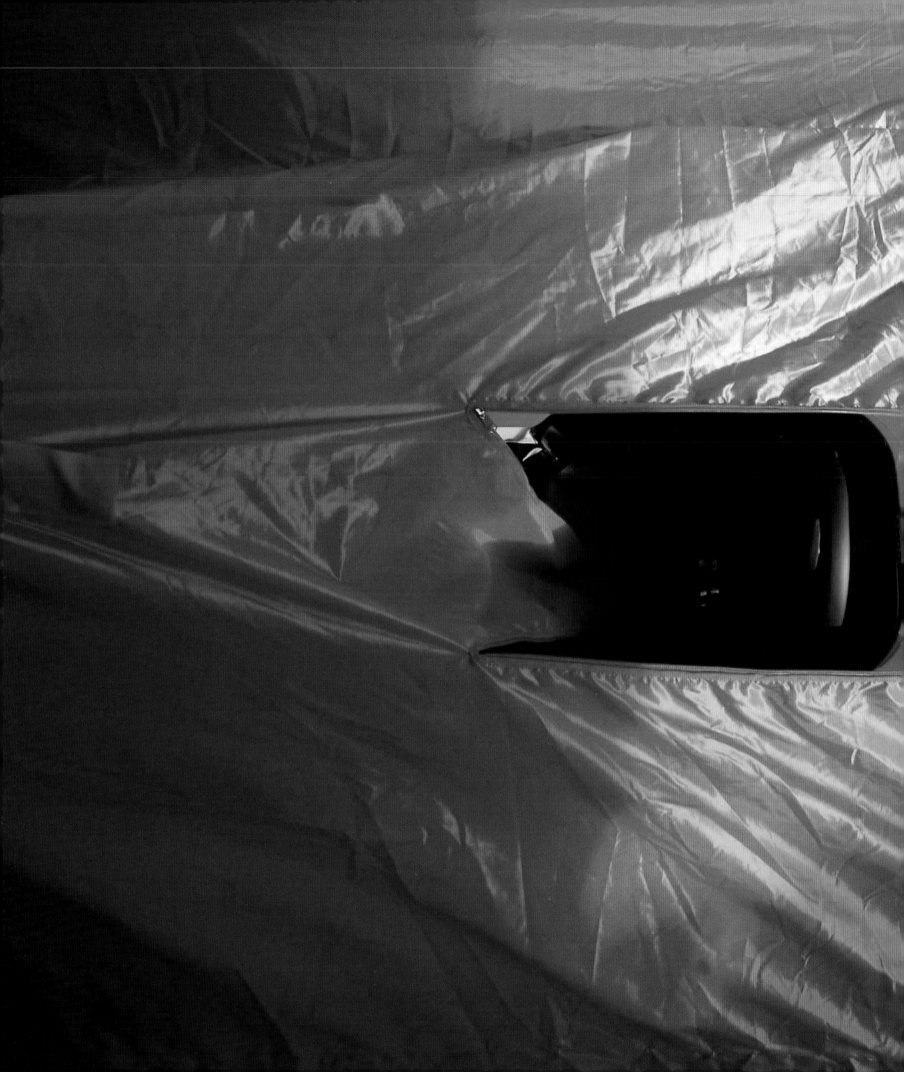

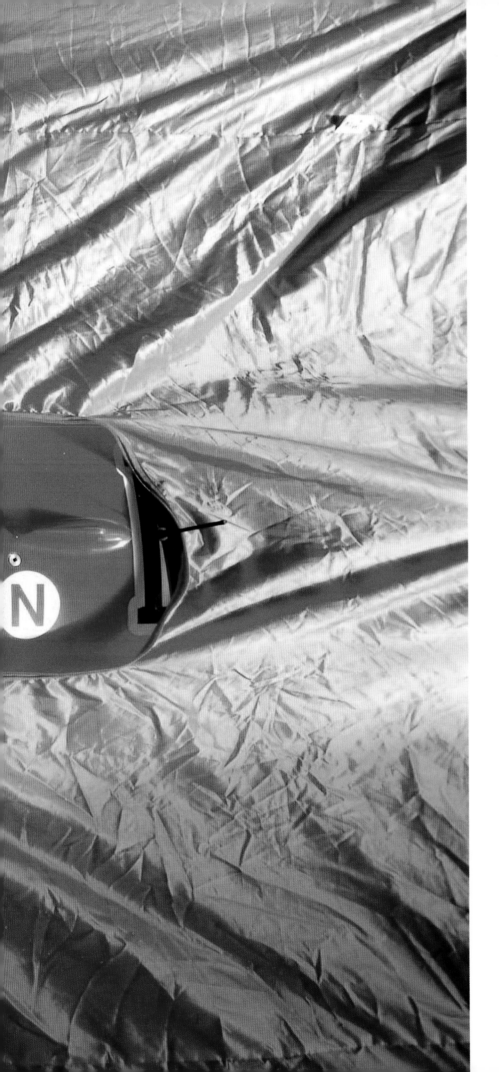

UNDER WRAPS
Testing can sometimes be held
in complete secrecy, such is the
importance of trials for novel
developments that might give the
team a performance advantage.

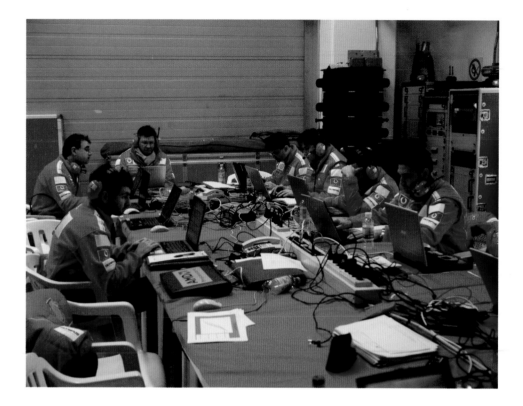

BEHIND CLOSED DOORS
The first test with a new car is a pivotal moment for the team and its technical director. Although Ross Brawn does not attend many test sessions, he braves the winter cold at Mugello (below right) to witness the first serious outing for the 2004 model. The actual running of the car is only half the battle. Once the car has returned to the pits, a team of technicians (left) sits behind the closed garage doors to study information downloaded from the car. Then begins the first of many discussions before the car has so much as started a race.

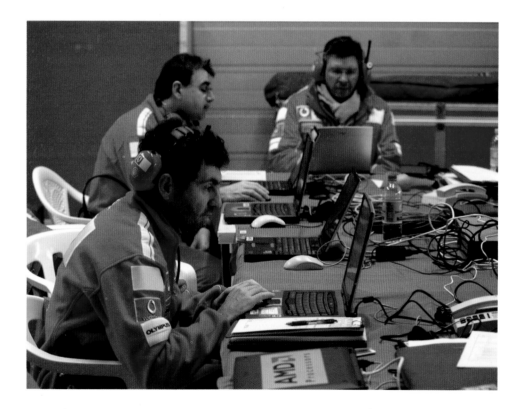

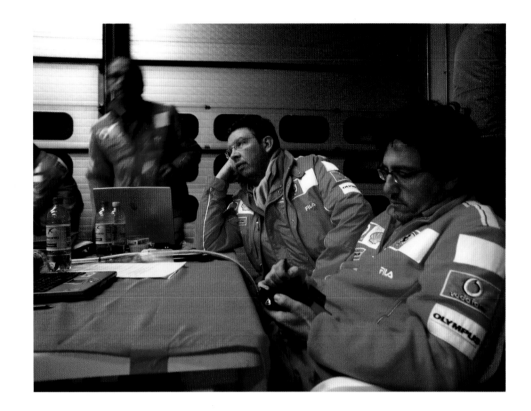

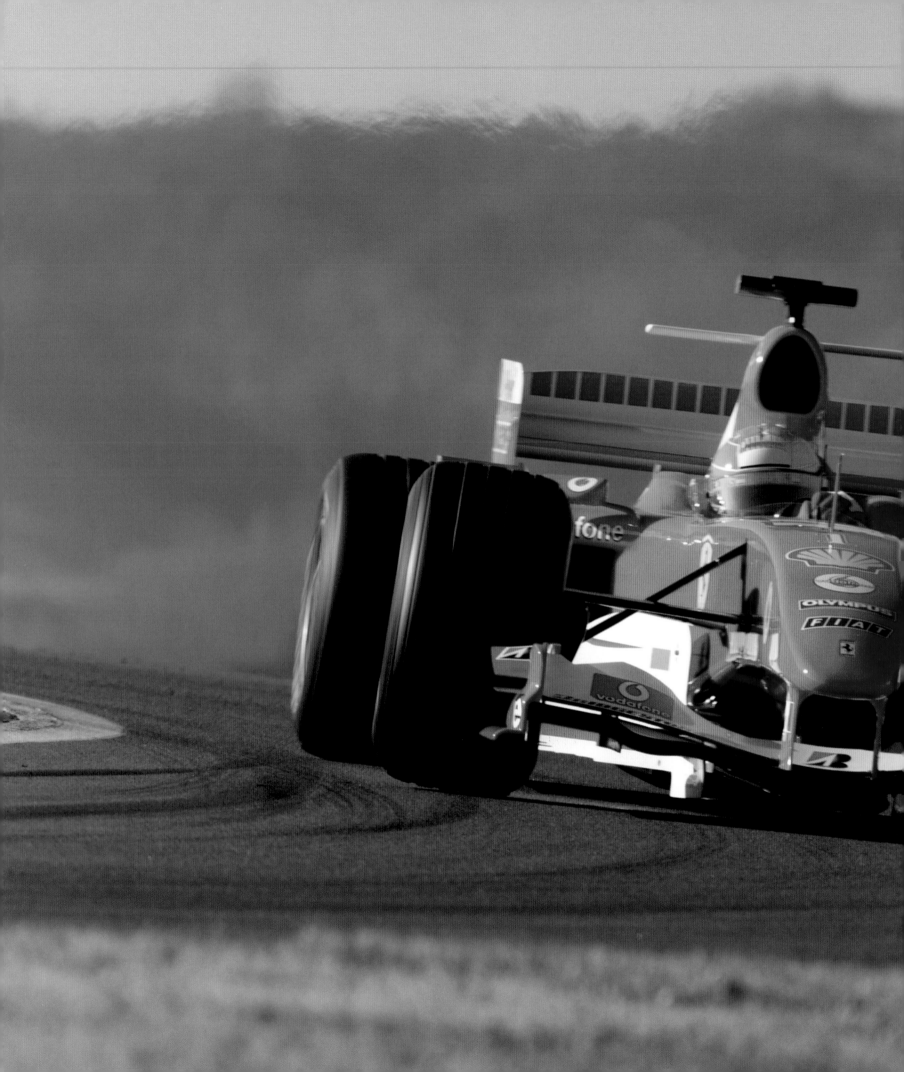

Luca Badoer (wearing Michael
Schumacher's helmet) comes
off the bridge section of the
Fiorano figure-of-eight track
during a routine test in July.
Emilia Romagna's hills provide
an unusual backdrop by
comparison with most
circuits visited by F1 cars.

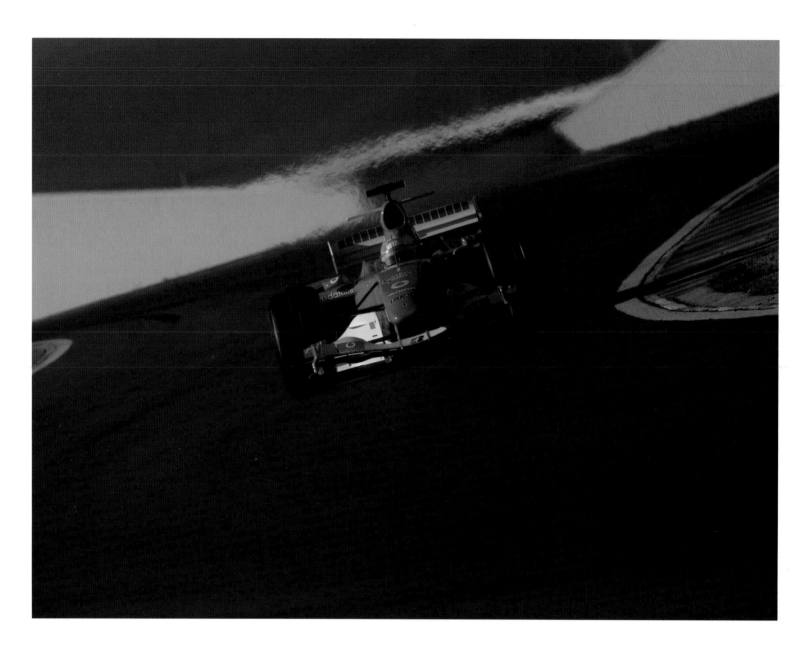

CAST A FAST SHADOW
Michael Schumacher brings
a long day's testing to a close
at Mugello.

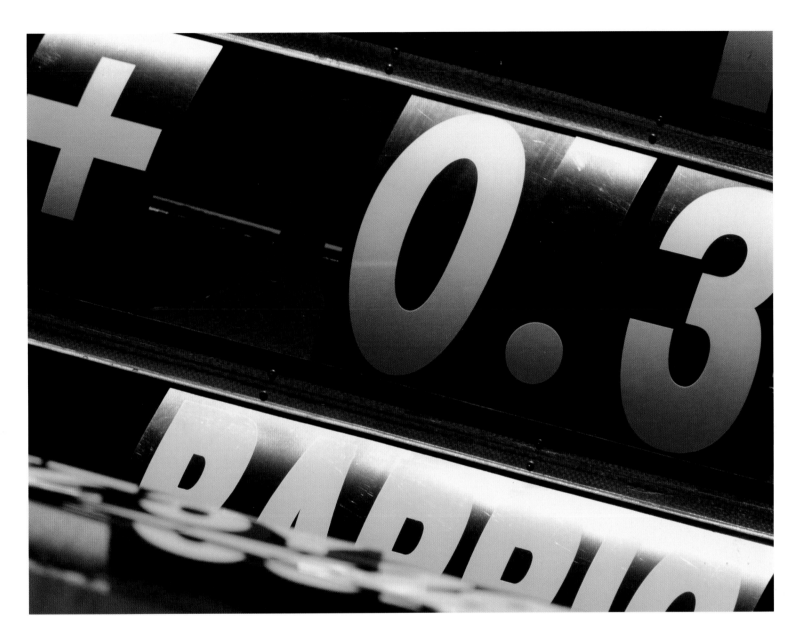

TIME IS EVERYTHING
Pit boards relay vital information
to the drivers, giving lap times
during practice and testing, as
well as indicating gaps to other
drivers during races.

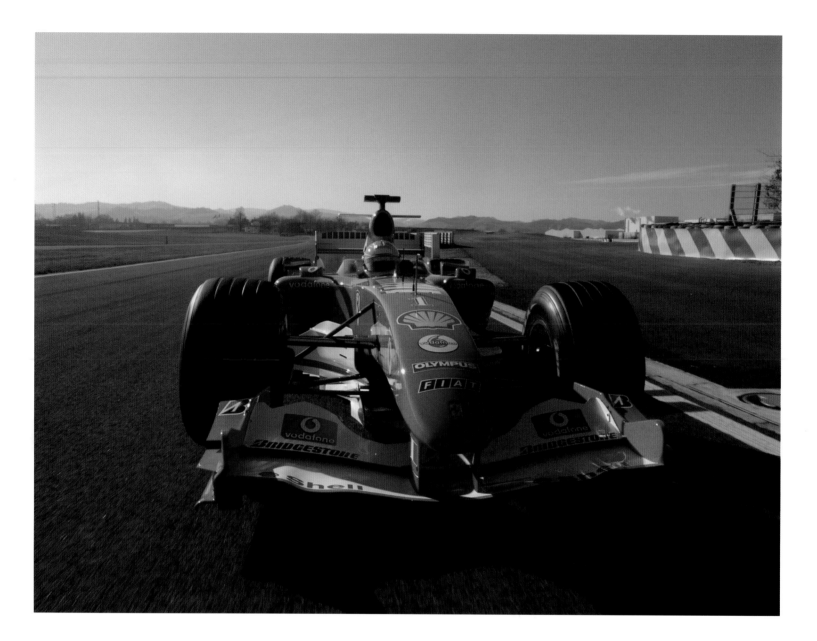

THE HEAT GOES ON

When necessary, every available moment between races can be devoted to testing. The pit garage at Fiorano is set up at 6.30am on a summer's morning (right). By the time testing begins a few hours later (left), the ambient temperature is 30°C (85°F) and rising rapidly. When the F1 team has no need for the track, Fiorano is in full service as road cars blast past the shimmering Logistica building in the background (below).

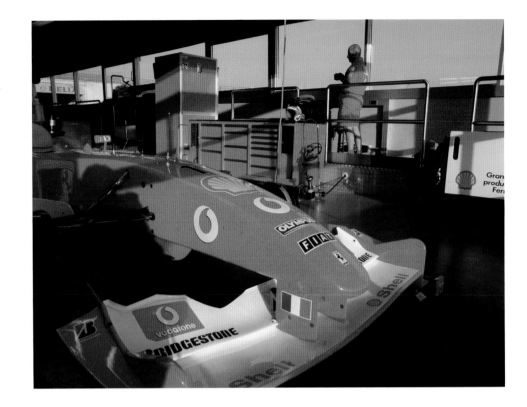

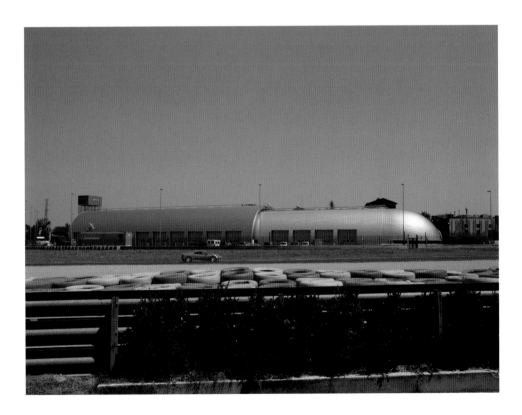

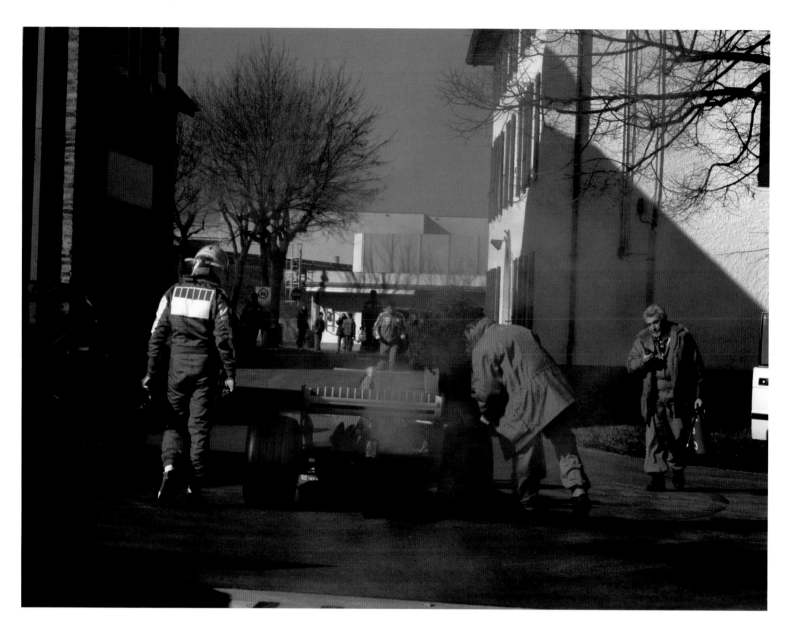

A PLACE FOR ALL SEASONS
The F1 car is taken away from
Fiorano at the end of a summer's
day (above), while Rubens
Barrichello (right) explores
the Ferrari's handling in a
puddle, during the less
pleasant winter weather.

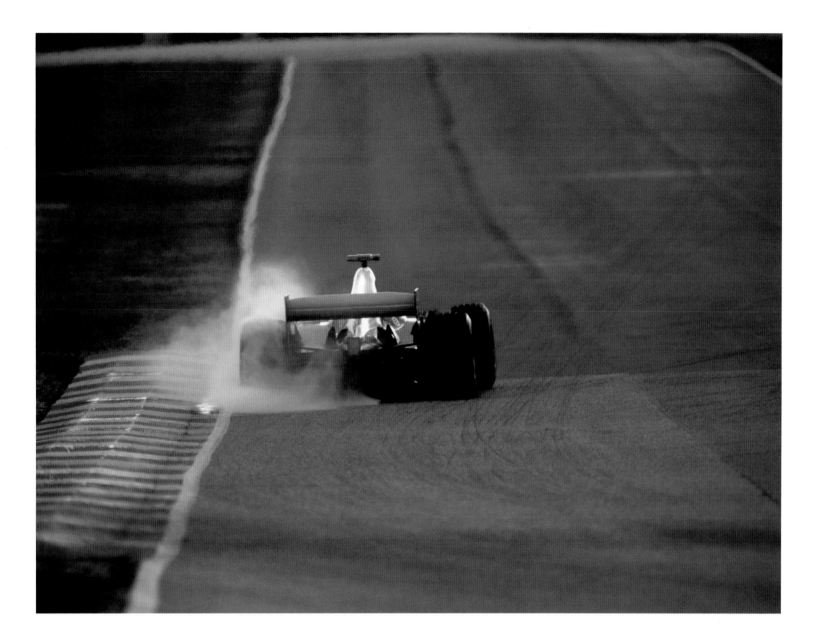

Next page

ONE LAST THING
The day's activity on the track may be over during a test at Mugello, but there is always time for pit stop practice. A mechanic readies an air gun in preparation for a wheel changing and refuelling rehearsal. It is a routine that can ultimately win or lose races.

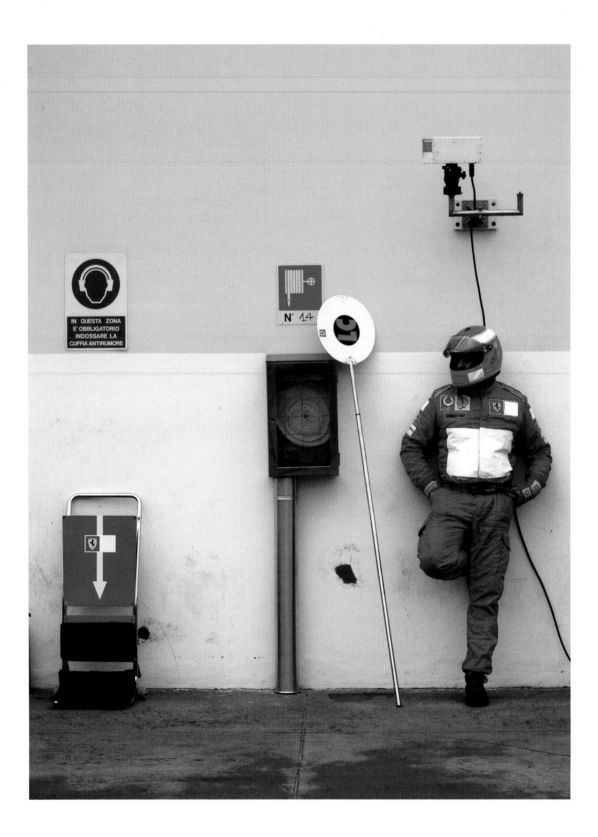

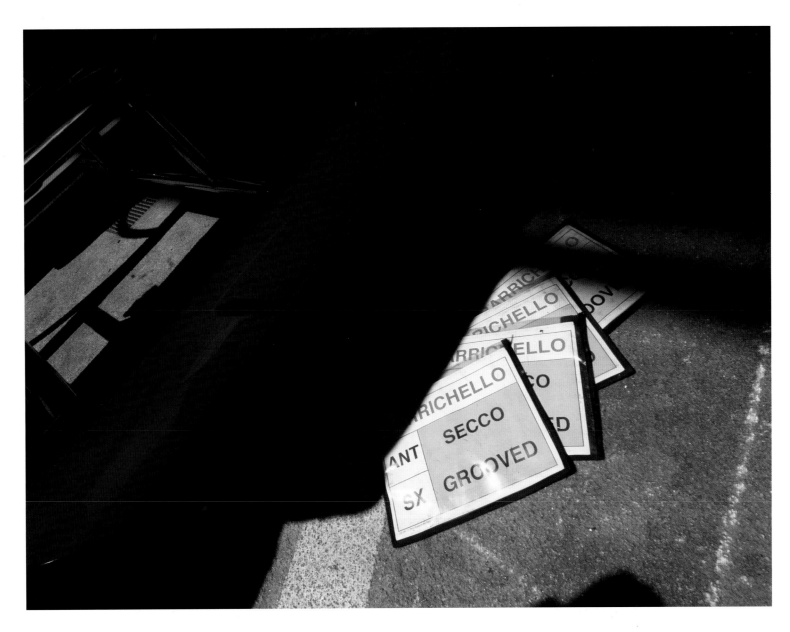

TRAPPINGS OF TESTING
Much of testing can be time spent hanging around. A mechanic waits for pit stop practice during a test at Mugello (left), the front jack and "lollipop" to his right. Elsewhere, labels from batches of tyres (in this case, grooved dry-weather rubber for Barrichello) lie scattered in the pit lane (above).

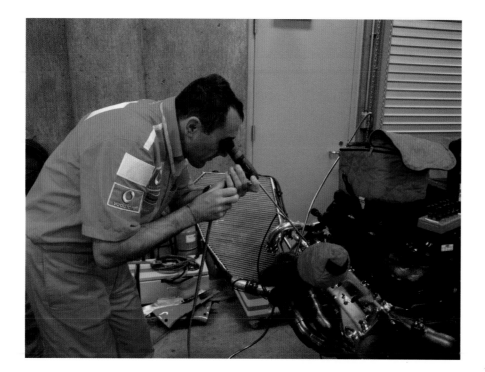

LOOKING FOR TROUBLE
An engineer uses an endoscope to examine the inside of a cylinder of the Ferrari V10 for wear and tear.

PETROL PLUS
Shell engineers work closely with Ferrari to produce fuel and oil that are tailored for the demands of the engine, depending on the track and climate. Samples are taken regularly for analysis during the race weekend.

GETTING HAMMERED
Air hammer poised, a mechanic kneels (right) at the exact spot where a wheel will come to a halt during pit stop practice.

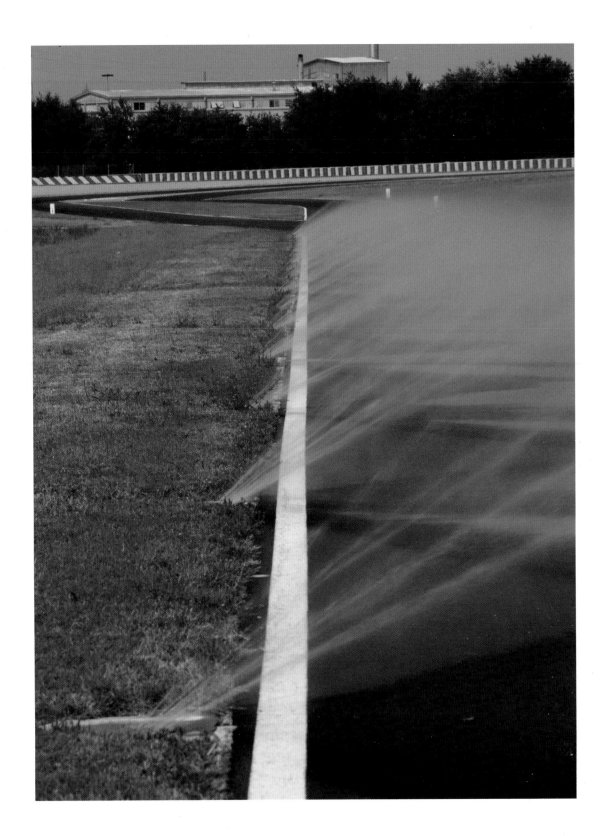

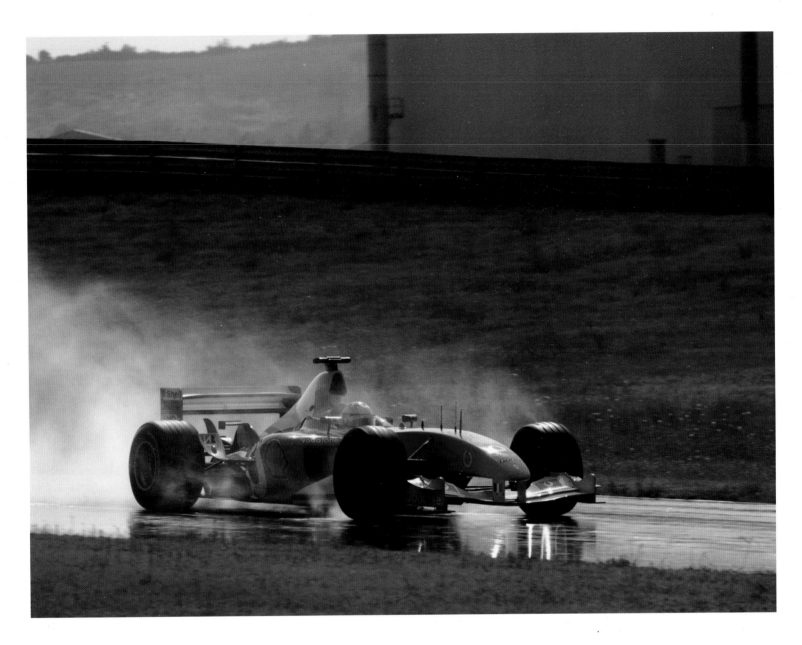

IT NEVER RAINS – BUT IT CAN POUR
If Ferrari and Bridgestone need to experience running various tyres in the wet but the weather remains dry, the Fiorano test track is soaked by sprays specially installed for the purpose.

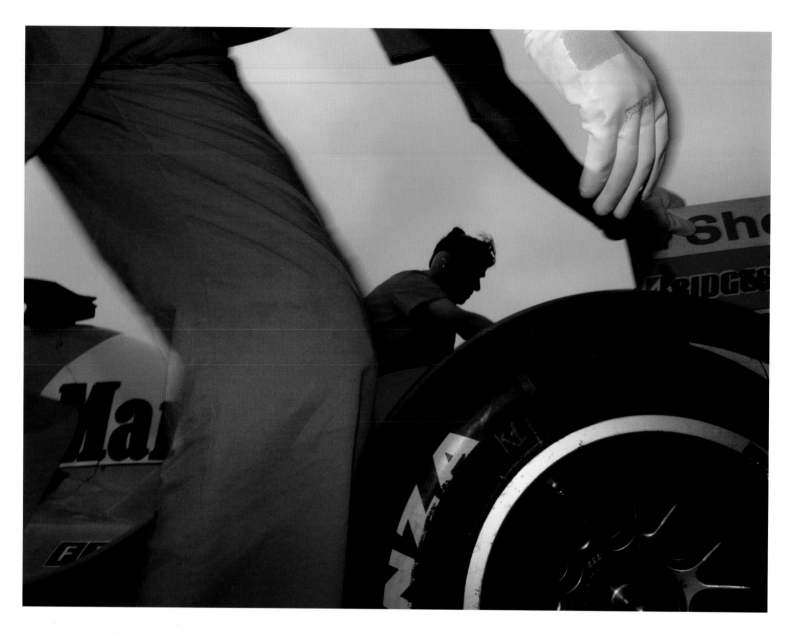

WHEELED IN FOR SURGERY
An F1 car is pushed backward
from the pit lane and into the
garage for checking over, with
careful handling, during a test.

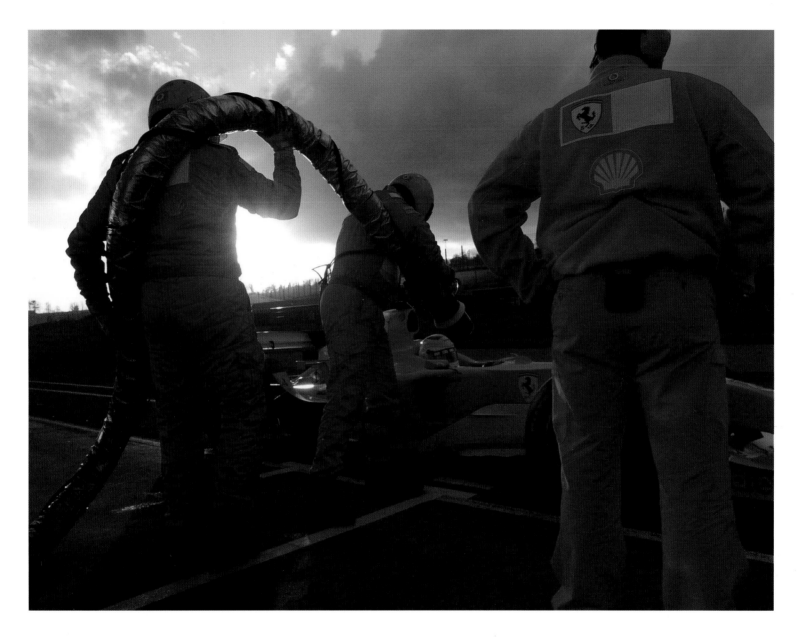

FAST FUEL

As evening closes in, pit stop
practice continues at Mugello.
Two mechanics are needed to
handle the heavy hose, which
blasts 12 litres of fuel into the
car every second. The fuel pump
on the forecourt of your local
garage takes 20 seconds to
deliver the same amount.

Next page

EMPTINESS ALL AROUND

The solitude of the test driver's
role is evident, as a long day's
work draws to a close with the
last lap at Mugello. Progress –
perhaps significant, perhaps
minimal – will have been made,
but no one outside the team will
have witnessed it.

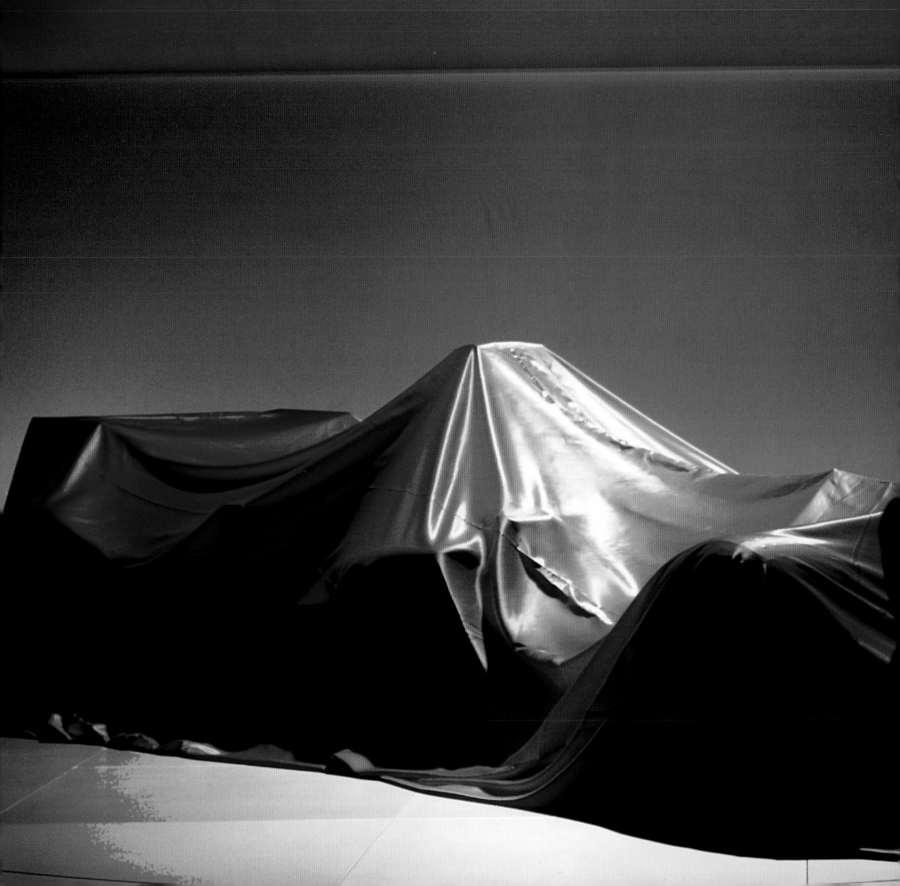

MARLBO

CAR

READY TO ROLL
The 2004 Formula 1 car under
close guard in the factory, prior
to its official launch. Ferrari's
championship hopes start here.

Any Formula 1 car looks fast standing still. None more so than a Ferrari with swooping curves carrying that shiny and distinctive red hue. Every team bar Ferrari has undergone a change of image at some stage in deference to sponsors and their financial clout. Ferrari remains very much Ferrari because the colour has stayed the same for almost six decades.

The actual shade of red may have been adjusted slightly but the symbolism and the work on and beneath the surface has remained exactly as before. There is not a single square centimetre of a Ferrari F1 car that has escaped the closest examination in pursuit of either mechanical or aerodynamic perfection.

Every flick and flap on the bodywork has been created and crafted with efficiency as the watchword; every component beneath made and positioned with lightness, effectiveness, and reliability as the principal arbiters. Cost comes some way down the list of priorities because F1 racing is not an economy run. It is about winning. The question is rarely, "How much?" More likely, "How soon?" or, "How fast?"

The fit within the cockpit is so snug that the driver almost wears the car. It is built around him, the reclining driving position meaning that only his head is visible. The rest of his body, from his lightweight boots to the shoulders of his flameproof overalls, is cloaked in a carbon-fibre chassis. Along with the engine, this "survival cell" is the heaviest part of the car. It is designed for the precise combination of weight-saving without compromising the strength that could be called upon to save the driver's life in the event of an accident.

The performance of an F1 car is breathtaking in every sense. The driver can have the wind knocked out of him by acceleration that takes the car from 0 to 160km/h (100mph) in 3.5 seconds, and braking forces so violent that it requires less than two seconds and just 120 metres (130 yards) to go from 310km/h (195mph) to 95km/h (60mph). For lap after lap.

The engine, designed and made within Ferrari's factory, has more than 1,500 moving parts and as many as 20 different metals. Each engine must last for two races, a very tough requirement when you consider that, in 2005, the V10 revved more than 300 times every second – for at least an hour and a half.

It is much the same in 2006 as Ferrari joins the rest of the teams in running V8 engines. But, whatever the configuration, the stresses within are searingly familiar as internal surfaces reach 300°C (570°F). So much force is generated that it would fire a piston 1.6km (1 mile) into the air if it wasn't being contained within this small but incredibly dramatic jewel which tips the scales at less than half the weight of an engine in a small saloon car.

The fit within the cockpit is so snug that the driver almost wears the car.

Containing all that power within a lightweight cylinder block is one thing. Stopping its effect on the car at speed, quite another. The brakes are so effective that deceleration generates more than 5g acting on the driver, a force so severe that facial perspiration can be flicked onto the inside of the driver's helmet visor. Carbon is the only material capable of both providing the stopping power and coping with temperatures which can shoot instantly to 1,000°C (1,800°F) and beyond, causing the carbon brake disc to glow bright red. This can happen as many as 300 times a race. At those speeds, the consequence of brake failure is unthinkable.

The driver's fate, to a very large extent, is literally in his own hands. The steering wheel costs £10,000 ($17,000) because it does more than merely affect the direction of travel. There is no need for a dashboard in an F1 car because all the necessary information and operating buttons are on the steering wheel itself. This is an electronic control centre which can adjust the brakes, the differential, traction control, throttle, air–petrol mixture, and fuel consumption, as well as providing the means of operating the radio, selecting neutral, activating the pit lane speed limiter, and running a liquid crystal screen displaying anything from pressure and temperature readings to lap times.

At the back of the wheel, paddles operate the clutch and the gear selection, the right-hand paddle for changing up, the left for changing down. By flicking the paddles with his fingers, the driver calls upon his on-board control box, another miniature marvel which responds instantly by packing the power of 100 desktop computers.

Slighter larger than a car radio, the control unit deals in nanoseconds (a thousandth of a millionth of a second). When a paddle is activated, this electronic brain declutches, switches on the rev limiter, rotates shafts and checks the correct gear has been selected within the gearbox, engages the clutch, and switches off the rev limiter. This takes one hundredth of a second and occurs constantly throughout the race. The sound of the gearchange is, not surprisingly, almost seamless.

The same control box is dealing with commands to the ignition, fuel injection, and engine. It runs the telemetry, the system which fires information from the car back to the pits, the equivalent of a set of encyclopedias being transferred from car to pit garage every lap.

None of this technology would be of any use if the tyres did not work properly. Ferrari's partnership with Bridgestone means that the cars are set up to ensure the downforce created by the wings and bodywork generates the loads necessary to have the tyres reach a working temperature of 100°C (212°F). The suspension set-up also plays an important part in ensuring an even spread of temperature across the width of the tyre's tread. Then it is up to Bridgestone to be certain that the blend of more than 200 ingredients making up each tyre works efficiently and, most important, consistently.

That is the watchword for the entire Ferrari, arguably the most sophisticated thing on four wheels in the world. It is a superb piece of automotive architecture. Proving that it is the fastest is the entire *raison d'être* of the Ferrari team.

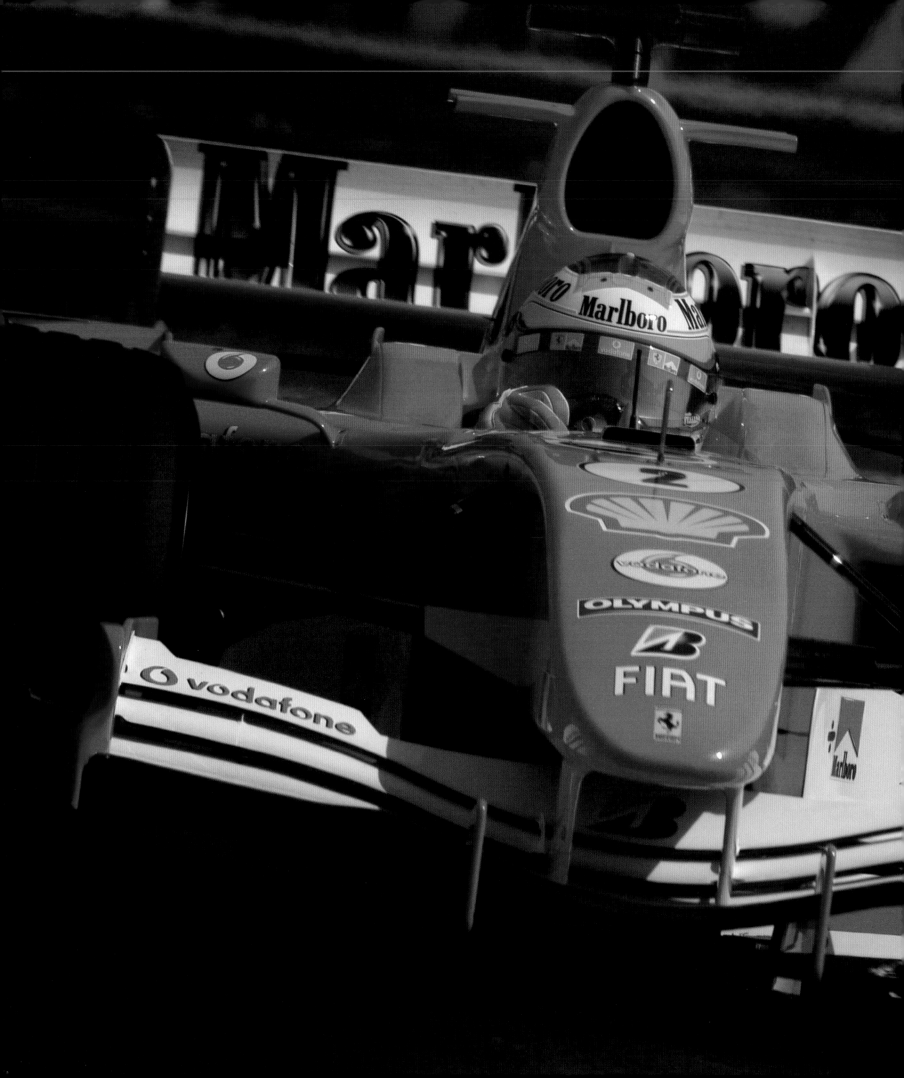

FOCUS OF ATTENTION
Ferrari cars have been central
to Formula 1 for more than
50 years. Rubens Barrichello
plays his part with the 2005
version in Hungary.

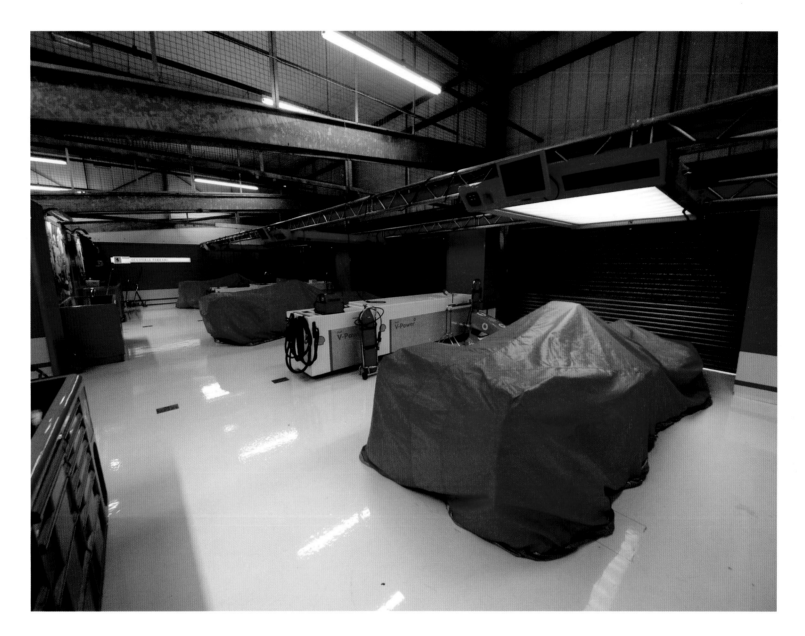

PRELUDE TO PERFORMANCE
The shadowy outline of Luca di Montezemolo (left) as the Ferrari president gives his predictions at the launch of the 2004 car at Maranello. Six months later, three of the same model wait for the start of action early on the first day of practice at Silverstone (above).

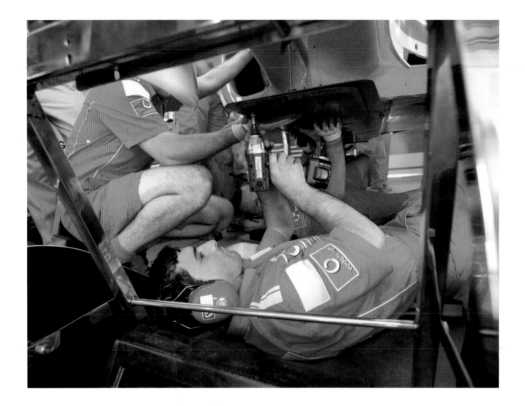

LYING DOWN ON THE JOB
Mechanics use flat-bed trolleys to roll beneath the chassis when preparing and fixing the undertrays and skid blocks.

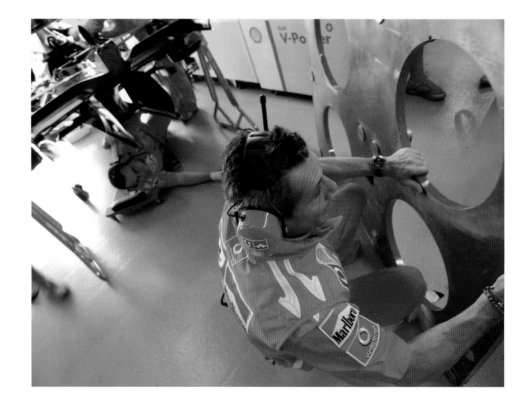

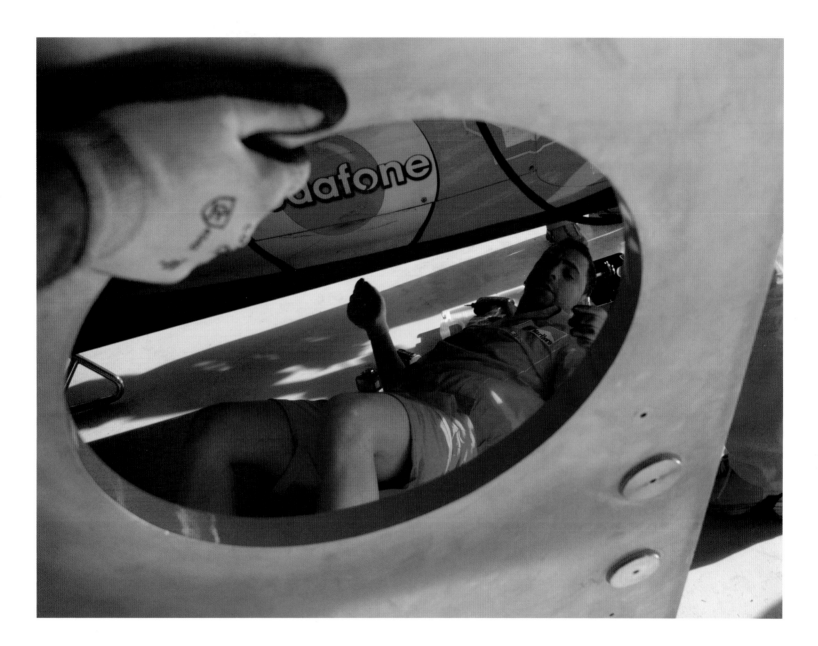

RED BONNETS

The upper rear bodywork is designed to fit like a glove, around both the airbox and the top of the engine with its attendant ancillary equipment. Apart from providing valuable advertising space, every single square inch of the engine cover is worked to the maximum, easing the flow of air across it toward the rear wing while generating as much downforce as possible without creating unnecessary aerodynamic drag.

GUNS AND GEAR
Nothing is left to chance as wheel-change guns and spares are laid ready at each corner of where the car will come briefly to a halt (left). The equipment needed for pit stops alone requires a trolley (above) to carry it from the truck to the front of the garage.

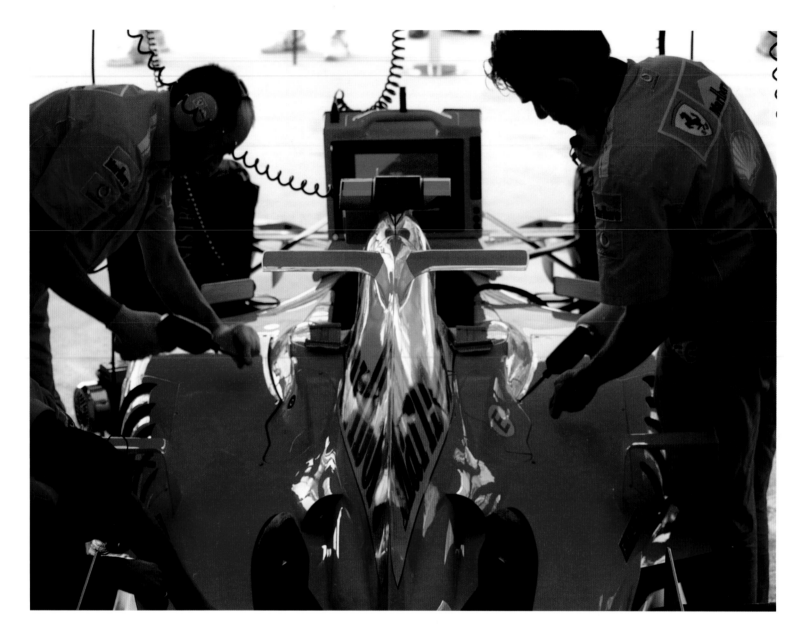

DRESSED FOR THE OCCASION
The sleek engine cover is secured in place, the winglets either side of the airbox providing additional downforce. The box directly above them is the on-board camera, with its fluorescent red markings either side signifying that this is the Number 1 car. Driver identification is thus made easier from a distance, as the Number 2 car in each team does not have any markings on the camera.

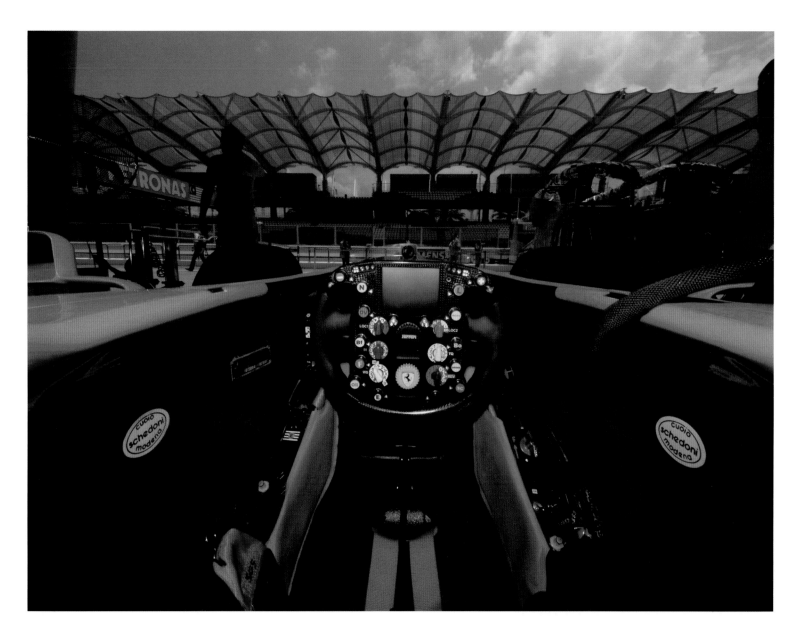

FITS LIKE A GLOVE
Cockpit view of the pit straight grandstand in Malaysia. The driver's legs find a tight fit beneath the multi-purpose steering wheel. Spread beneath the digital display at the top of the wheel, the buttons, knobs, and dials control brake balance from front to rear, the differential, traction control, throttle, air–petrol mixture, and fuel consumption, as well as providing the means of operating the radio and of engaging reverse. Levers behind the wheel operate the clutch and gear shift. And, in the midst of this wizardry, the wheel retains its original function of controlling the car's direction of travel.

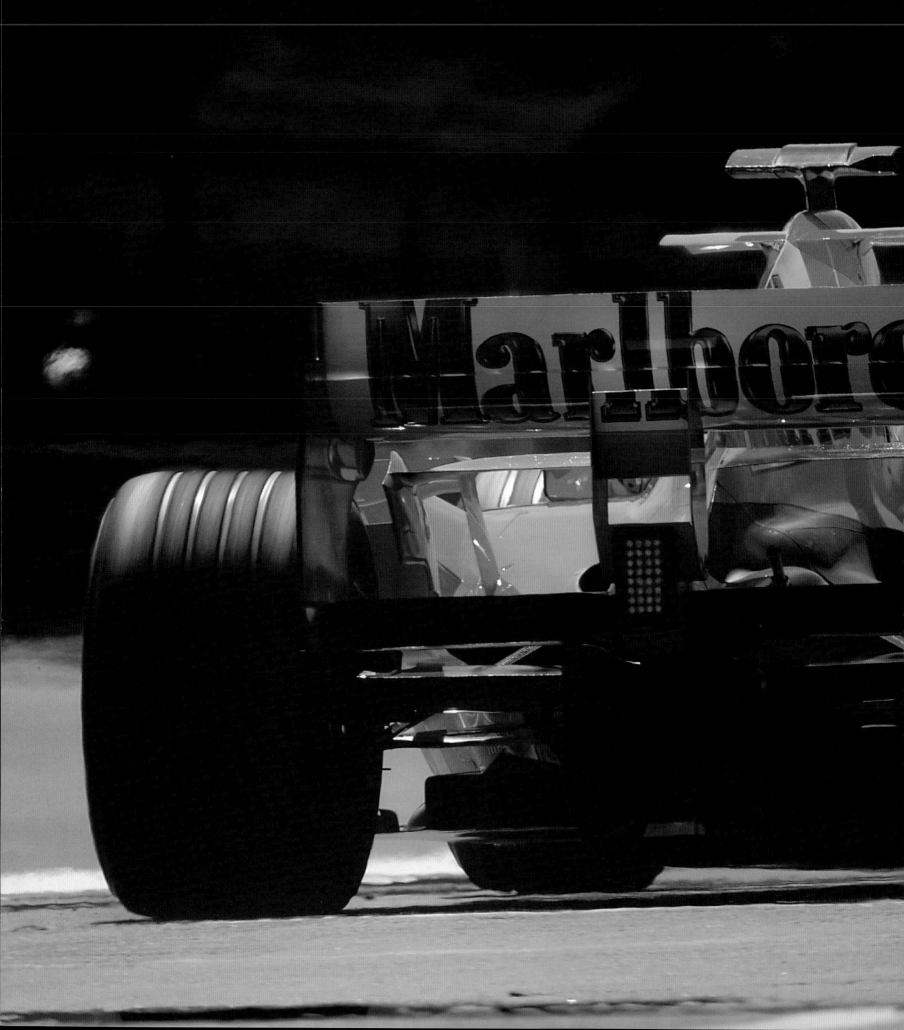

BUSINESS END
The Ferrari's carefully refined but brutal power reaches its final destination through the footprints of the rear tyres on the track. Delivery comes from the engine, via the gearbox and transmission, before turning through 90 degrees and heading via a driveshaft to each rear wheel. All around, the wing and bodywork are creating downforce to assist the efficient transfer of the power to the ground.

POLISHED TO PERFECTION
The top of the engine cover
gleams, highlighting the graceful
lines around the opening where
air is drawn into the engine.

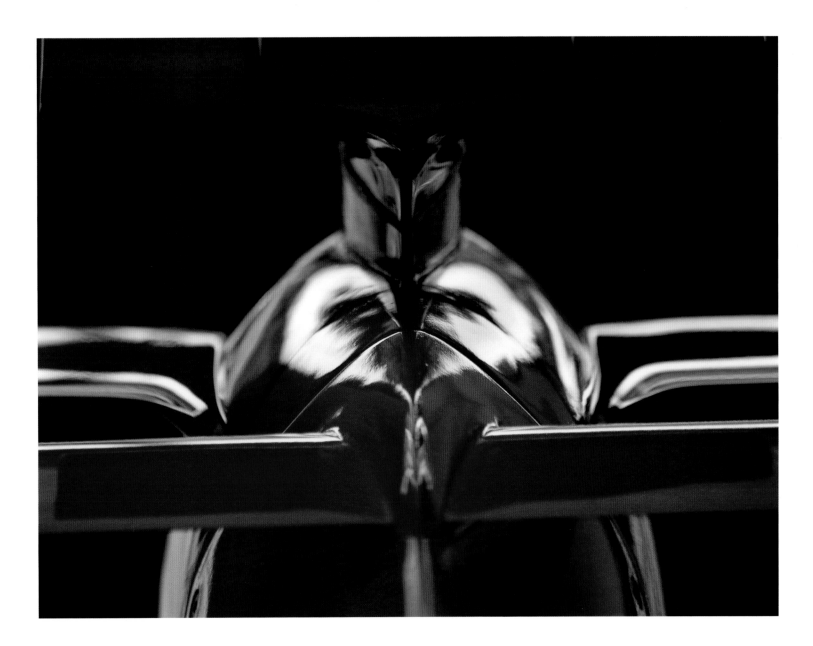

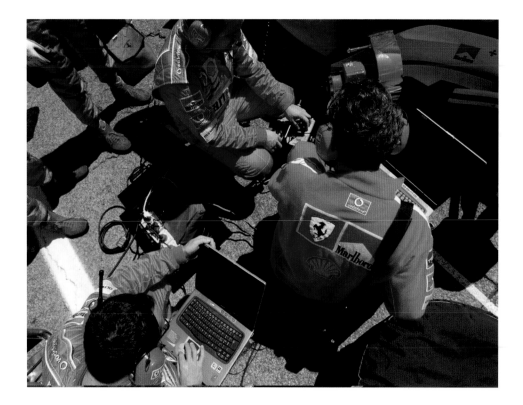

GET READY, GET SET...

Rubens Barrichello (below right) leaves the pits at Monaco to make his way to the grid. Drivers have 15 minutes to make their exit before the pit lane closes. Once the drivers are on the grid, the final 20 minutes or so allow time for complex final adjustments to software programs via laptop computer (left). This is also the time for more traditional and simpler changes by hand to crucial settings such as front wing angles (right). Electric blankets keep tyre treads close to working temperature (below left) during the wait. The pit crew communicates by headset, away from the prying ears of the media, hangers-on, and rival team members, as they stand as close as the temporary barriers will allow. The engines may be silent, but the tempo continues to rise dramatically in the midst of this controlled but tense hurly-burly. Finally, after two and a half days, it is time for the real business.

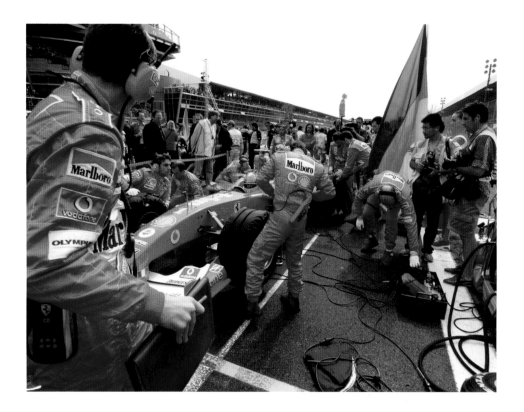

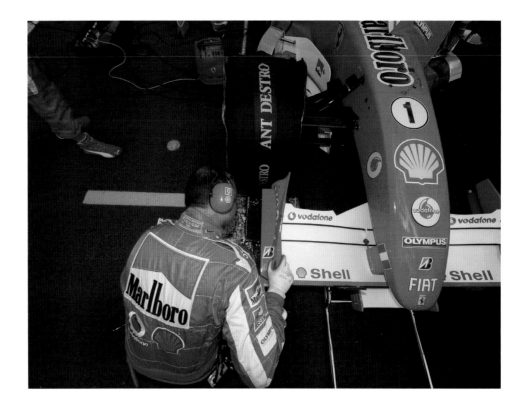

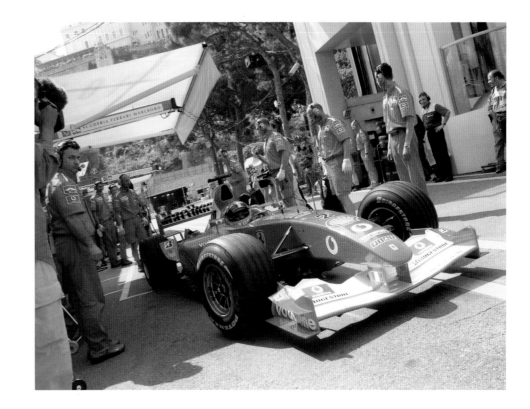

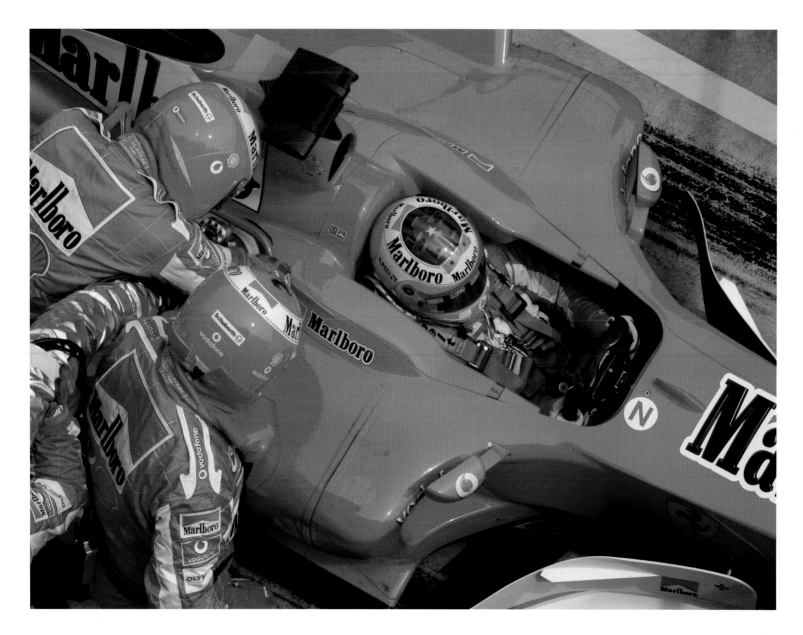

WAIT FOR IT!
Barrichello, left fingers engaging the clutch lever, waits patiently during the Malaysian Grand Prix while fuel is dumped into the tank behind his seat.

ON THE STRAIGHT...
Michael Schumacher sweeps
downhill toward the pits at
Magny-Cours (right).

...AND NARROW
The only way to deal with
the twists and turns of the
Hungaroring is to attack the
kerbs (below). The Ferrari must
be adaptable enough to cope
with every obstacle presented
by the many different circuits.

Next page

UNDER ARREST
The stopping power of an F1 car
takes some believing. The carbon
discs and pads can slow the
Ferrari from in excess of 305km/h
(190mph) to a third of that speed
in the space of 120 metres
(130 yards), and in less than two
seconds. The brakes may be
called upon to do this three or
four times every lap, the discs
reaching 950°C (1,740°F) each
time. Blue signifies the right-front
hub of the Ferrari; red, the left-
front. In this picture they are
shown complete with discs.

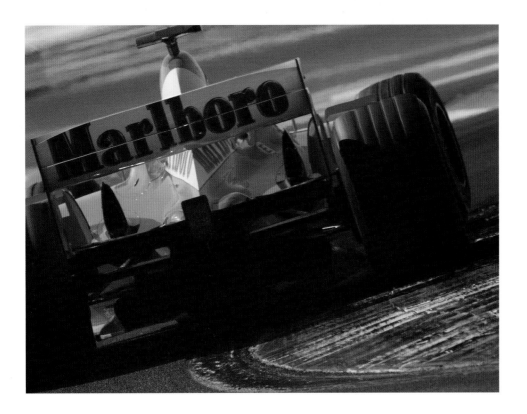

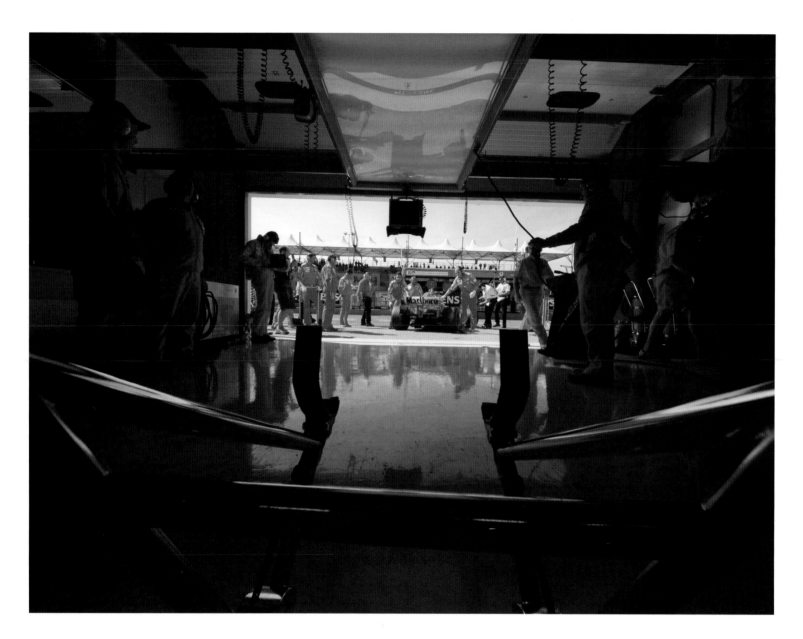

GET READY...
The rear jack awaits as the Ferrari
is pushed backward into the
garage in Malaysia. This is part
of the regular routine during
practice, with each mechanic
knowing his particular job and
standing ready.

...GO!

The car comes to a halt and immediately becomes the focus of attention as mechanics swarm all over it. They remove bodywork and wheels, check for damage, and wait for further instruction from the engineer after he has conferred with the driver about what changes may be necessary to the car's set-up.

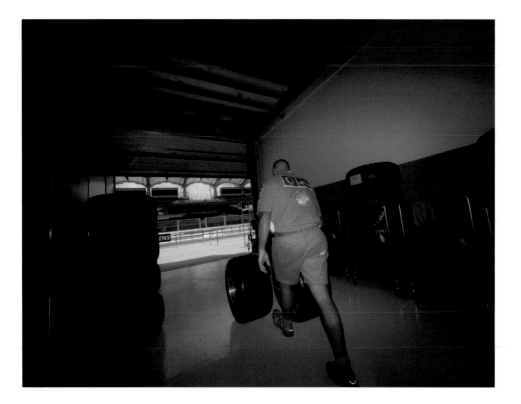

TREADING CAREFULLY
Correct tyre choice is crucial.
The first day of practice will be
spent trying the different options
presented by Bridgestone, and
then selecting the tyre type which
the driver and team believe will
be best both for qualifying and
the race. The different types
and sets of tyres are stored in
the garage next door and must
be carefully numbered and
monitored, ready for use.

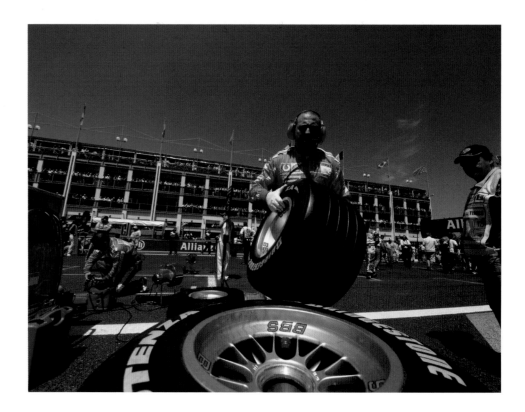

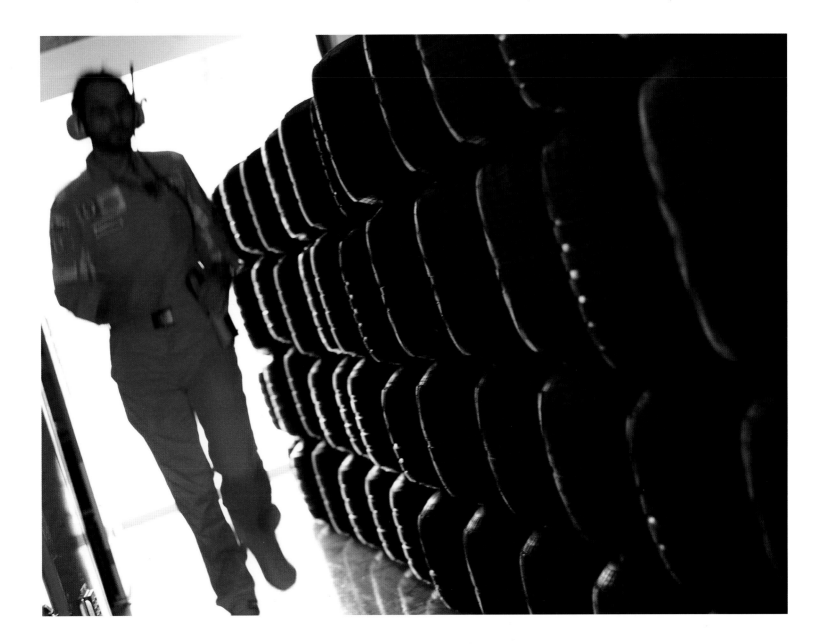

AUTOMATIC PILOT
The only time the driver has his hands off the wheel when in the cockpit is during practice, as the car is pushed from the pit lane to the garage. Having pulled up and switched off the engine, the driver folds his arms and thinks about whatever adjustments may be necessary while a mechanic takes charge of the steering as the car is pushed backward.

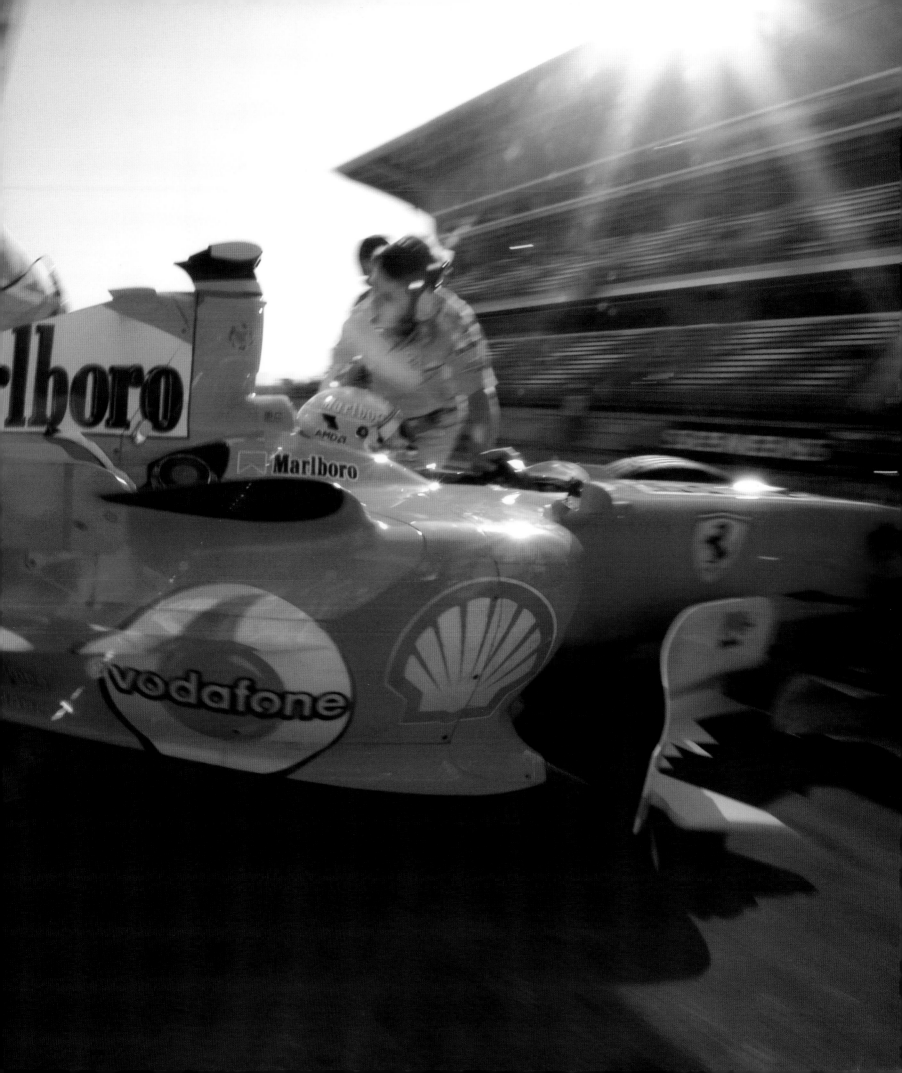

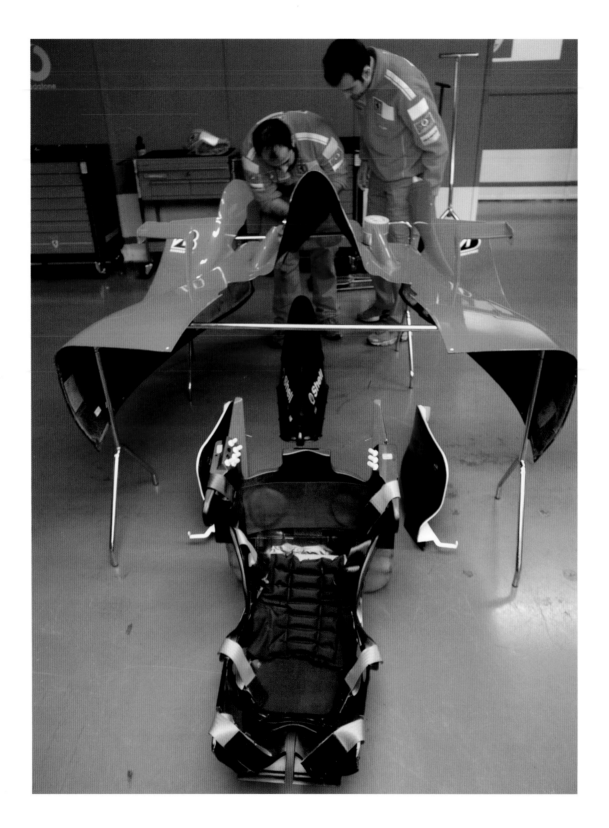

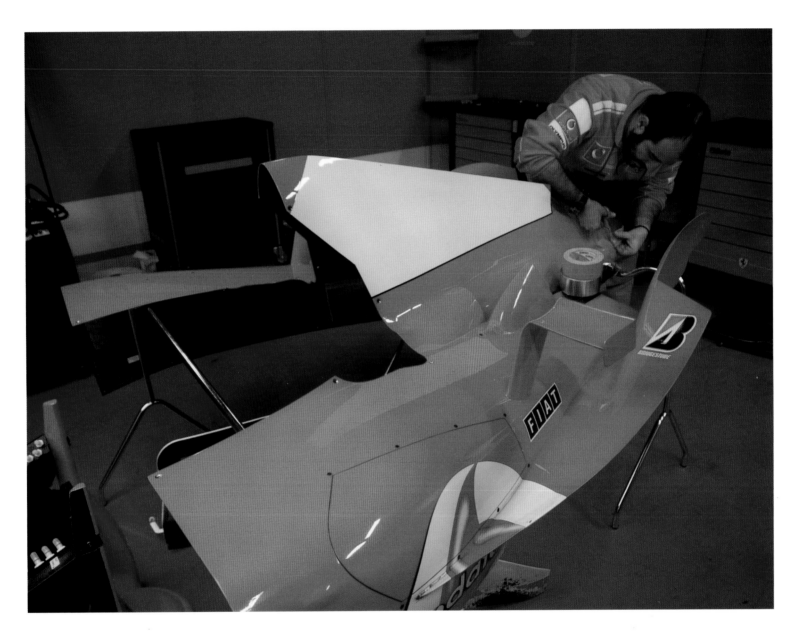

SEATING PLAN
Part of the ongoing safety
crusade in F1 is illustrated by
the driver's seat when removed
from the car (left). Apart from
being moulded to fit like a glove,
the seat has been designed to
enable its removal from the car
with the driver still in place. In
the event of an accident, the
orange straps allow rescuers to
lift an injured driver, complete
with seat, from the cockpit. The
seat acts as a splint to prevent
further and unnecessary harm.

ATTENTION TO DETAIL
Final touches to the rear
bodywork make the point that
appearance is considered
almost as important as
performance (above).

UP CLOSE AND POSITIONAL
A mechanic lies on his side by the
front wing endplate on Michael
Schumacher's car, while making
a small but crucial adjustment to
the wing angle.

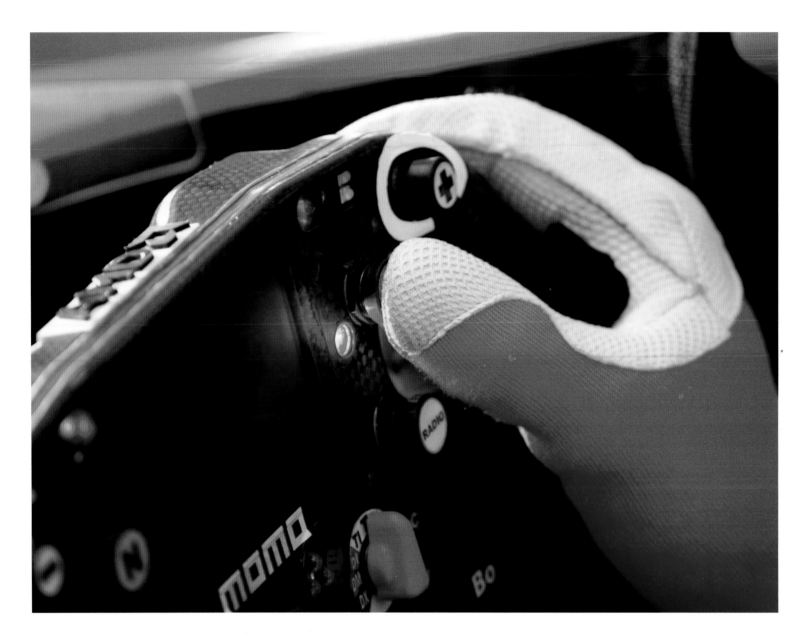

COMMUNICATION CENTRE

The driver makes contact with his crew by pushing the radio button with his right thumb and speaking into a microphone built into his helmet. The button similarly positioned on the left-hand side of the steering wheel selects neutral. Once he has left the garage, the driver uses the small screen between the two buttons to display chosen information such as lap times, pressure, and temperature readings. The complex steering wheel has long since made dashboards redundant in racing cars.

ALL IN BLUR
No time to lose, even while
leaving the garage for a few
more laps of practice.

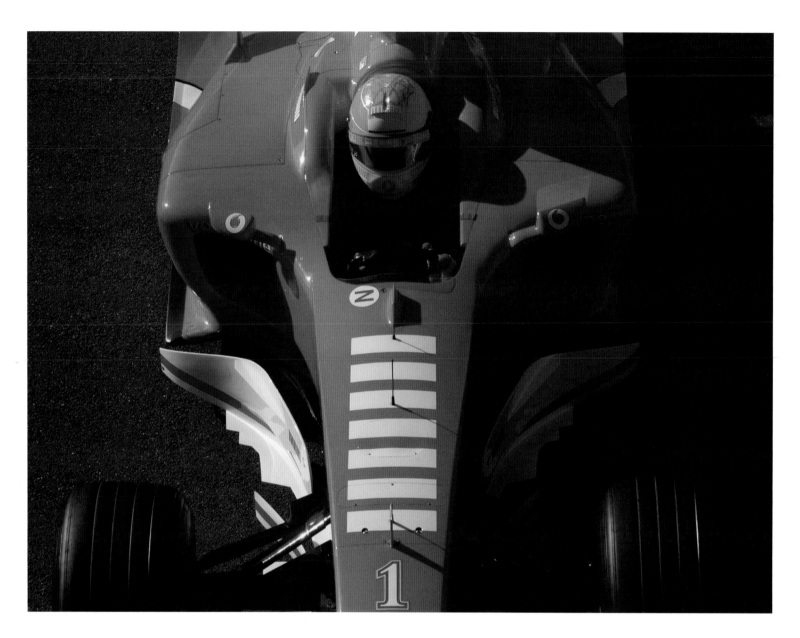

AIR BRUSH

The white barge boards direct disturbed air from around the front wheels and suspension away from critical parts of the car, while channelling clean air into the sidepods containing the water and oil radiators. The curious zigzag shape on the bottom edge of each barge board is neither decorative nor the flight of some engineer's fancy; the shapes have been arrived at after careful wind tunnel analysis of the flow of air as well as the elimination, as far as possible, of unnecessary aerodynamic drag. At the same time, the shape must follow strict rules that forbid the protrusion of certain lower bodywork parts beyond the upper profile of the car.

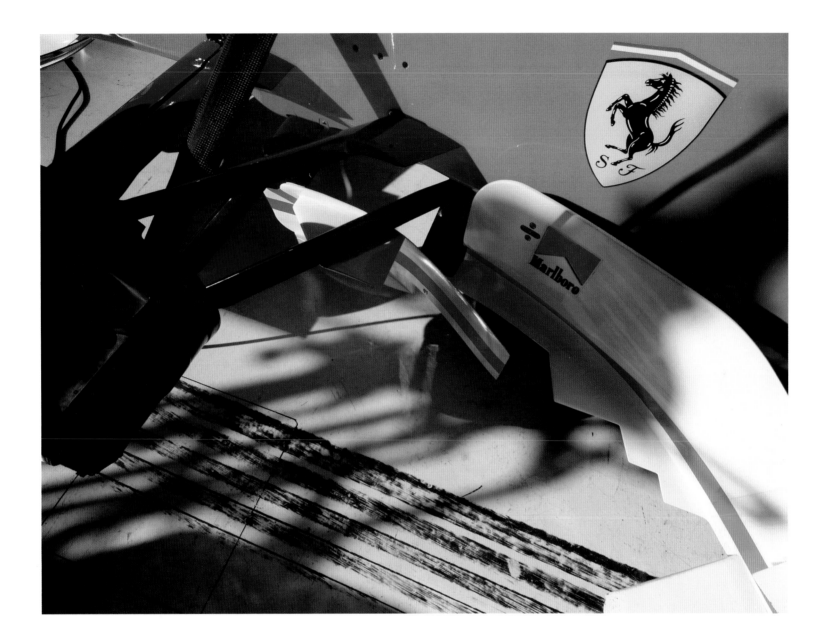

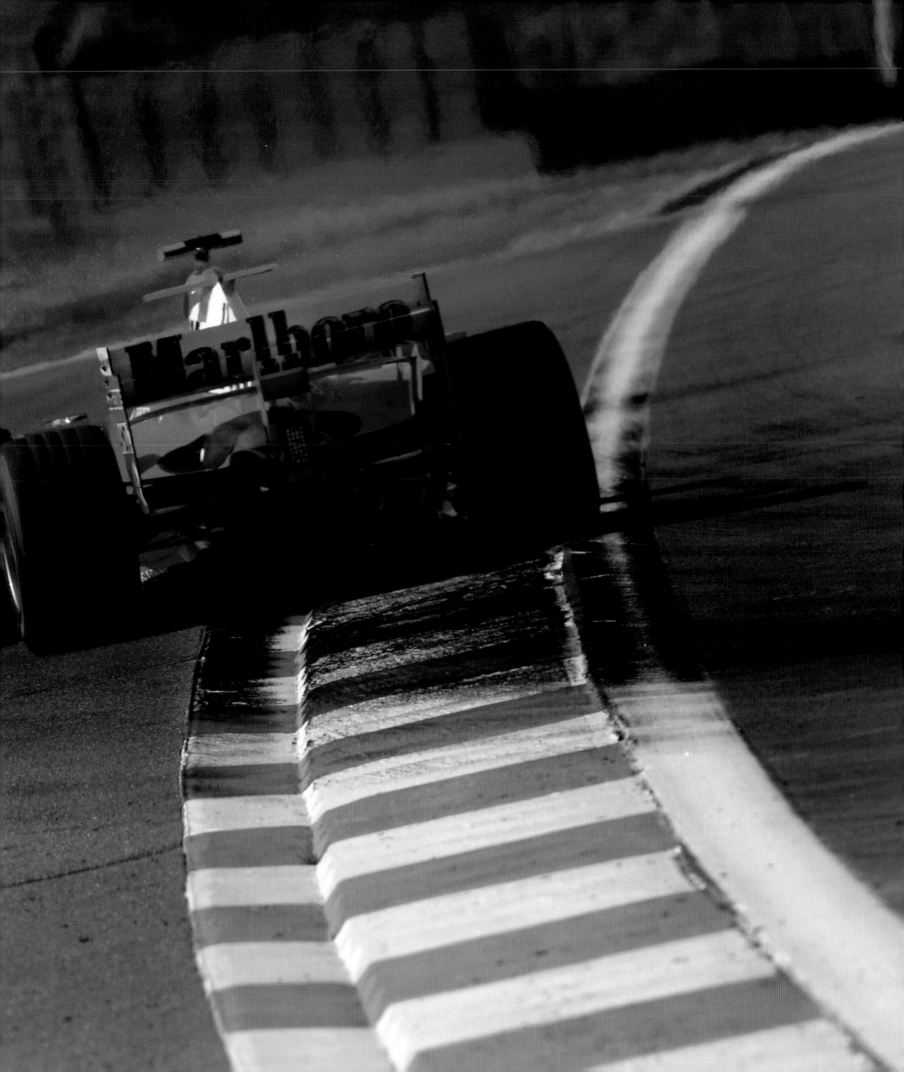

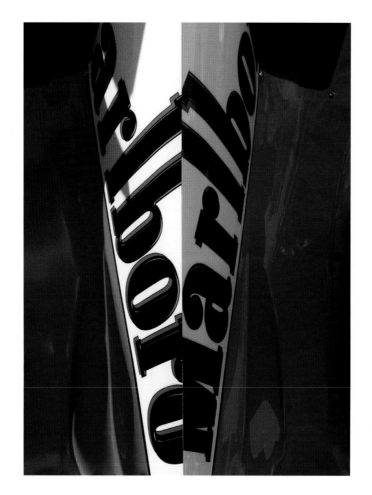

PRIME SPOT

The top of the engine cover is one of the most sought-after advertising spaces on a racing car. Marlboro, a major supporter of Ferrari for more than a decade, enjoys full exposure (above).

ON THE EDGE

Drivers will use as much of the track as they dare – and sometimes more. Michael Schumacher crosses the kerb (left) during the closing minutes of the final practice session before qualifying, and deliberately uses the concrete run-off area at the exit of the final corner at the Nürburgring. Layers of black rubber show that other drivers have had the same idea when trying to save fractions of a second.

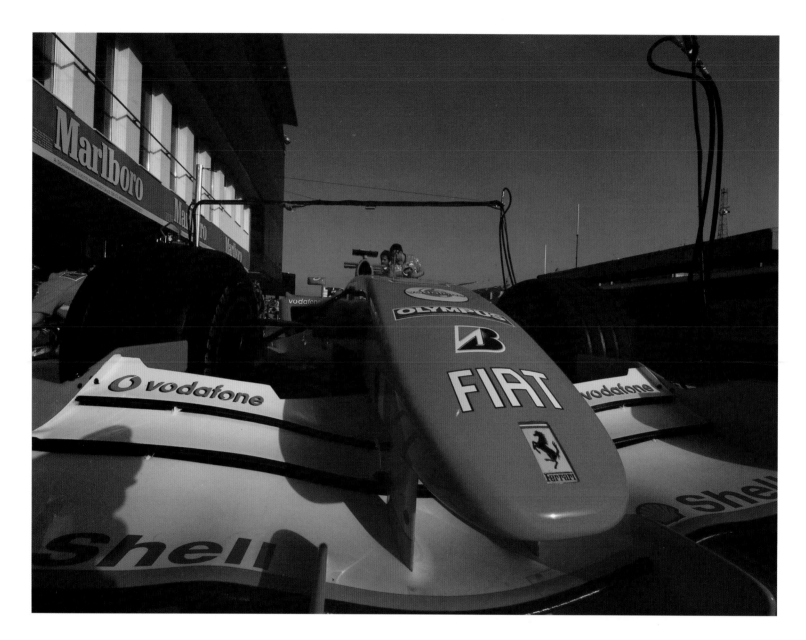

THE MUSIC COMES OUT HERE

Previous page

The exhaust pipe arrangement is as carefully thought out as the rest of the car. The length and positioning of the exit, as five exhausts merge into one on each side of the V10 engine, can have a crucial effect on engine performance and driveability. The position of the outlet must be moulded as closely as possible into the top of the engine cover, so as to neither disturb the aerodynamics unnecessarily nor create heat damage to ancillary equipment. Exhaust gases reach 800°C (1,470°F).

MULTI-PURPOSE NOSE

The front of the Ferrari must conform to stringent crash-test requirements, in which deformation must not exceed certain limits. The nose, with its distinctive chisel shape, is defined by the size of the driver's feet positioned just behind the front axle line (above). And, conveniently, the expanse of bodywork provides a prominent location for advertising.

LEGAL SYMBOLISM

The regulations require that the name or emblem of the make of a Formula 1 car must appear on the nose and be at least 25mm (1in) in size. Fiat receives prominence (right) because of the motor manufacturer's ownership of Ferrari, which began with a 50 percent interest in 1979.

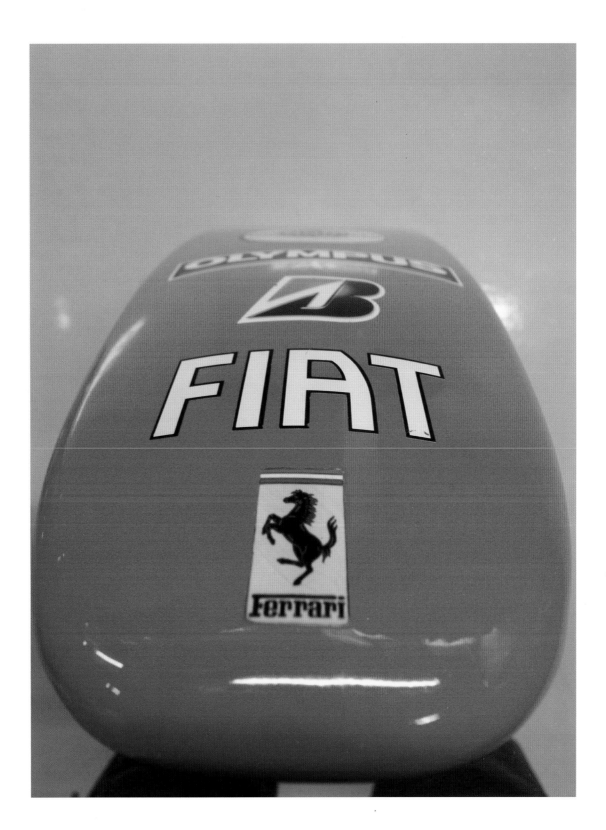

TIME TO LEAVE

When the race is over, the lengthy packing process immediately begins. In Europe, the cars and accessories are loaded into the transporters parked behind the garages. At the end of the long-haul races, packing is more complicated. Every last item – including the cars – must be listed, and carefully wrapped and protected. The cars (minus delicate detachable parts such as front and rear wings) are mounted on pallets, and are often stowed one on top of the other in the cargo area of a Boeing 747 for the flight to the next race or the return to Milan airport. At least 80 boxes will be used; the smallest the size of a beer crate, the largest, a bulky container. At the end of so-called flyaway races – such as the Japanese Grand Prix at Suzuka (pictured) – the team often has just four or five hours to be packed and ready to depart.

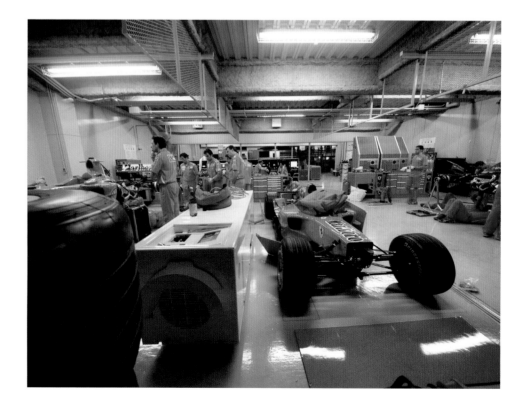

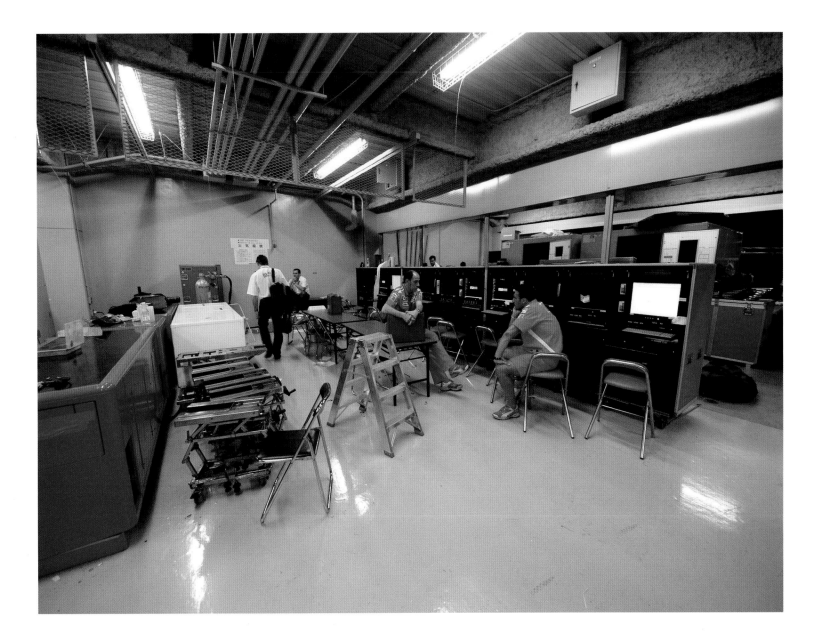

FALSE IMPRESSION

The seemingly deserted pit lane in Bahrain gives no indication of the drama that is about to unfold. The Ferrari pit apron is prepared with air lines, wheel hammers, front jack (red), and fuel rigs (under silver protective covers). Most of the team members have moved to the grid on the other side of the pit wall on the right, in readiness for the start. The false impression is made complete by Ferrari's position in the first garage on the pit lane approach. The scene behind the camera is less serene as the other teams make ready.

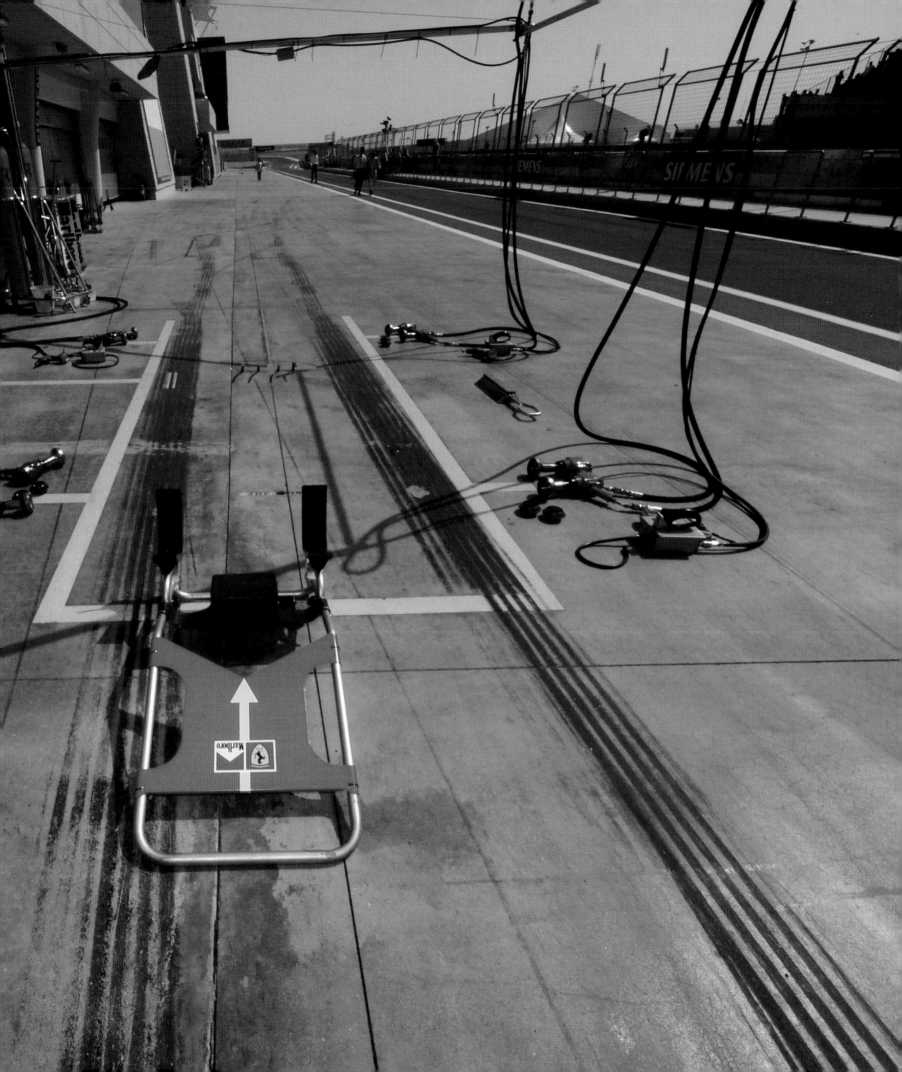

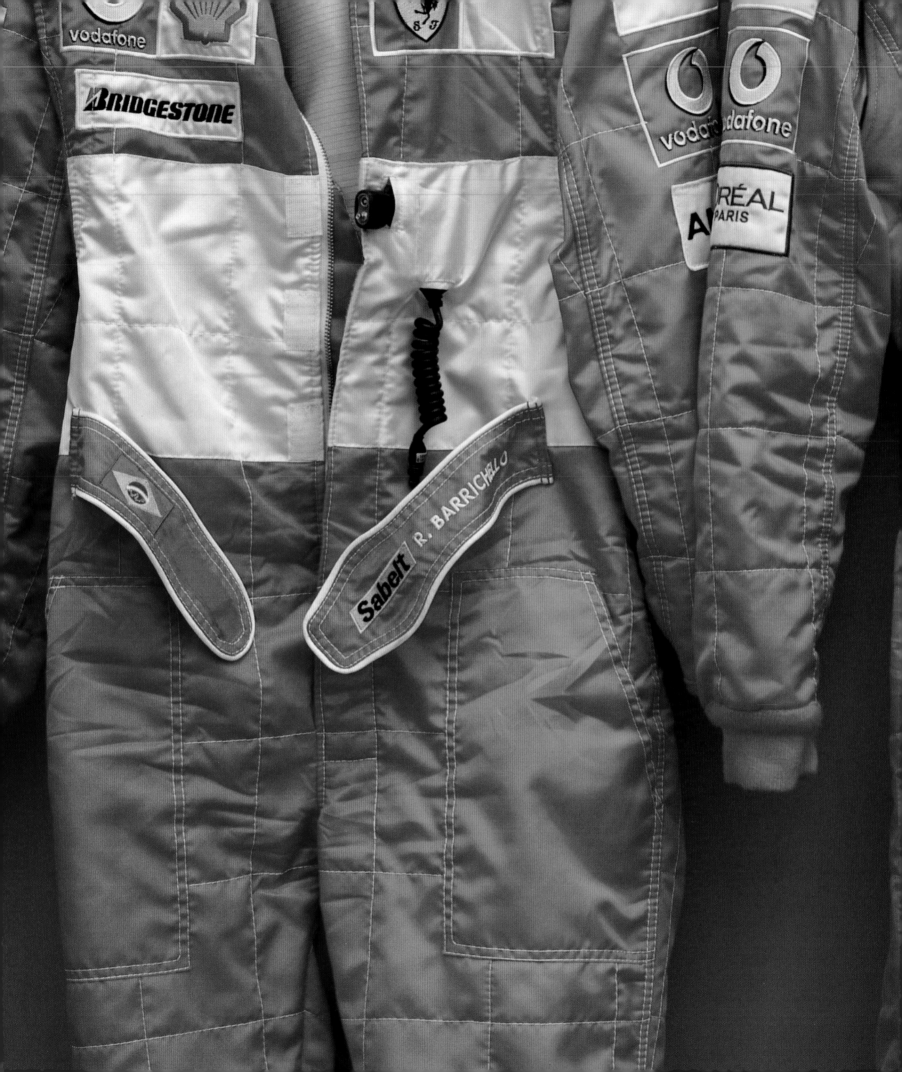

DRIVERS

EXPENSIVE YET PRICELESS

Driving suits with three layers of flameproof material cost in excess of £500 ($850) to buy. The drivers get them free, which is just as well because they use dozens in a season; a clean one each day during a race weekend and two or three on standby with the test team. Michael Schumacher wore OMP in 2005; Rubens Barrichello chose Sabelt. Their respective suits hang here, ready for use. Sockets for the radio are showing, ready to be connected inside the suit to the cables running to tailor-made earpieces. The mouthpiece inside the helmet has a separate connection. The value of each suit is actually worth 100 times more than cost price when you consider the rate for advertising across a driver's chest. But, ultimately, no price would be too high for a driver's suit when it allows him a minute's vital protection during the evacuation of a blazing car.

Enzo Ferrari had a way of dealing with drivers. They were employees; no more than that. Even from the earliest days, the team, in Ferrari's view, was more important than any individual, no matter how skilled or revered the driver might be. It was a defensive mechanism in some ways; a protective barrier against the inevitability of having a driver lose his life at the wheel of a racing car. Death was an unmentioned agent within the sport. In 1968, one leading racing driver was killed every month between April and July. It was viewed as a terrible but nevertheless contingent part of the business right up to the period when, in the early 1970s, "safety" began to become an acceptable word.

Ferrari embraced the new mood as readily as any team owner. But that did not prevent him from keeping his drivers at arm's length. Harmony was never a tactical consideration. Ferrari instead seemed to encourage a potentially destructive sense of rivalry between his own drivers, never mind fostering a burning desire to hammer the opposition. His view was that a cosy relationship blunted a driver's competitive edge. Far better to have him angry and hungry. Such a theory may have had its merits but it merely added to the sizeable myth Ferrari was creating around his team.

Drivers hated it, but such was the kudos and potential associated with getting behind the wheel of a Ferrari that they endured the downside. Communication would be at a minimum. If the driver did not speak Italian, then too bad: he would have to get by as best he could. It boiled down to, "Here's your car; now get in and drive."

A more relevant and productive approach gradually pervaded the team following the death of Enzo Ferrari in 1988. It was particularly noticeable following the arrival in July 1993 of Jean Todt, who as Ferrari's new sporting director built a particularly strong rapport with Michael Schumacher when he joined from Benetton three years later.

Now the team is family. A driver is not exactly the head of the household but he is a much-valued member; the eldest boy who everyone hopes will continue to do well and bring the family dignity and honour while creating a sense of purpose.

English is the common language at meetings within the race team but, if the driver is clever, he will learn enough conversational Italian to have fun with his mechanics and build a rapport. There is no better foundation for respect than a driver doing what he is paid for and winning a race. But to get there, he first needs to blend into the team and then help mould it. Racing an F1 car is stressful enough: there is no point in making life more difficult when out of the cockpit.

A driver's race weekend is planned by the team in great detail from the moment he leaves home. If in Europe, private or rented aircraft will sidestep the angst associated with commercial airlines, a waiting

Nothing is too much trouble. If the team could drive the race car for the driver, it would do that, too.

car at the destination avoiding further delay and aggravation at the hire car check-in desk. Once at the racetrack, there will be a briefing with engineers and tyre representatives, possibly a call to the official press conference set up by the F.I.A., motor sport's governing body. Then television interviews and perhaps a group interview at the Ferrari media motor home with journalists from the driver's home country. Finally, time to escape and check in to a first-class hotel. Dinner might be with friends and personal management or it could be with a sponsor or a select media group. And the weekend has hardly started.

Drivers need not worry about bringing their overalls and crash helmets. Because sponsors pay handsomely for the privilege, it is important that the driver, the focus of attention, is properly attired from the moment he steps outside his hotel. An adequate supply of correctly logoed T-shirts and polo shirts will have been delivered to his room. At the track, there will be two helmets; a selection of visors of different shades plus tear-off strips to be removed when covered in oil or grime during the race or long runs during practice; three race suits; three pairs of fireproof underwear, socks, gloves, and balaclavas; plus a rainproof race suit, a winter jacket, a summer jacket, and as many as five caps bearing allegiance to his personal sponsor and that of the team. Nothing is overlooked and nor is anything too much trouble. The impression is that if the team could drive the race car for the driver, it would do that too.

There can be as many as four briefings each day and the driver will attend most of them as every detail and nuance is examined. Tyre choice is crucial and this occupies much of the discussion on Friday. On Saturday, the gathering in the meeting room will cover fuel loads for qualifying, the weather prospects, and tactics for the race. If in the first three during qualifying, the driver will attend the television unilaterals before moving directly into the F.I.A. press conference. Then a debrief. Followed by more pre-arranged interviews and chats with sponsors. And then another meeting.

Apart from the drivers' parade and a visit to the paddock club to address sponsors' guests, Sunday morning is comparatively quiet as the driver winds down in one respect and builds up in another. Watched over by his fitness guru, the driver will eat a light but specially prepared meal and sip continuously from an energy drink. Then he will spend time in quiet contemplation while resting and running through possible sequences, bearing in mind his starting position and the drivers around him on the grid.

Each driver has a mental filing cabinet containing a simple dossier on each competitor. "Driver A tends to get over-excited at the start, and is particularly likely to today because this is his home race. Driver B's car is a fast starter but he is a safe pair of hands. Driver C can be intimidated if I show my nose down the inside on the run to the first corner." And so on.

By the time he zips up his flameproof suit and walks to the garage, the driver is ready to do what he knows best. He is one of an elite group that can take an F1 car to its maximum. Even Enzo Ferrari would have agreed with that.

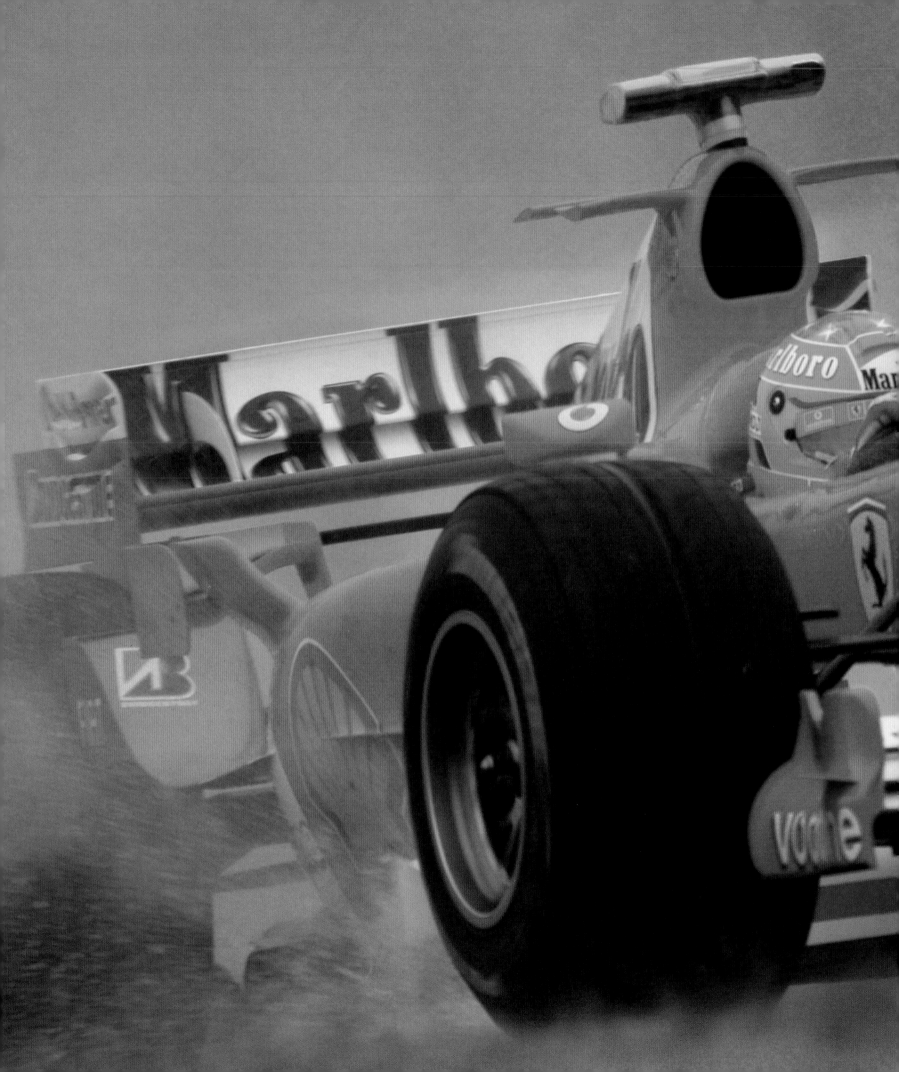

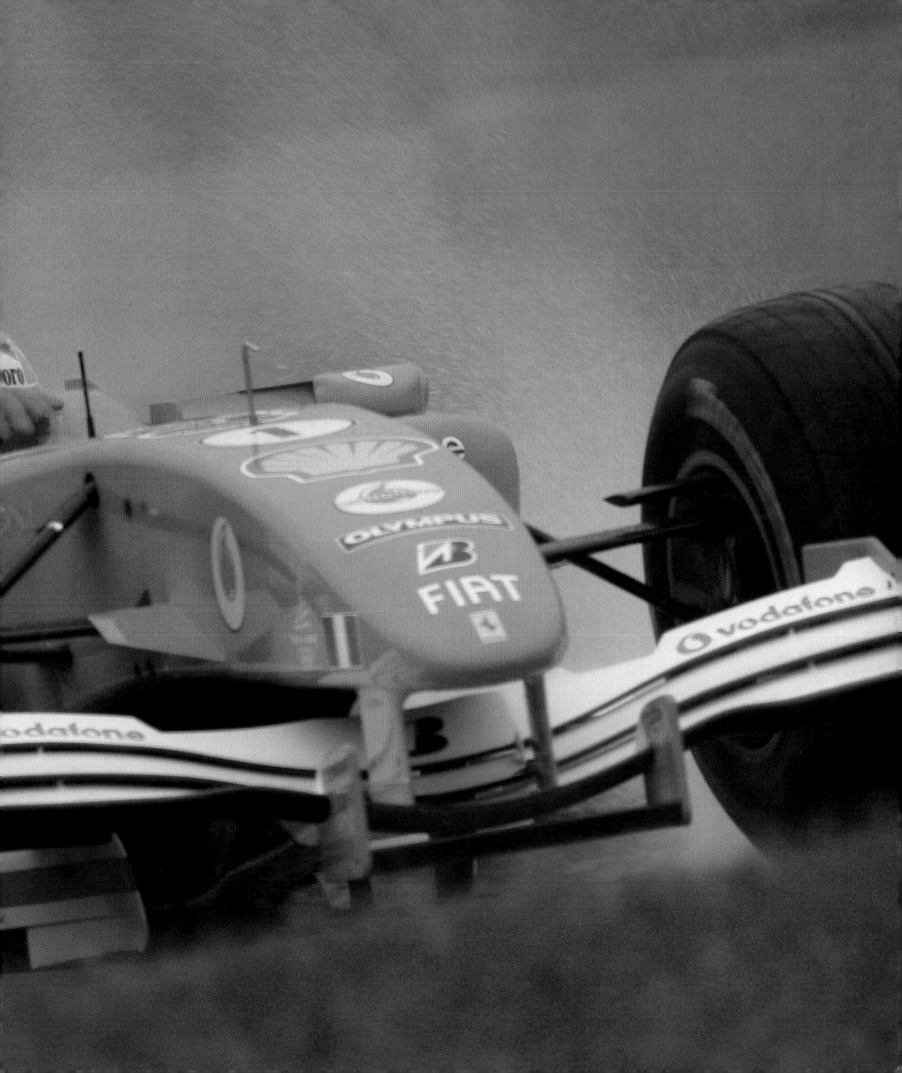

Previous page

RAINMASTER
Michael Schumacher presses
on during wet qualifying for
the 2005 Japanese Grand Prix.
Standard wet-weather tyres (as
opposed to the "Monsoon" tyre
for extremely wet conditions) will
disperse approximately 34 litres
of water per second, per car, at
295km/h (185mph).

PROTECTIVE SHELL

In the midst of the mayhem which often surrounds them on the grid and in the pit lane, drivers can literally retreat within their crash helmets to find comparative solitude and time to think. The main purpose of the helmet is obvious – the carbon, polyethylene, and Kevlar construction gives maximum protection, yet does not weigh more than 1,300 grams (46oz). The helmet is also designed to reduce drag as much as possible but, more importantly, it must successfully pass extreme deformation tests. That done, the most public face of the crash helmet is its platform for the personal colours of the driver it protects.

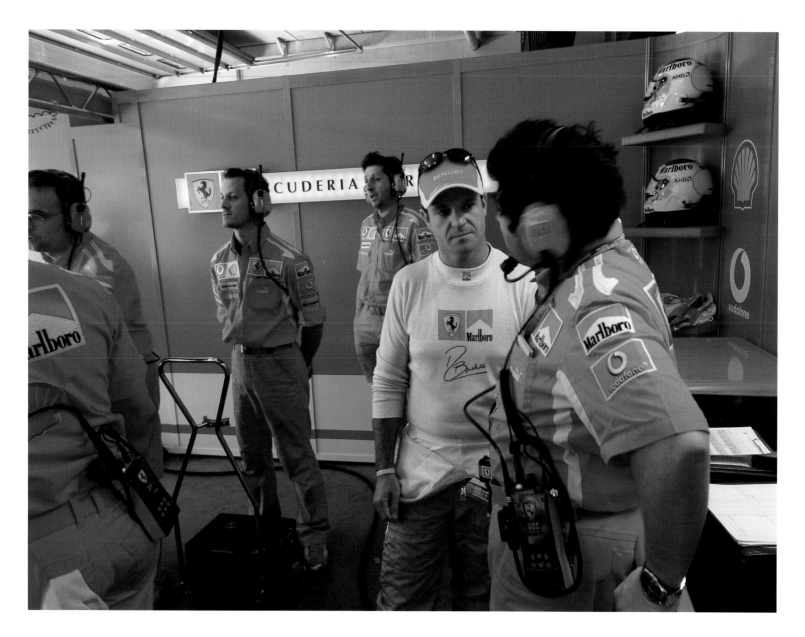

THE TRANSLATOR
The relationship between a driver and his engineer is crucial. Here Rubens Barrichello discusses his car with Gabriele Delli Colli (above). The engineer listens to his driver's comments about the handling, and translates those thoughts into changes which might or might not be made to the Ferrari's set-up. Every detail is noted for present and future reference. When the car moves, the engineer writes about it. Michael Schumacher shows what appears to be more than a passing interest in the notes covering his team-mate's car (right).

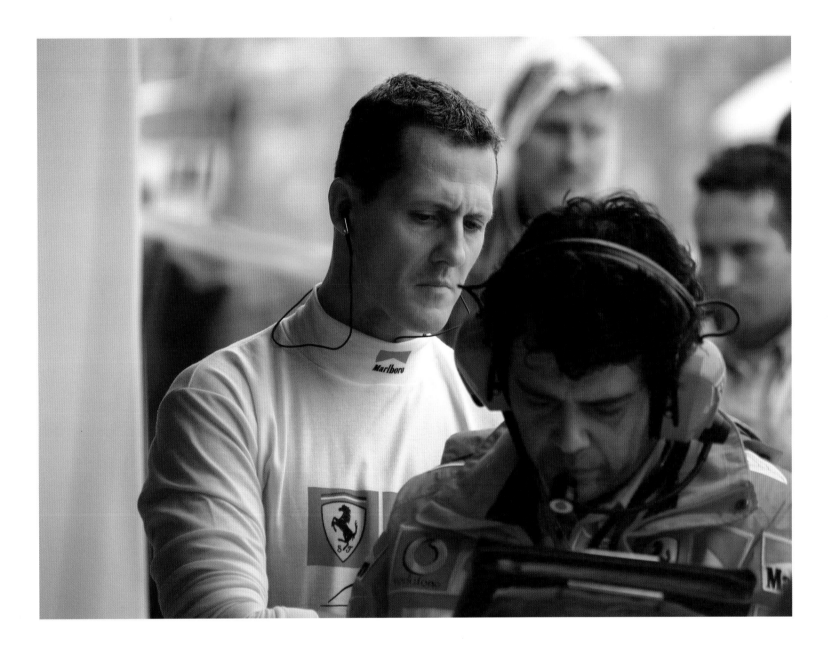

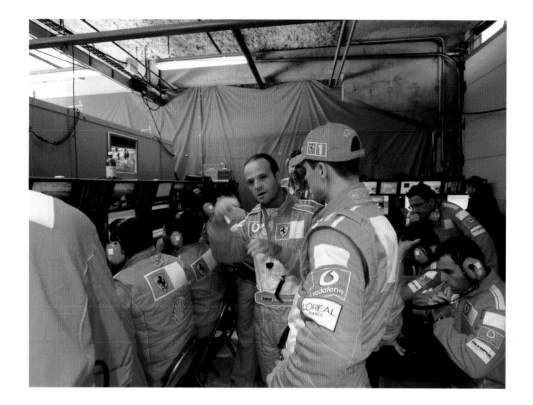

A SHARED AMBITION
Ferrari drivers pool their knowledge and experience when working toward a competitive set-up on their respective cars during practice. Rubens Barrichello discusses the handling of his car with Michael Schumacher (left), while engineers analyse the telemetry. Schumacher also consults with Luca Badoer (below), who will have tested the latest developments now being used in earnest.

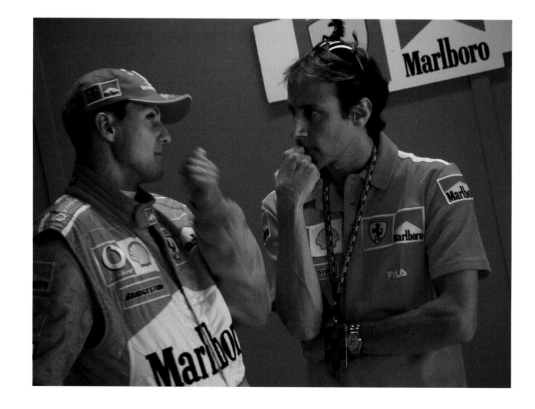

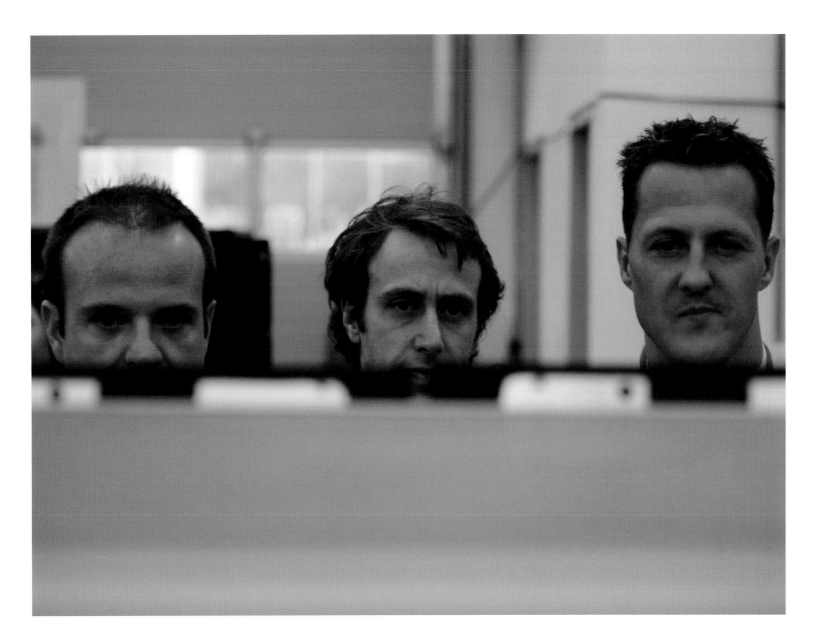

FOOD FOR THOUGHT
Badoer (centre) joins Barrichello (left) and Schumacher at the bank of computer screens in the garage after a practice session in Bahrain. They can view a breakdown of lap times, which show sector times and straight-line speeds for every competitor, as well as examining Ferrari's telemetry for precise detail of throttle, braking, and steering inputs. Only now will the true picture begin to emerge of where the Ferraris are gaining or losing on each lap. The news after this particular session does not look encouraging.

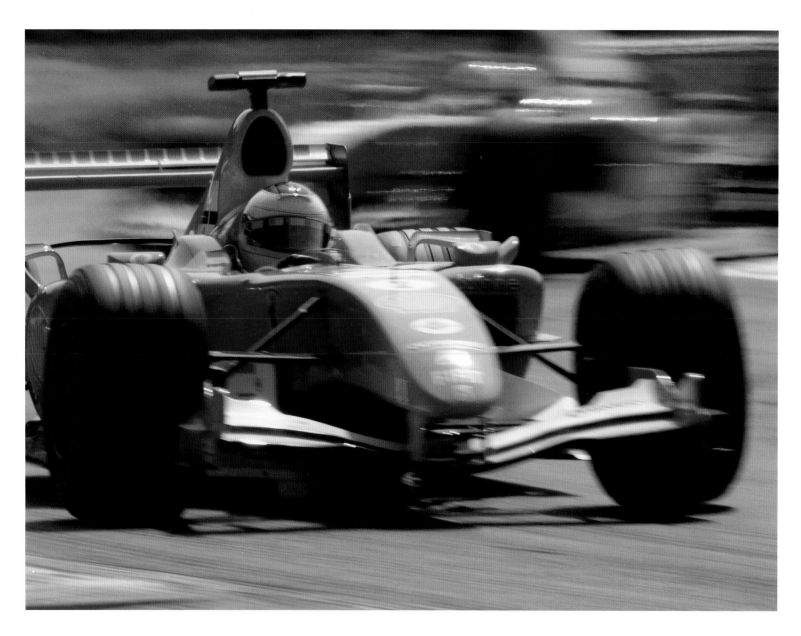

MEN AT WORK
Drivers are never happier than
when doing what they do best.
Barrichello leads Schumacher,
the pair spurring each other
on in Ferrari's fight against
tough opposition.

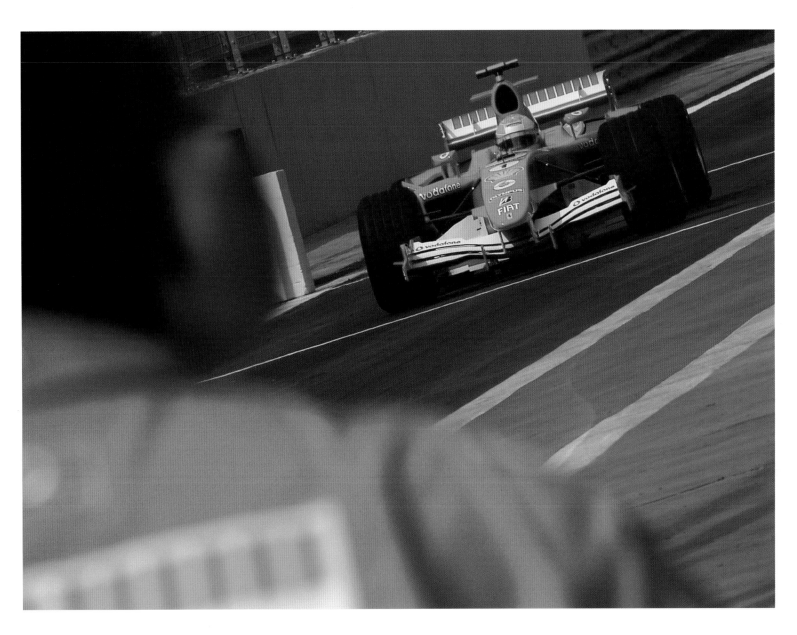

THAT'S IT FOR THE MOMENT
Schumacher returns to the pit lane during practice in Turkey.

LOOKING OUT FROM WITHIN
Michael Schumacher walks into the Ferrari garage, dressed and ready for action (above). The pictures on the right show the view that he sees through his raised visor. Technicians and engineers study the telemetry screens and program software ready for downloading into the car. Meanwhile, having prepared the cars, the mechanics (middle right) wait for their drivers to climb aboard and commence the serious action.

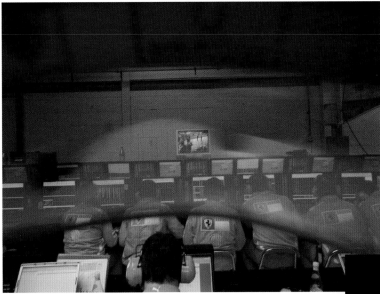

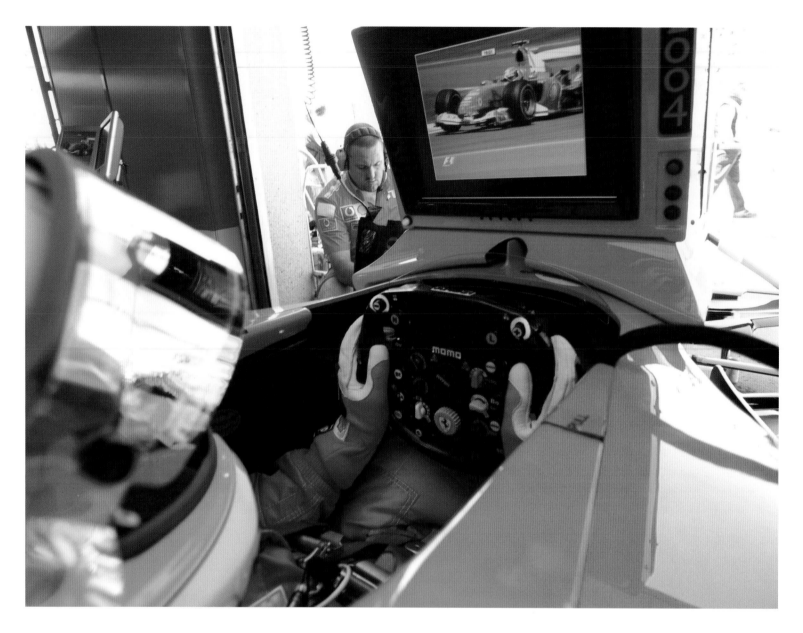

TV TO GO
Once Rubens Barrichello is settled into the car, a screen lowered from an overhead gantry provides the latest lap times and television pictures. Here he checks out the lines used by his team-mate.

WALKING TO WORK
Barrichello, overalls rolled down in the heat, walks into the back of the Ferrari garage to collect his helmet and prepare for practice.

Next page

WEARING A CAR
Barrichello demonstrates the snug fit inside the cockpit. The seat, stretching from his shoulders to beneath his thighs, is moulded around the driver's contours. He is held in place by the seat harness. The red webbing runs across each shoulder to be joined in a central quick-release buckle with the belts across each hip and the crotch strap. The harness enables the driver to become part of the car, the better to feel its every movement and not be buffeted by momentary forces which can measure in excess of 5g under braking, acceleration, and cornering. The sense of being in a high-speed cocoon is accentuated by the U-shaped collar that blends in with the upper edge of the cockpit sides. This foam padding is placed around the driver once he is seated, to provide extra protection for his head and neck muscles in the event of a sideways impact. The collar can be removed quickly, without the aid of tools.

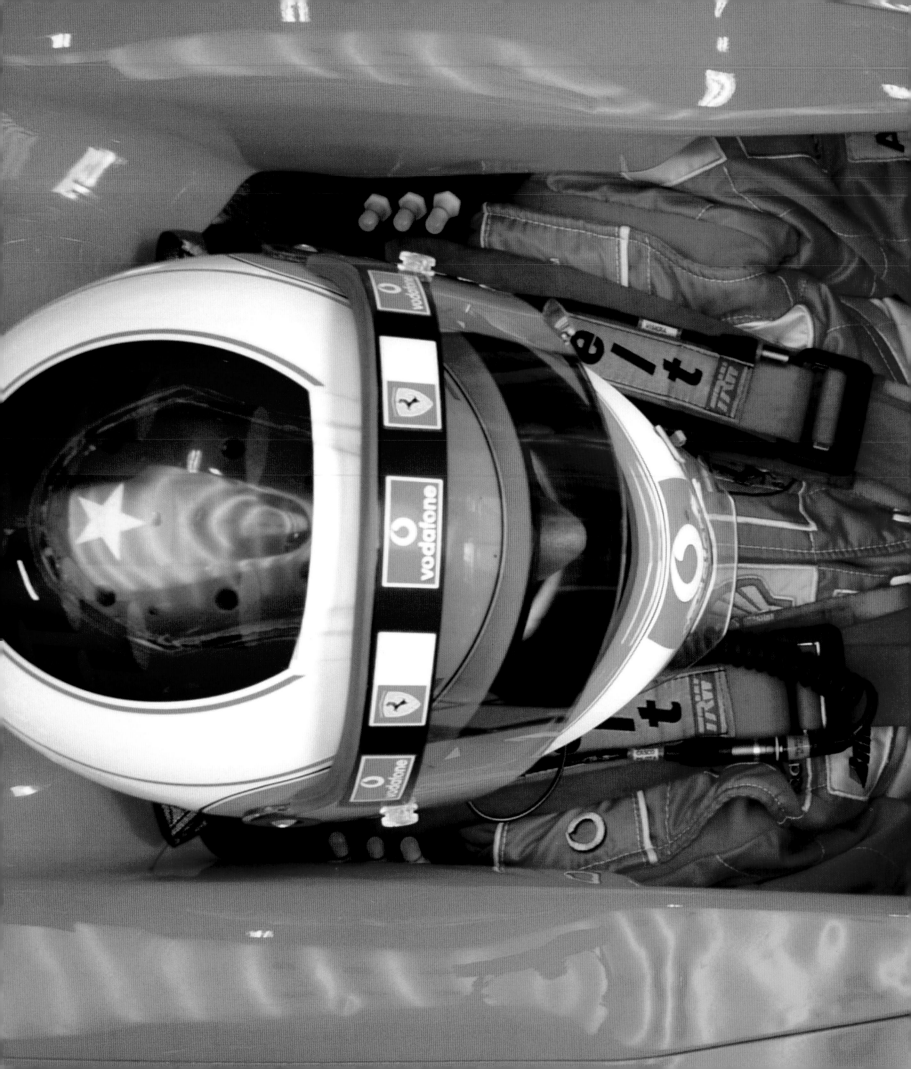

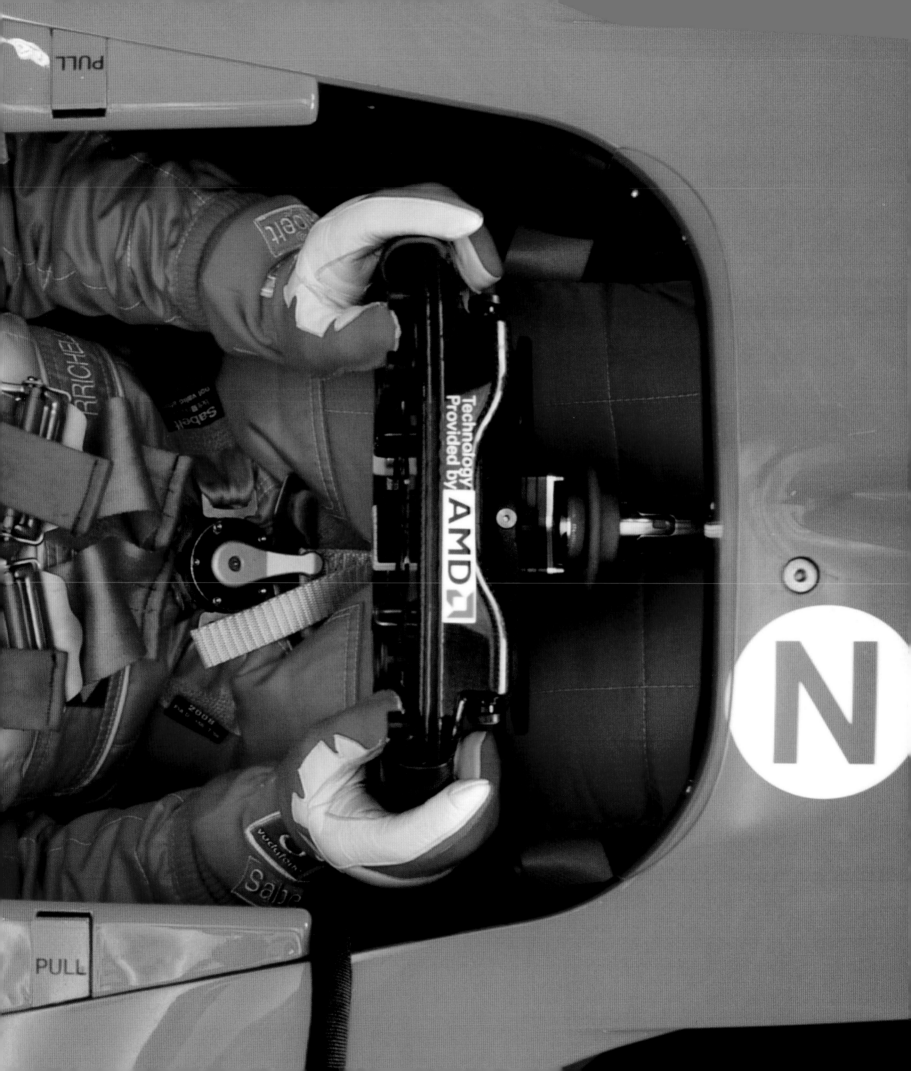

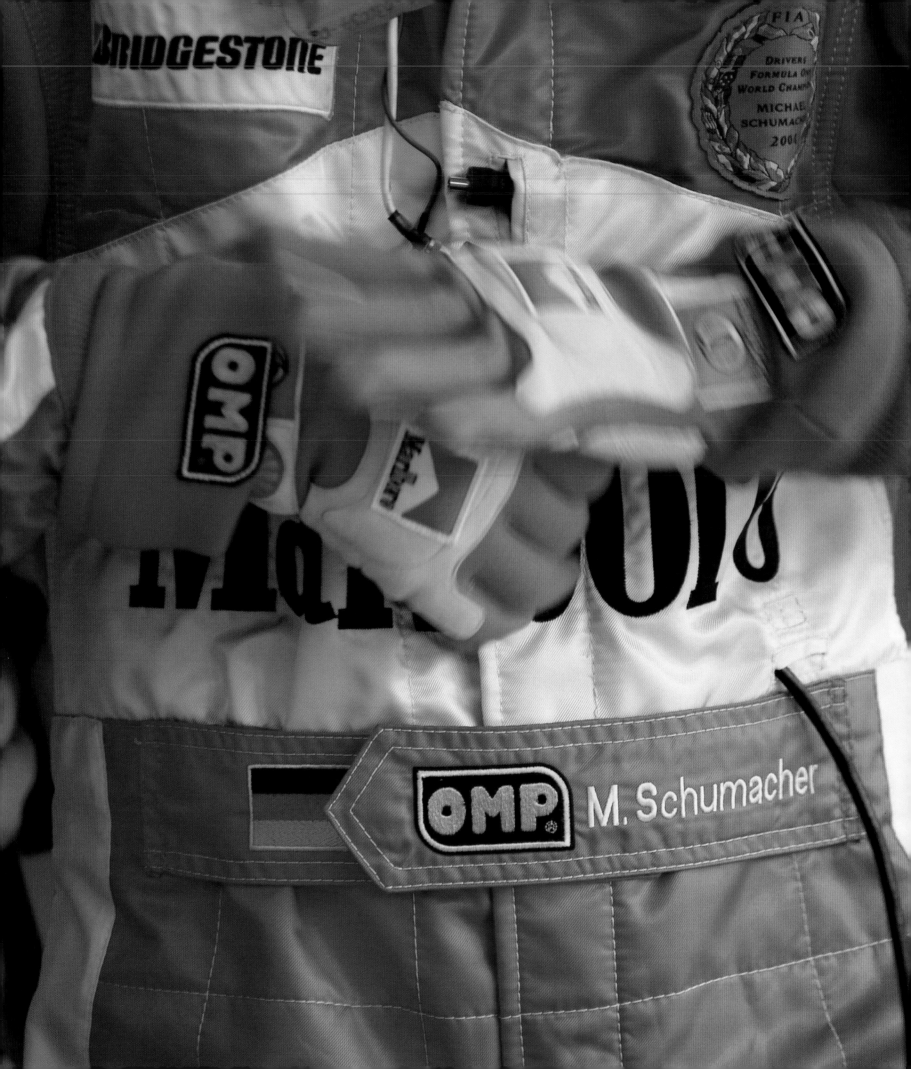

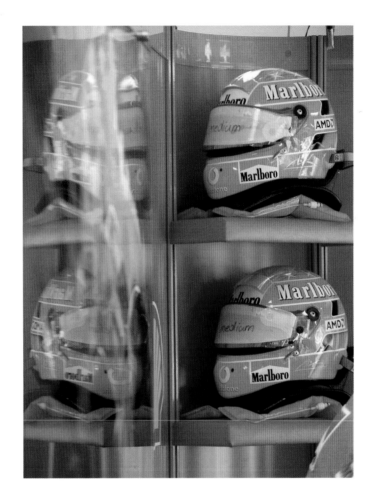

HAT AND GLOVE DEPARTMENT
A choice of crash helmets awaits Michael
Schumacher, each with a fresh visor of
"medium" light sensitivity (above). The final
act before climbing aboard is to ensure
that his flameproof gloves are a snug fit
(left). Note how no space is left free of
advertising (the backs of a driver's gloves
having become a prime spot with the
advent of the on-board television camera).

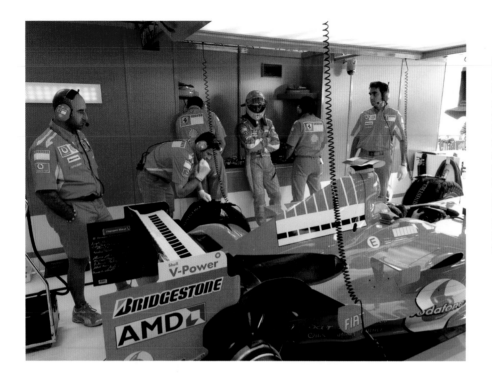

GOING AND COMING
Michael Schumacher, with arms folded, waits for the start of practice as a mechanic prepares to fit a rear tyre, complete with blanket (left). Once he is in the cockpit, final adjustments are made to the left mirror (right). Forty-five minutes later, Schumacher checks the final practice times on the screen before stepping from the cockpit (below left). A mechanic, air hammer at the ready, prepares to remove the right-front wheel.

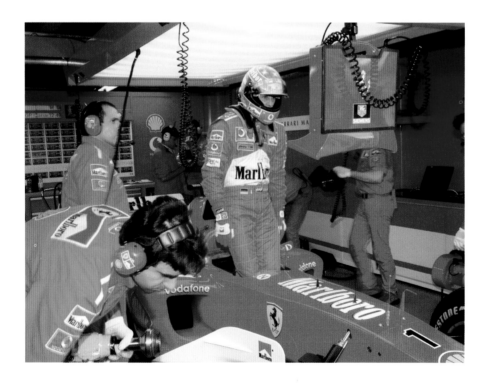

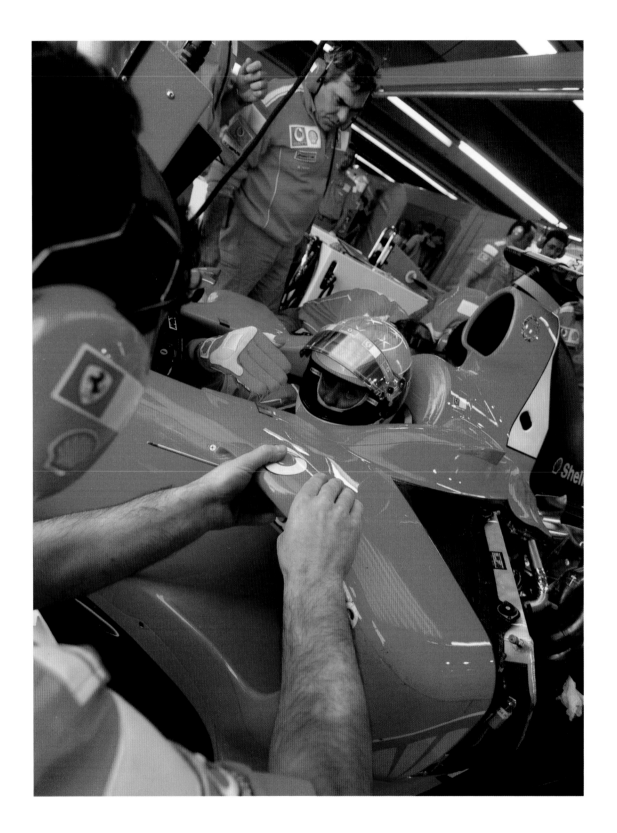

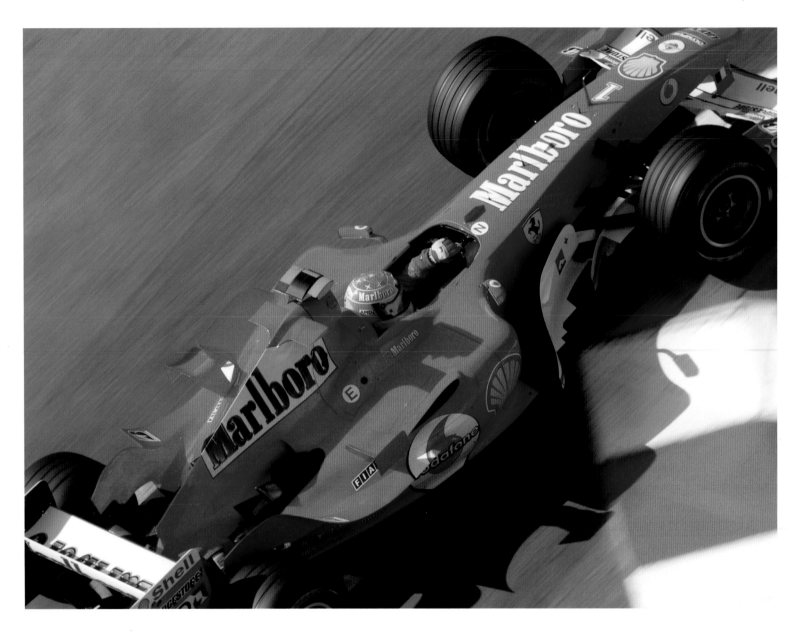

KERB CRAWLING
Drivers travel comparatively
slowly at Monaco, thanks to
tight chicanes and kerbs such
as this one. Schumacher takes
a tight line onto the harbour front.

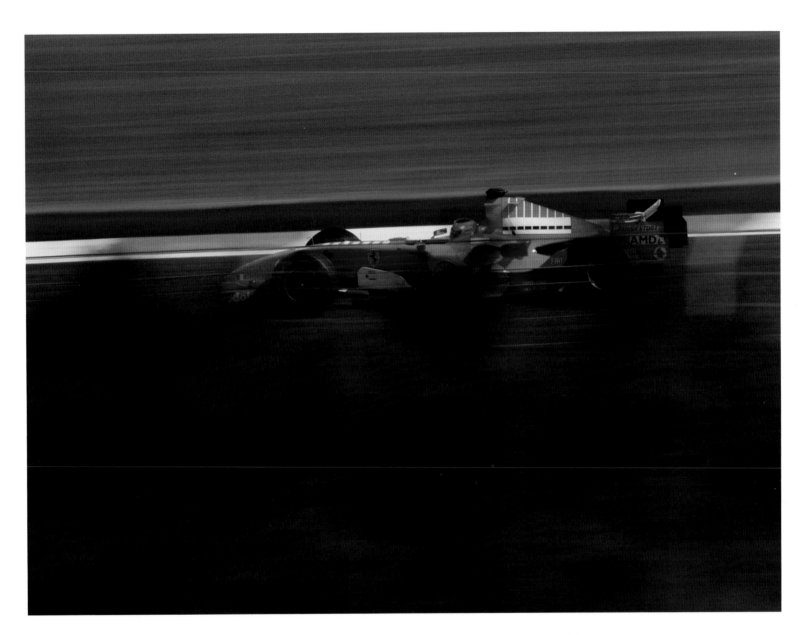

TURKEY TRIMMINGS
Barrichello sweeps past one
of the many expansive run-off
areas that fringe the Istanbul
Park track.

Next page

SEEING RED DARKLY
Michael Schumacher's smoky
reflection of the Ferrari garage
at the Nürburgring.

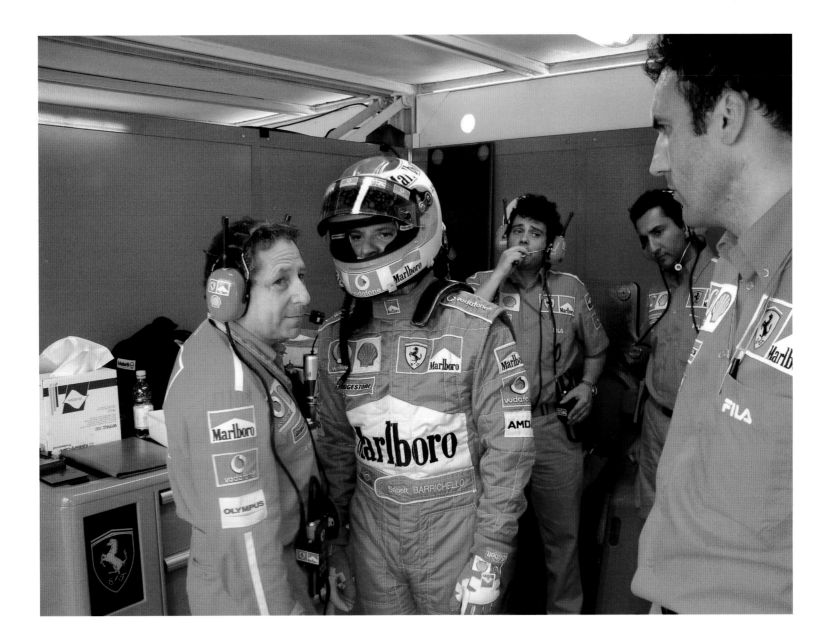

THINKING AHEAD
Schumacher's crash helmet
is removed from its protective
travel bag (above) and placed
with another in readiness for his
arrival (right). The aerodynamic
covers for the cooling slots on
the helmet's upper surface sit
alongside his gloves.

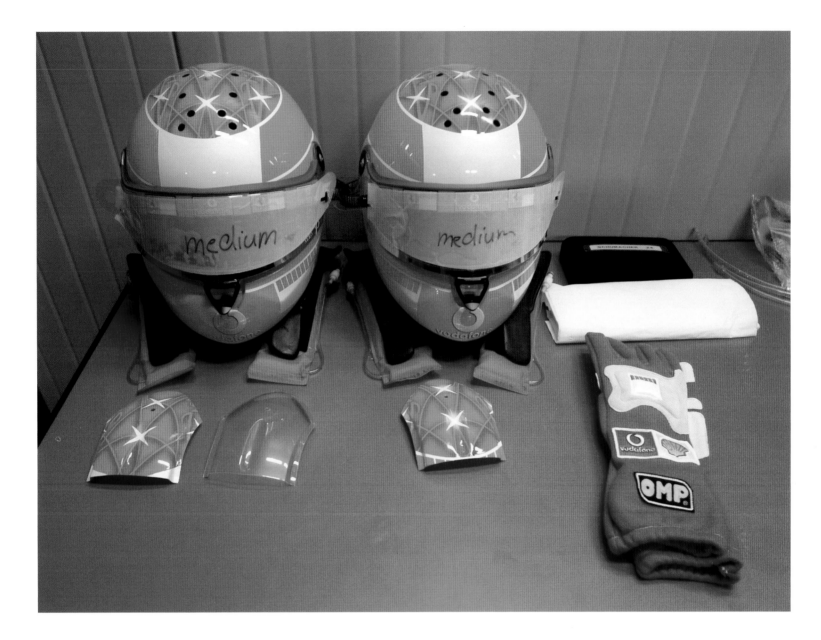

QUIET CONTEMPLATION
Michael Schumacher gathers his thoughts at the back of the garage in Barcelona, in complete contrast to the noise and action about to erupt before tens of thousands of fans just a couple of hundred metres away.

GREASING THE WHEELS
As Schumacher prepares for action in Turkey, a mechanic gives the mini-screen on the steering wheel a final polish.

WORKING LUNCH
Schumacher finds time for a quick bite in the garage at Magny-Cours while discussing progress with Luca Baldisserri.

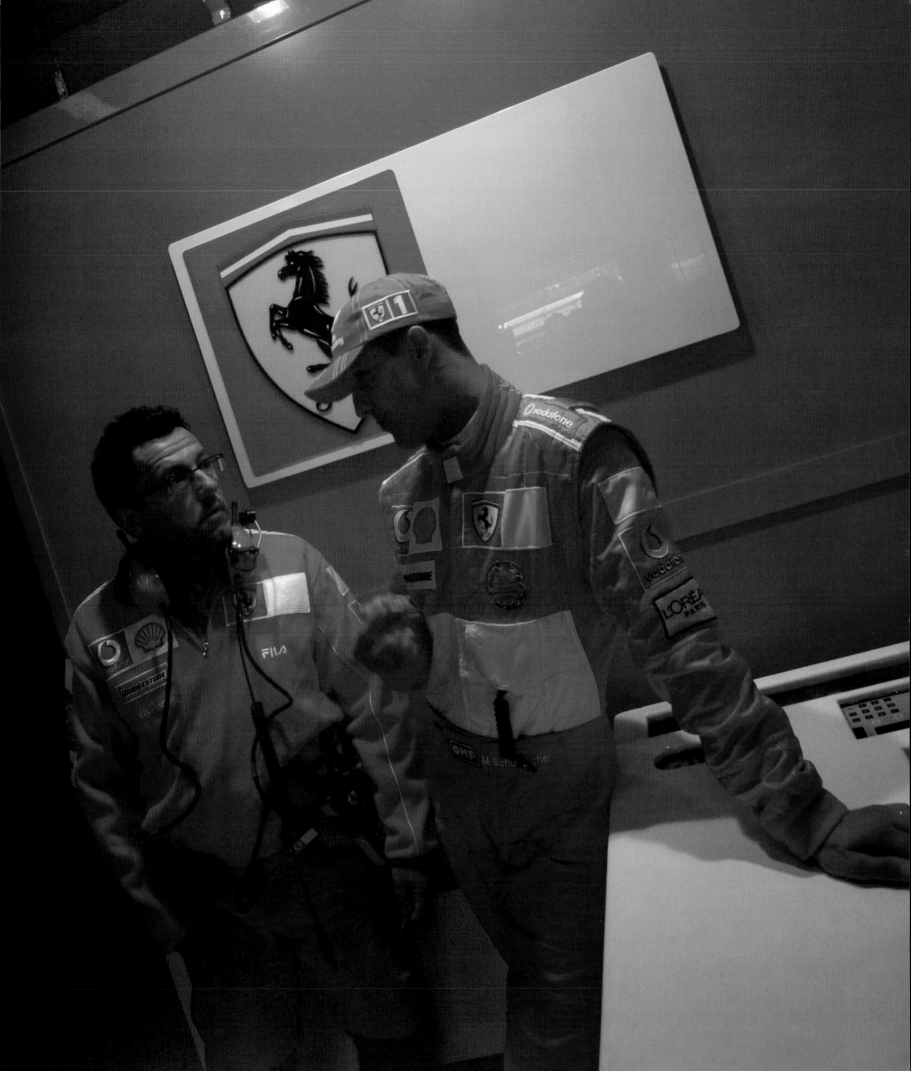

PREPARING IN PRIVATE

Having tired of photographers covering his every move at Monza, Schumacher chooses not to get ready for action in his usual place in the garage. Here he has carried his helmet and gloves from their usual position and moved behind the screen separating the technicians from the cars. Having removed his Ferrari cap and donned his balaclava, Schumacher will complete the ritual by reaching for his gloves, helmet, and neck support. Then he will be ready and fully focussed for the job in hand, without having been distracted by a battery of flashlights. Usually this is not a problem for him, but today Schumacher prefers a degree of privacy.

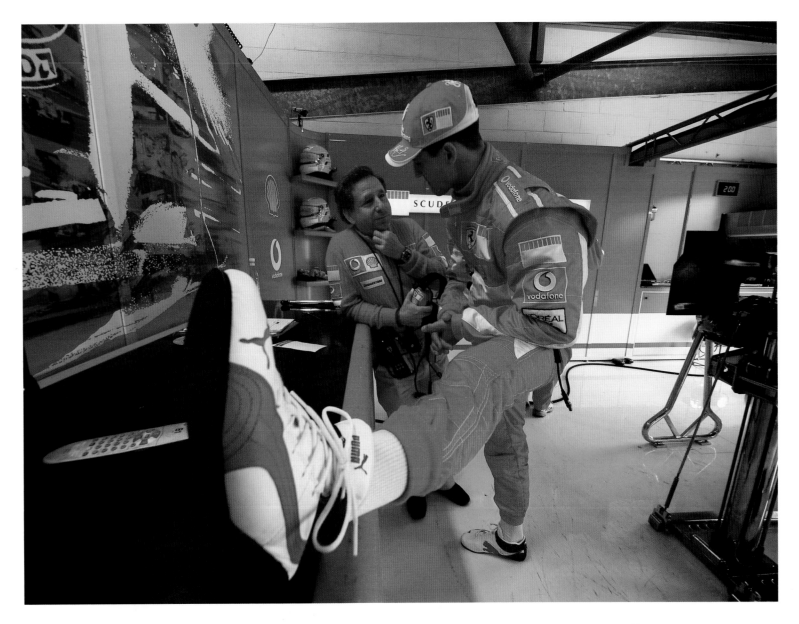

MULTI-TASKING

Schumacher uses a worktop in the garage to carry out his hamstring exercises while discussing the forthcoming Silverstone practice session with Jean Todt. The choice of crash helmets awaits in the background on specially designed shelves. Out of sight and to the right of the picture, photographers are already lining the front entrance of the garage in the hope of catching Schumacher walk to the far corner and don his helmet and balaclava. For the moment, though, there are muscles to be stretched and important matters to be discussed.

Next page

TOP CLASS

The facilities at Bahrain raised standards when the track joined the grand prix trail in 2004. This is the eating and relaxation area for the team, with the kitchen, complete with stainless steel facilities, just beyond.

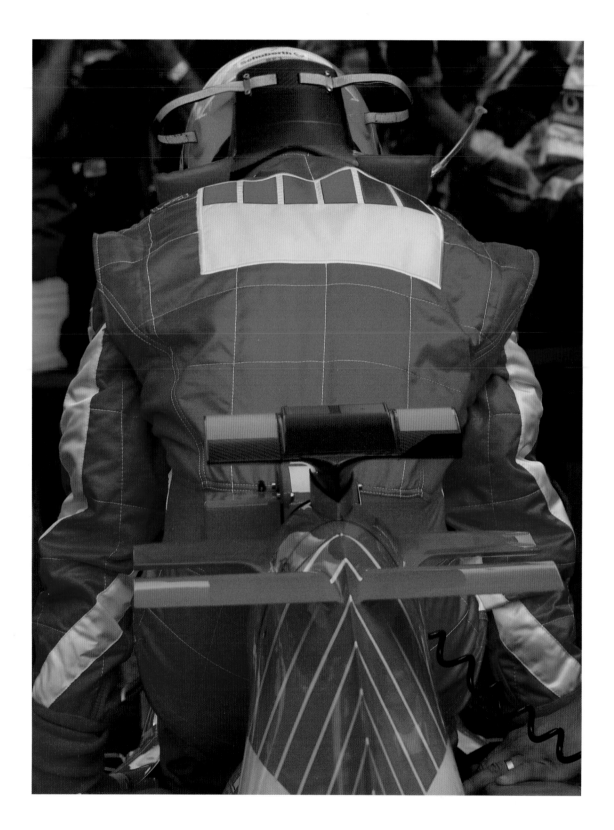

GOING TO WORK
Schumacher slides into what will be his office for the next hour and a half (left), as he prepares for the start in Turkey. The black HANS device at the back of his helmet is designed to protect neck muscles by preventing whiplash in the event of an accident.

ABOVE AND BEYOND
Facilities at Monaco, for so long the worst in F1 because of the circuit's temporary nature, took a major leap forward in 2004 when new pits were introduced. Schumacher gets ready at the back of the garage, while an engineer emerges from the upstairs office (above).

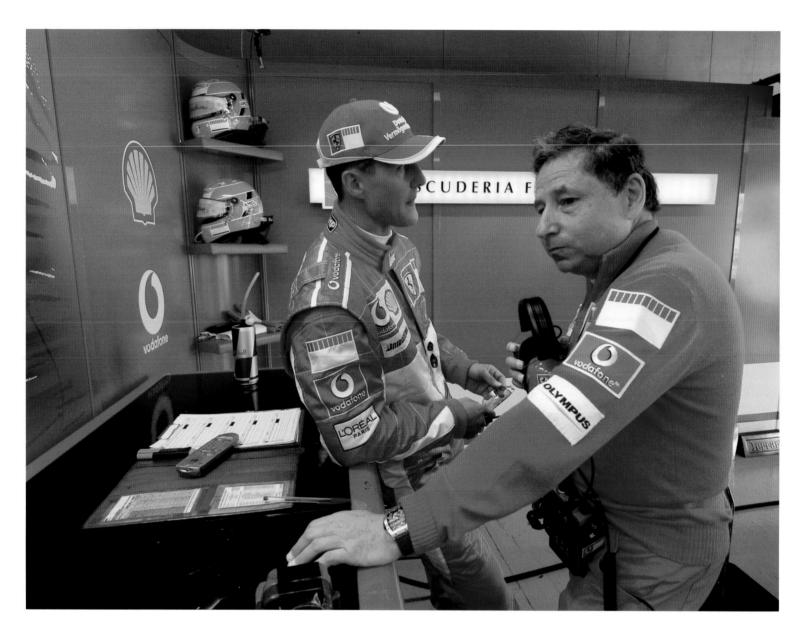

HIGHS AND LOWS
The body language and the thoughtful expressions of Michael Schumacher and Jean Todt (above) suggest times are difficult for Ferrari, in complete contrast to Schumacher's reunion with Nigel Stepney (right) after victory in the 2003 Japanese Grand Prix.

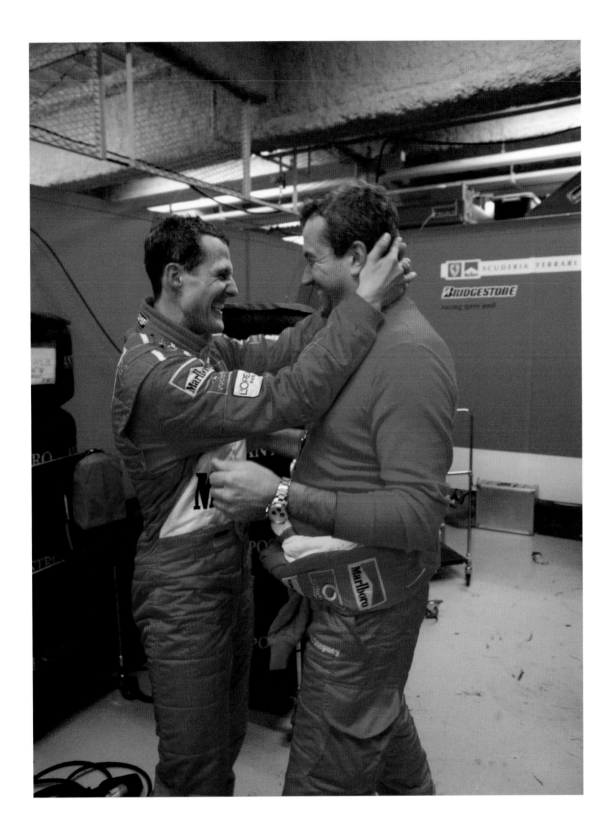

THAT BAD, HUH?
Never one to miss the smallest detail, Schumacher checks out the tyre-wear on a Jaguar as he walks through *parc fermé* at the end of a race (left).

COURSE LANGUAGE
The most important notice is written in English – in an Italian team with German and Brazilian drivers and a French general manager.

WINNING PROFILE
The unmistakeable silhouette of the man who has brought Ferrari more victories than any other driver.

REAL AND IMAGINED
Whether he is seen in the flesh or in cardboard, Schumacher is the focus of attention: after qualifying in the Bahrain paddock (above) and in the public enclosure at Suzuka in Japan (right).

RACING

THE WINNING HABIT

A Ferrari has been first across the finishing line more than 180 times since the inception of the Formula 1 World Championship in 1950. This is Michael Schumacher at Barcelona. The shot, taken from the BBC *Radio Five Live* commentary booth high in the main grandstand, illustrates both Jon Nicholson's relentless search for an unusual angle and Ferrari's winning habit. Schumacher brought the red car home first at Barcelona for three years in succession.

There was a time when a grand prix was not considered to be a proper race if Ferrari was absent. These days, it is impossible to imagine a grid without the red cars. No team can afford to miss a single race, such is the level of championship intensity, never mind the contractual obligation to appear. But F1 was not always as well organized as this. Old hands at Ferrari can recall the time when each team dealt independently with race organizers. There would be circumstances when Ferrari might not reach agreement and, if the championship was not going well, then the team might send just one car. Or none at all.

On those occasions, the race was the poorer. Apart from the absence of that evocative red on the multicoloured grid, the unspoken feeling was that the grand prix had no yardstick. If Ferrari won, then that was as it should be. If you beat both cars then, such was Ferrari's reputation, the result held even more meaning.

Very little has changed except that, in these more professional times, Ferrari is an ever-present player in the F1 circus that travels across five continents between March and October. The racing may take place over only eight months but, in reality, the season is 12 months long as the team designs, builds, and tests its new car while, in the background, management and administrators deal with the unique logistics associated with flying the team around the world.

The race may be on Sunday but the advance party will have arrived at the track on the previous Tuesday to begin preparing the garage and setting up the motor homes. When practice begins on Friday morning, everything will be in place, the garage looking and feeling like an extension of the race shop at Maranello. The mechanics and engineers will feel entirely at home because everything will have its place – exactly as it did at the last race and the one before that.

Thirty years ago, arrangements were more hit and miss. The teams would sometimes be based in local premises or operate from their trucks in the paddock: garages were unheard of at most of the tracks. Practice would be held at the whim of the race organizer and the timetable might not be finalized until the day before.

Now, F1 runs with military precision and the teams are happy to fall into line. When practice opens on Friday morning, the mechanics will have breakfasted at the motor home, engineers and drivers will have held a briefing, and the cars will have been started and warmed up, ready for action. Finally, it's down to serious business.

Technicians can calculate and predict with the aid of advanced computer science, but there is nothing to beat the feedback that comes from the cars and drivers when actually running on the track. And, just as important, this first outing on a level playing field begins to give some indication of the performance of each team relative to the

The reduction in chatter adds to the tension: something significant is about to happen.

opposition. That becomes even more closely defined as practice continues into the second day and ends with qualifying for grid positions. Now there will be more debriefs as race tactics are established. Every possible scenario – and many that are highly unlikely and yet cannot be ignored, such are the vagaries of motor racing – will have been analysed and discussed.

The driver will run through the various options in his mind, even as he mounts the flatbed trailer to join his rivals for the parade lap on race morning. The contrast is extreme as drivers chat and wave while travelling at 25km/h (15mph) through the very corners which they will approach under less sociable circumstances at ten times that speed a couple of hours later.

The build-up continues as mechanics don the red flameproof overalls worn during the pit stops. They are a close-knit unit behind the scenes; now they look the part in public. The air lines, wheel hammers, and fuel rigs are laid out in the pit lane. Trolleys loaded with tyres and sundry equipment are wheeled to the grid. Each team member has his specific task and does not need to be told what to do. The noticeable reduction in chatter adds to the increasing tension and the feeling that something significant is about to happen.

This is the climax of weeks of preparation, days of hard graft, hours of discussion and planning. There are ten points on offer to the winner in less than two hours' time. Ferrari may have won more races than any other team gathering on the grid, but that becomes irrelevant as the chance of another victory suddenly becomes tangible.

The car is almost lost beneath a cluster of mechanics, checking and adjusting, downloading from computers, conferring importantly on headsets. The driver, meanwhile, stands quietly under an umbrella held by a manager or close friend. The occasional television interviewer intrudes on his mental build-up as the driver otherwise becomes completely oblivious to the swirling blur of poseurs and beautiful people seeing and being seen on the grid.

The solitude when he dons his helmet and climbs into the car is bliss. Silent handshakes from management, then the mood of anticipation goes up several notches as engines start and make enough noise to drown normal conversation in the grandstand towering over the pit straight. A quiet wish of good luck from his engineer across the radio marks the driver's final piece of communication that has nothing to do with the fine detail of running their race.

All 800 employees, from the trackside to the factory at Maranello, have done their best. Now it is down to the driver to play his part. The sense of obligation and pressure would be enormous were it not for the total concentration required for the job in hand. The structure and the technology of F1 may have changed dramatically since Ferrari's first grand prix more than 50 years ago. But the fact that in a couple of hours' time only one man and one team can emerge as the winner remains as it always was.

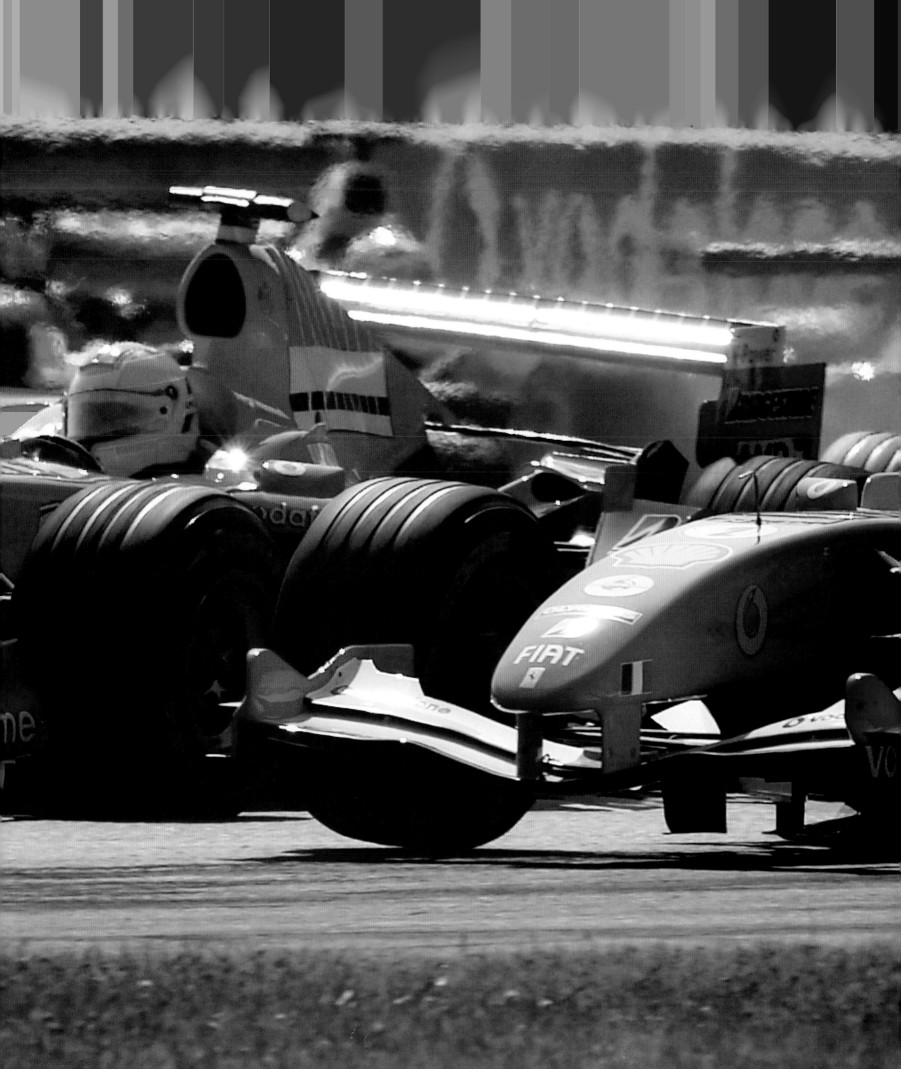

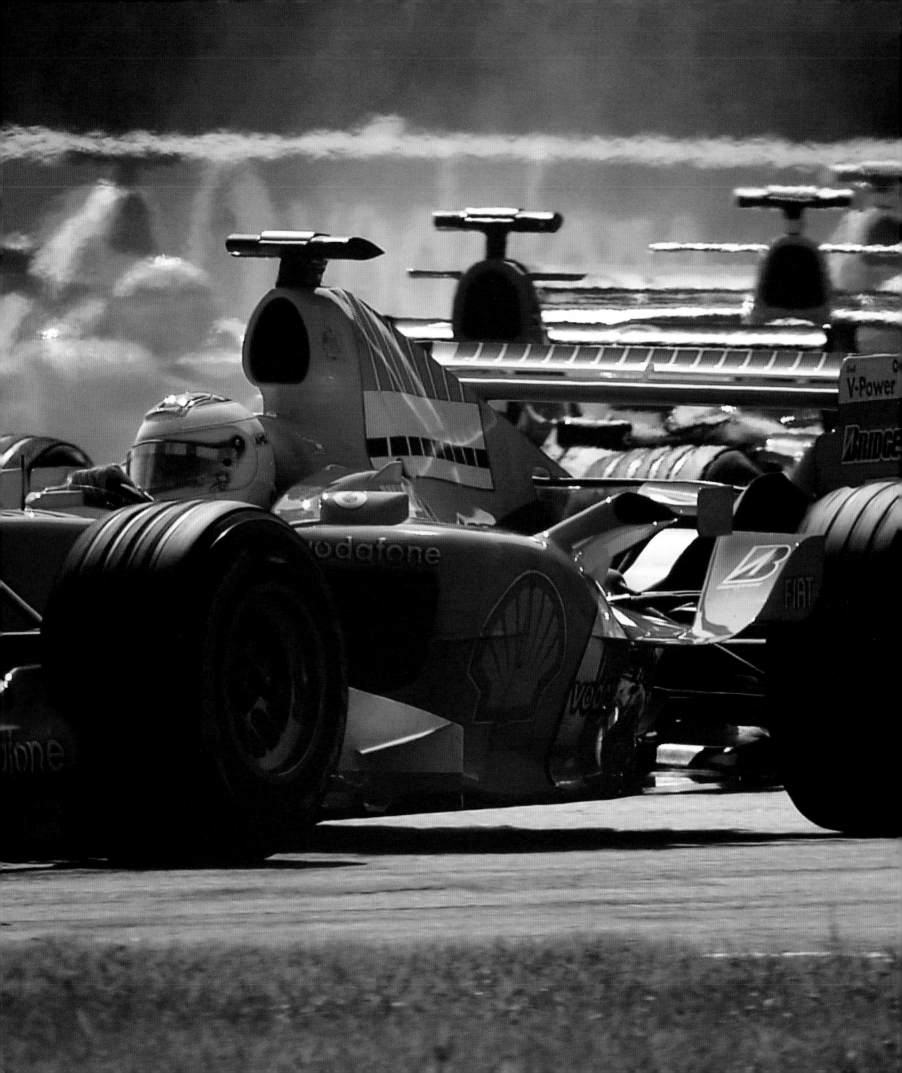

Previous page

MONZA MAGIC

The frenzied moments just after the start of the
Italian Grand Prix. Having accelerated from the
line to 290km/h (180mph), the drivers must brake
hard while jostling for position into and through
a bottleneck created by a tight chicane. Having
negotiated the right-hander, Michael Schumacher
(left) and Rubens Barrichello run side-by-side
while aiming for the left that follows immediately.
The slightest hesitation or mistake allows rivals to
capitalize during these crucial seconds before the
race settles down. And the Ferrari drivers know
that their every move at Monza is being watched
intently by a home crowd, for whom a good result
is not merely anticipated but demanded.

SUNDOWN BEFORE SUNDAY

The sun sets on the start–finish
straight at the Hungaroring
on the night before the race.
Twenty-four hours later, one
car will have raced across this
piece of track 70 times and
done it faster than anyone else.
This was the scene of Michael
Schumacher's crowning
championship glory in 2001.

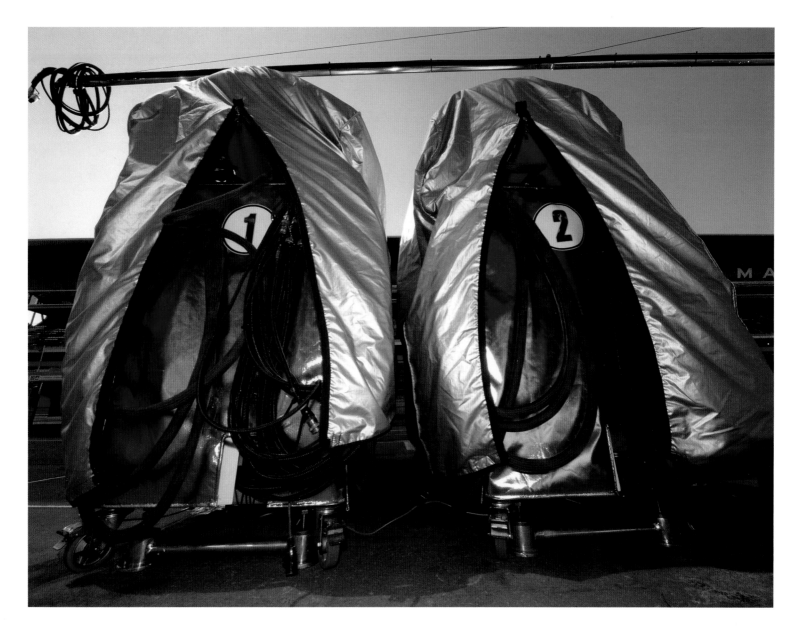

RIGGED AND READY
The fuel rigs for Schumacher and Barrichello at the entrance to the Ferrari garage, protected from the heat and ready for action.

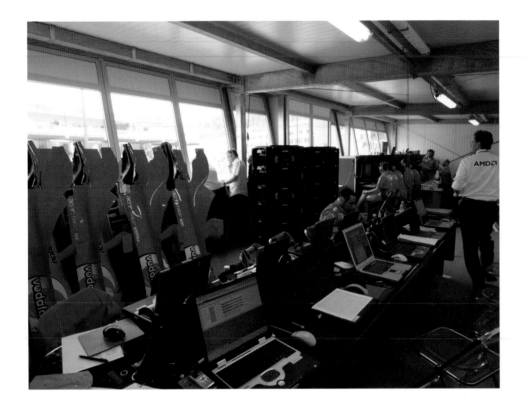

UPSTAIRS, DOWNSTAIRS

The new pit complex at Monaco provides Formula 1 teams with the only arrangement in which engineers and technicians (left, with all the spare bodywork) are placed above the working garage. They would usually be behind it but, as the photo below shows, there is no room. Space is always tight in Monaco – not that you would know it from the picture on the right, taken in the early hours of race morning.

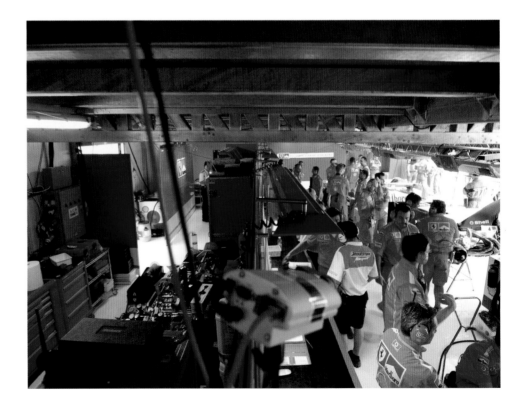

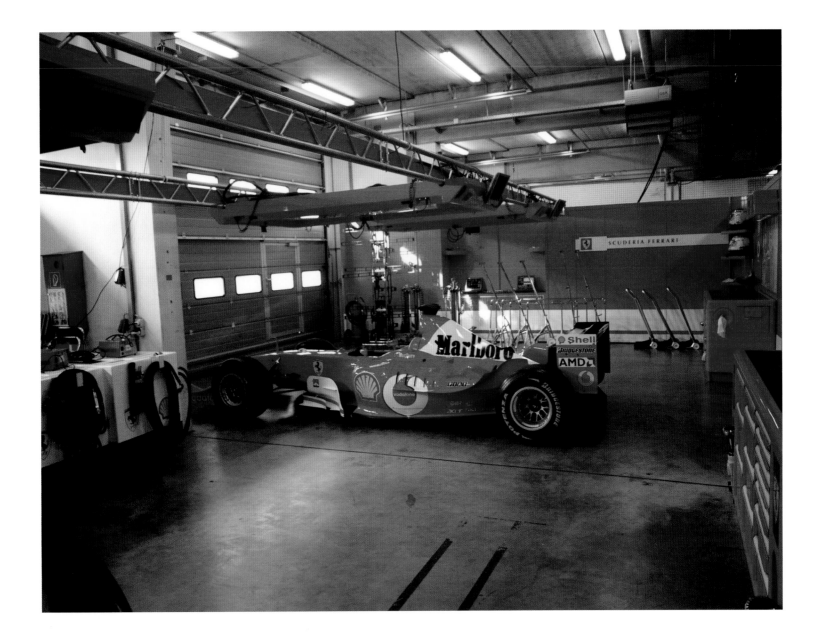

FUEL INDICATOR
A mechanic brandishes the Ferrari "lollipop" as a reference point for Michael Schumacher as he prepares to refuel during the US Grand Prix. Having been travelling at 320km/h (200mph) a minute or so before, a driver can lose his bearings briefly, despite the 100km/h (62mph) pit lane speed limit. It is not unknown for drivers to sweep into the wrong pit, particularly if the pit lane is busy.

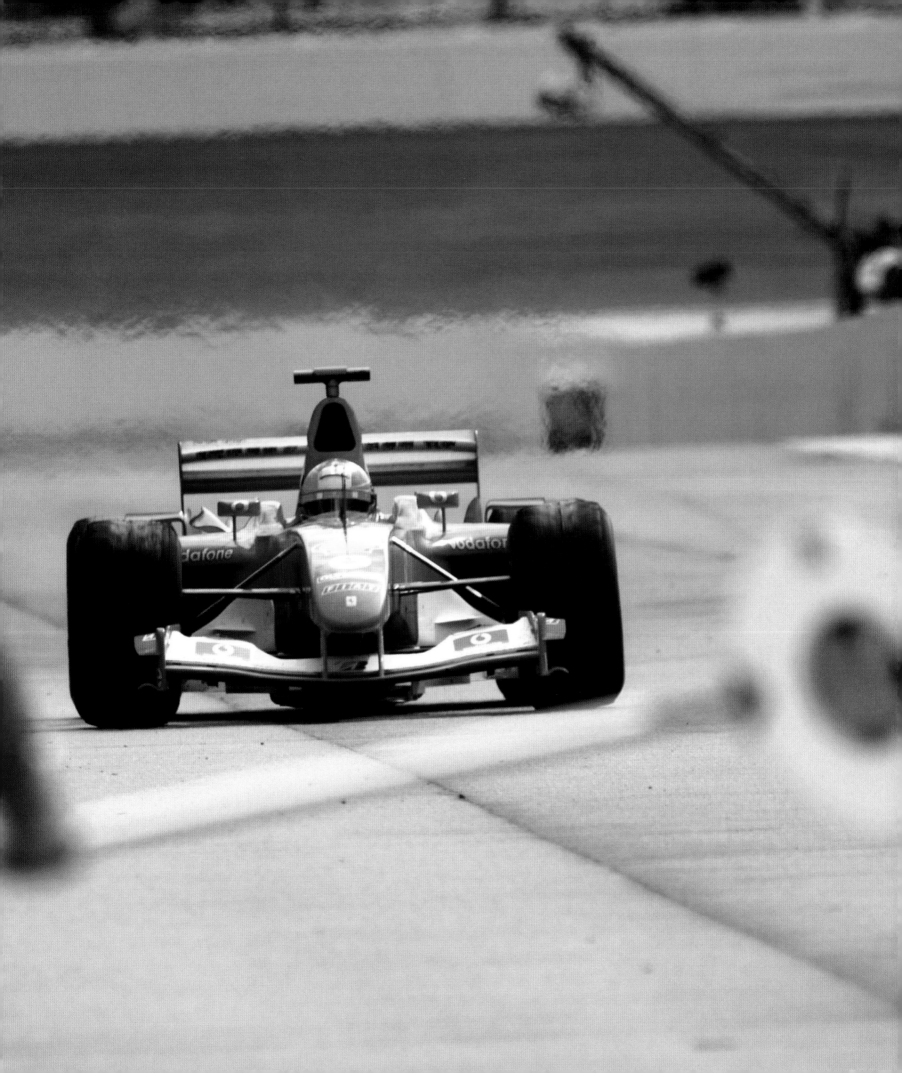

PRESSURE POINT
A Bridgestone technician jots down a tyre temperature or pressure for future reference. F1 tyres run at between 14 and 16psi, the slightest variation in pressure having a major effect on the car's handling.

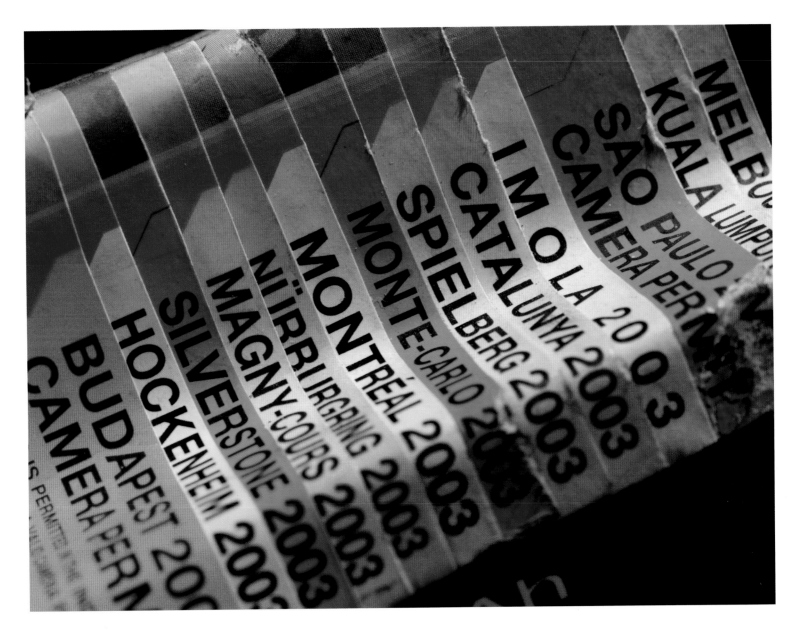

BEEN THERE; GOT THE STICKER
A cameraman covering the 2003 season for Marlboro creates an artistic arrangement on his film equipment, using a chronological display of the permits required for each race.

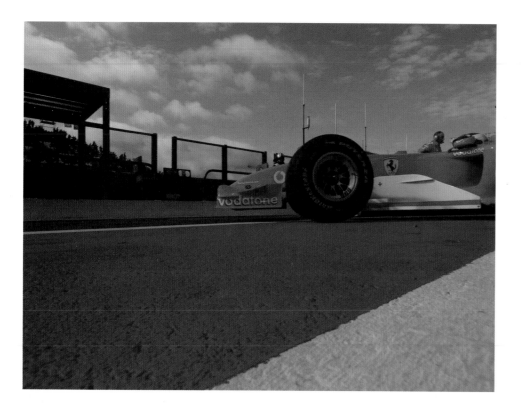

GOING OUT; COMING IN
Rubens Barrichello leaves the
garage at Magny-Cours (above).
Note the screens on the pit wall
to protect the crew from flying
debris in the event of a trackside
accident. Michael Schumacher
(right) returns to the pits during
practice at Monaco.

SHARP PRACTICE
Schumacher's Ferrari creates a
fleeting image as he accelerates
hard across the grey asphalt of
the starting grid during practice
at Imola.

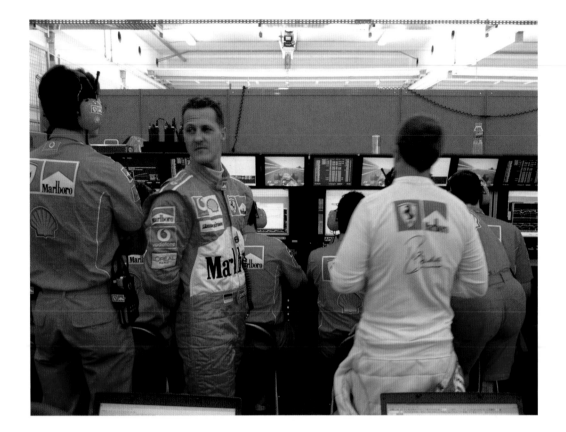

WAITING AND WATCHING

Drivers and crew can spend long periods of time waiting during practice, either for the track to reach optimum condition or for the qualifying slots to arrive (under the system employed from the start of 2003 to the end of 2005). Once his drivers are under way, Jean Todt (below right) watches the timing and television monitors at the pit wall at Monaco.

Previous page

DESERT FORM

The profile of Barrichello's Ferrari brings colour to the desert surroundings during the 2005 Bahrain Grand Prix.

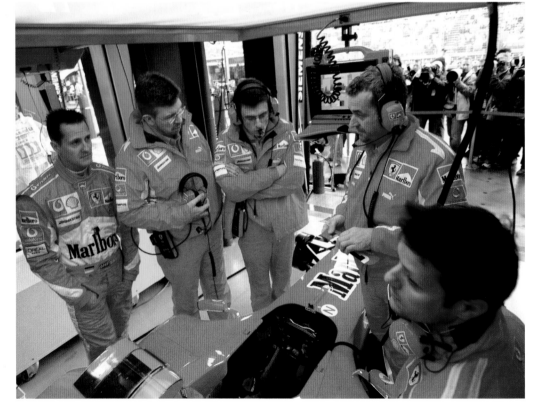

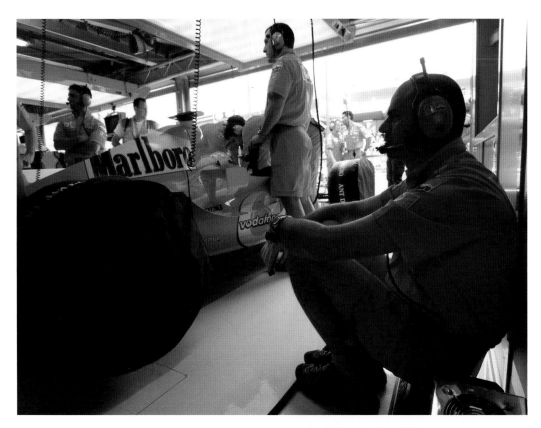

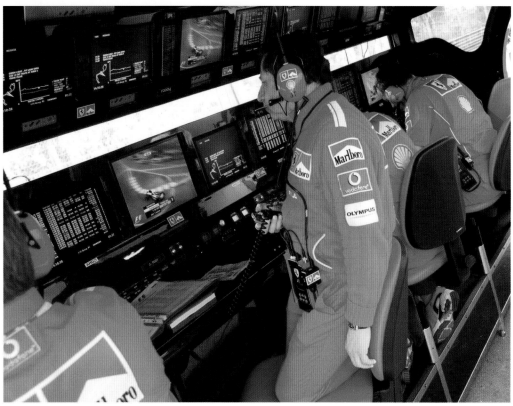

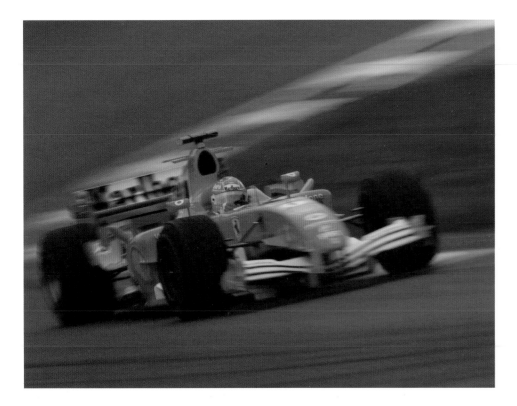

IT'S DOWN TO ME
Once on the track the driver is on his own, the rest of the team largely helpless as he takes the product of its labour to the maximum. The team would want it no other way as Schumacher explores the limits at Hockenheim (left) and Monza (below).

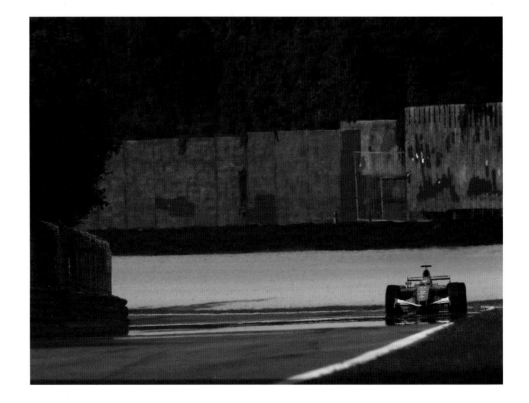

FLEETING IMAGE
The reflection of Schumacher's
Ferrari is caught on the double
glazing of the corporate suites
above the pits at Monza.

DAILY REFLECTION
Stefania Bocchi, Ferrari's assistant press officer, waits in the garage for the start of practice. Caught in the reflection of her sunglasses, Luca Colajanni, the Ferrari press officer, also relaxes before business begins. The media office produces daily press releases, including quotes on the day's activities from Jean Todt, Ross Brawn, and the drivers.

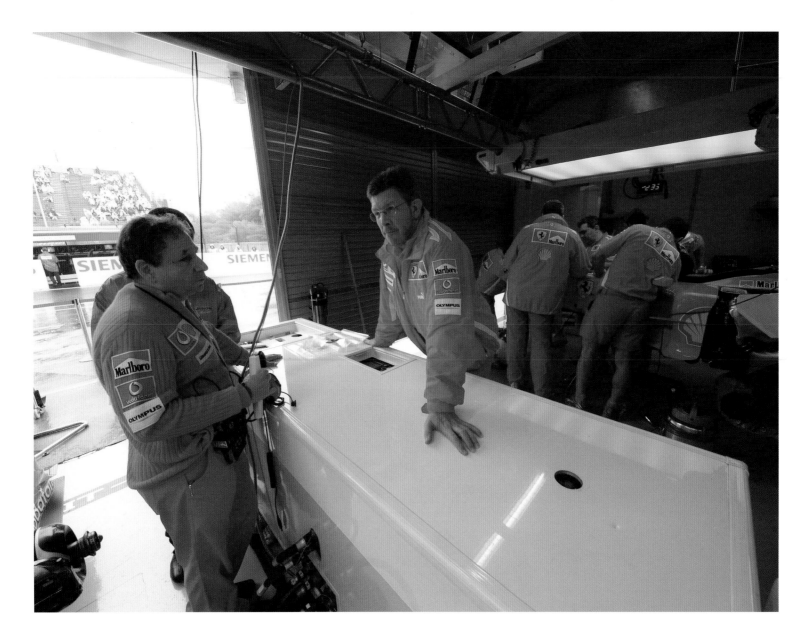

PUTTING IT RIGHT
With the garage door shut to keep prying camera lenses at bay, the mechanics set to work on Schumacher's damaged car after a crash during the first day of practice in Japan. Jean Todt and Ross Brawn ponder the loss of valuable track time, but can console themselves with the thought that Schumacher rarely makes mistakes.

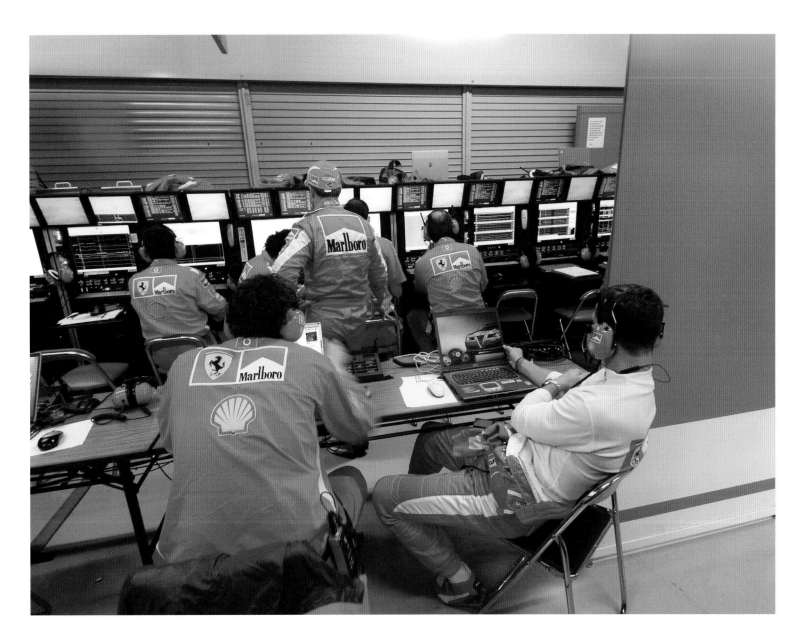

WAITING ROOM
Schumacher and Barrichello cool their heels at the back of the garage in Japan while their cars are worked on during practice.

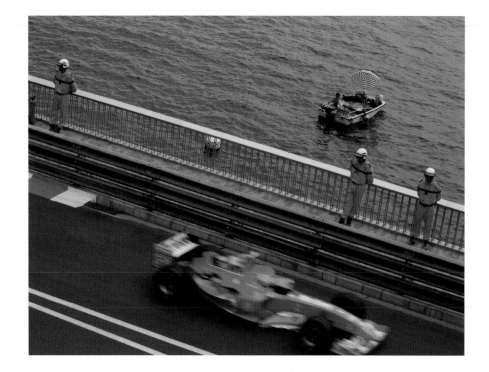

ON THE WATERFRONT

The Monaco Grand Prix is unique, thanks
to its glamorous location as the track
cuts a swathe through the middle of the
tiny principality. Having negotiated the
twisting and steep drop from Casino
Square, Schumacher accelerates out of
Portier corner and onto the waterfront
(above). Less than ten seconds later he
will have reached 280km/h (175mph) in
the long, curving tunnel, braked heavily
to 65km/h (40mph), and then pointed the
Ferrari through the tight chicane (right)
leading onto the harbour. Boats normally
moored by the quayside at this point are
moved back 100 metres (110 yards).
It was here that Alberto Ascari crashed
his Ferrari into the water during the 1955
Monaco Grand Prix. He survived, only
to lose his life during a test at Monza
a few days later.

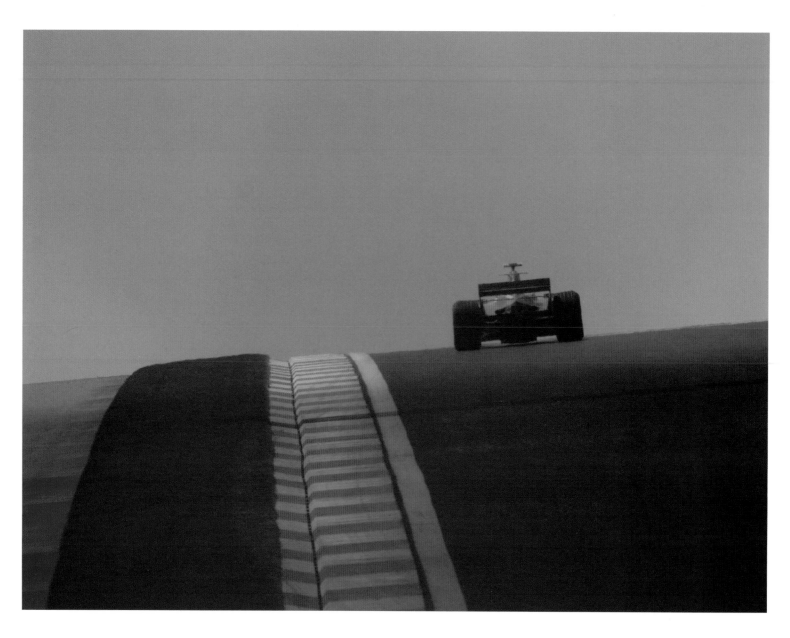

DIFFERENT TRACKS; SAME CHALLENGE
Schumacher looks for the ideal line during
qualifying in Turkey (above) and in Canada (right).

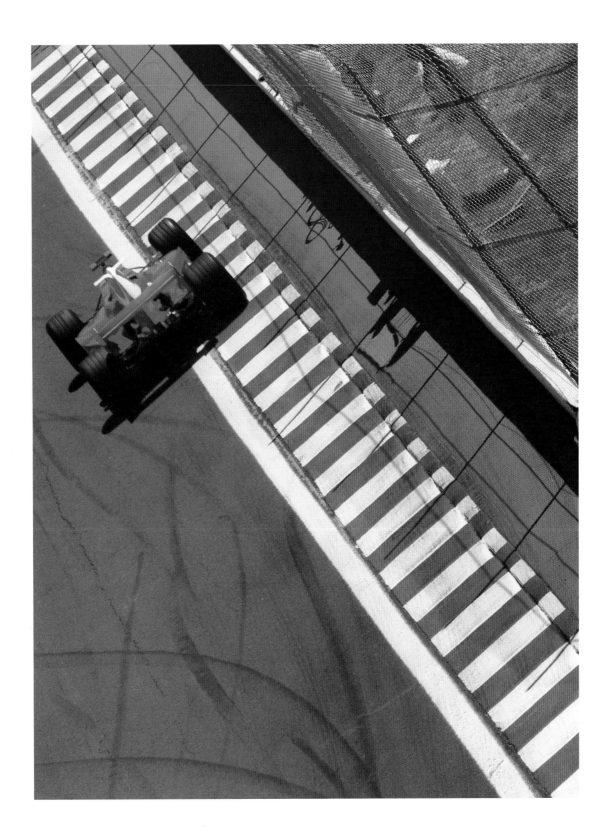

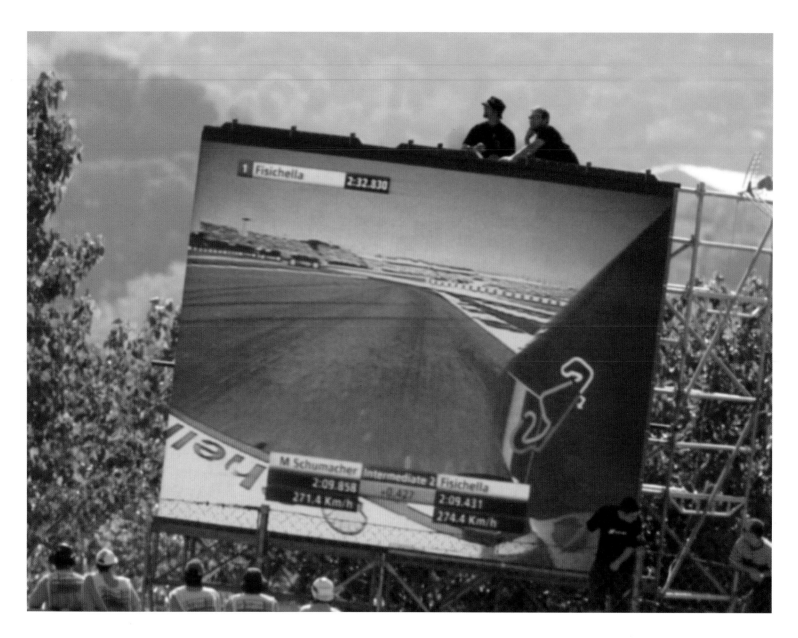

SEEING THE BIGGER PICTURE
Giant screens dotted around
each track help keep the crowd
informed. At Barcelona (above),
spectators watch the on-board
action as Schumacher attempts
to match Giancarlo Fisichella's
fastest time. The screen at Monza
(right) is framed here by one of
the many trees in the royal park.

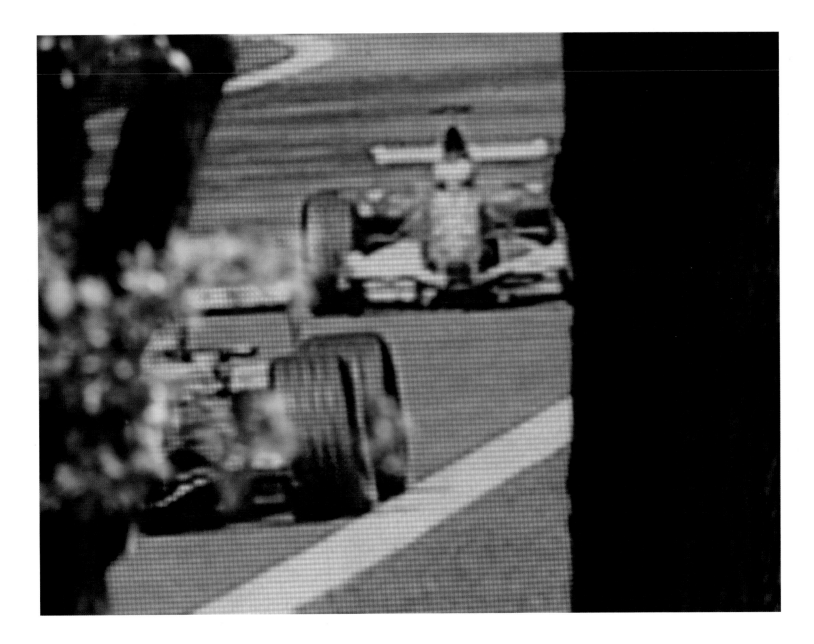

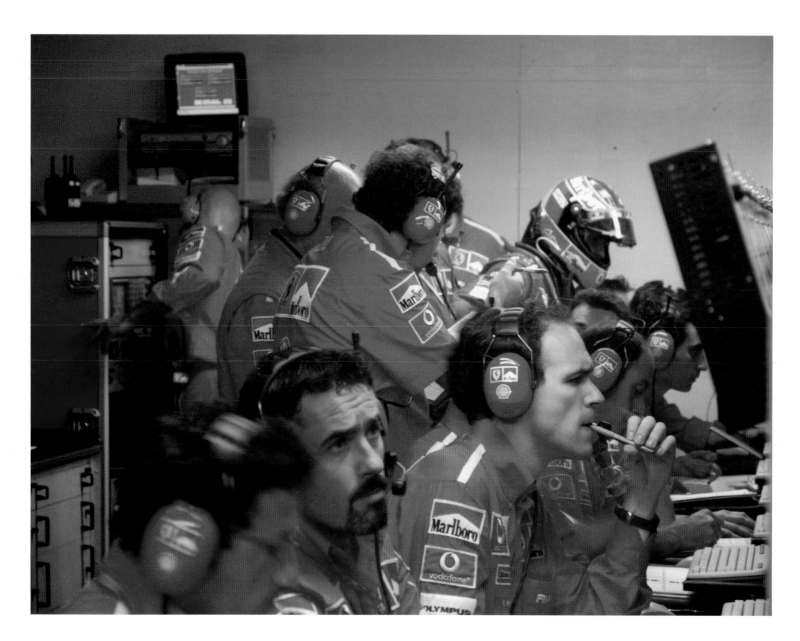

THE CONSTANT SEARCH

These pictures capture the endless quest for perfection at any given race. Schumacher joins engineers and technicians (above) the minute he leaves the cockpit, to check telemetry readings. Later, he is in deep conversation with his engineers (above right). The work continues on the grid (right) as Barrichello is strapped in place at Monaco. His engineer, Gabriele Delli Colli, listens to an instruction from the engineers located in the office overlooking the pit lane.

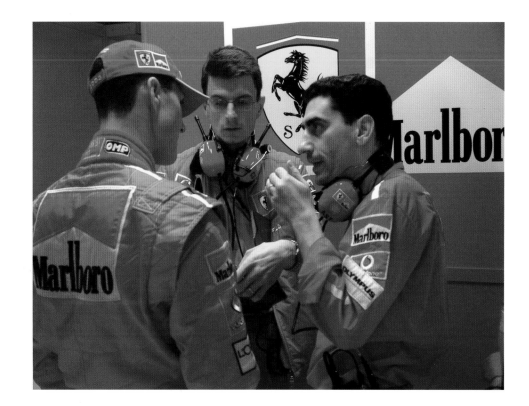

TIRED – BUT NOT EMOTIONAL
The body language says it all
(above) as Jean Todt and Michael
Schumacher consult with Hisao
Suganuma, technical manager
of Bridgestone Motorsport, over
tyre choice at Magny-Cours.
Tyre companies bring two
different tyres to each race –
the team must choose the best
tyre for qualifying and for the
race after the first day of practice.
The conclusion (right) does not
seem to be encouraging.

NOTHING MORE TO SAY
Discussion – for what it's worth – having been concluded, Michael Schumacher takes his scooter between the transporters at the back of the garage, and heads for the sanctuary of the motor home at the far end of the paddock.

ROLE MODELS
Pretty girls have always been part of the glamour associated with every grand prix. Models clip-clop toward the grid at Indianapolis (above), and Michael Schumacher has an attractive guard of honour (right) as he heads for the drivers' parade on race day at Barcelona.

FINAL COUNTDOWN
The front jack is readied for the car's arrival at its grid position (above). As the mechanics set to work on final checks, Michael Schumacher climbs out and removes his gloves and helmet, dons his sponsored cap, collects an energy drink, and has another discussion with Jean Todt (above right and middle right). Schumacher then double-checks strategy with his engineer, Chris Dyer (right).

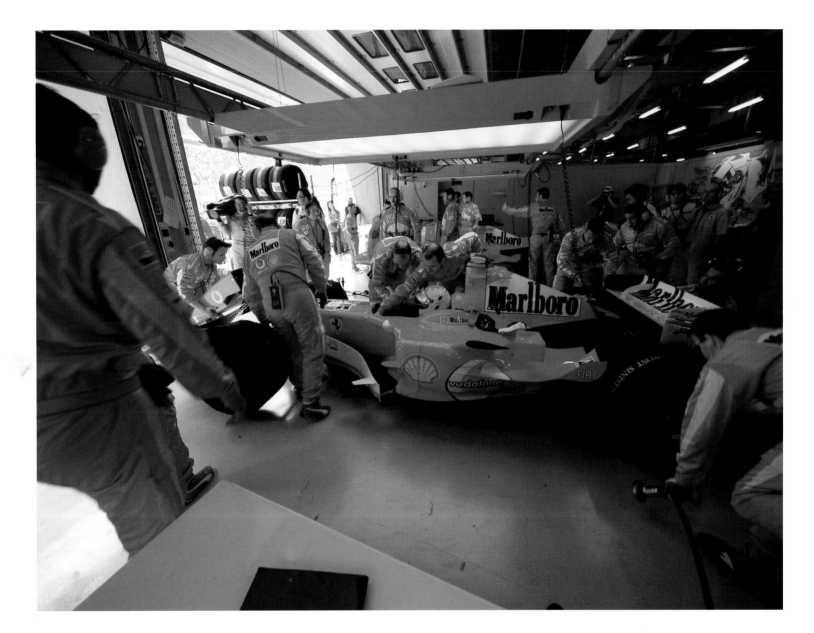

MORE THAN A PRETTY FACE
Each driver's grid position is indicated by a model holding a board with his name. This is Schumacher's marker in Turkey in 2005 (left). However, in China that year his position remained vacant after a collision with another car while on his way to the grid meant feverish last-minute preparation (above). His mechanics had to prepare the spare Ferrari to start from the pit lane.

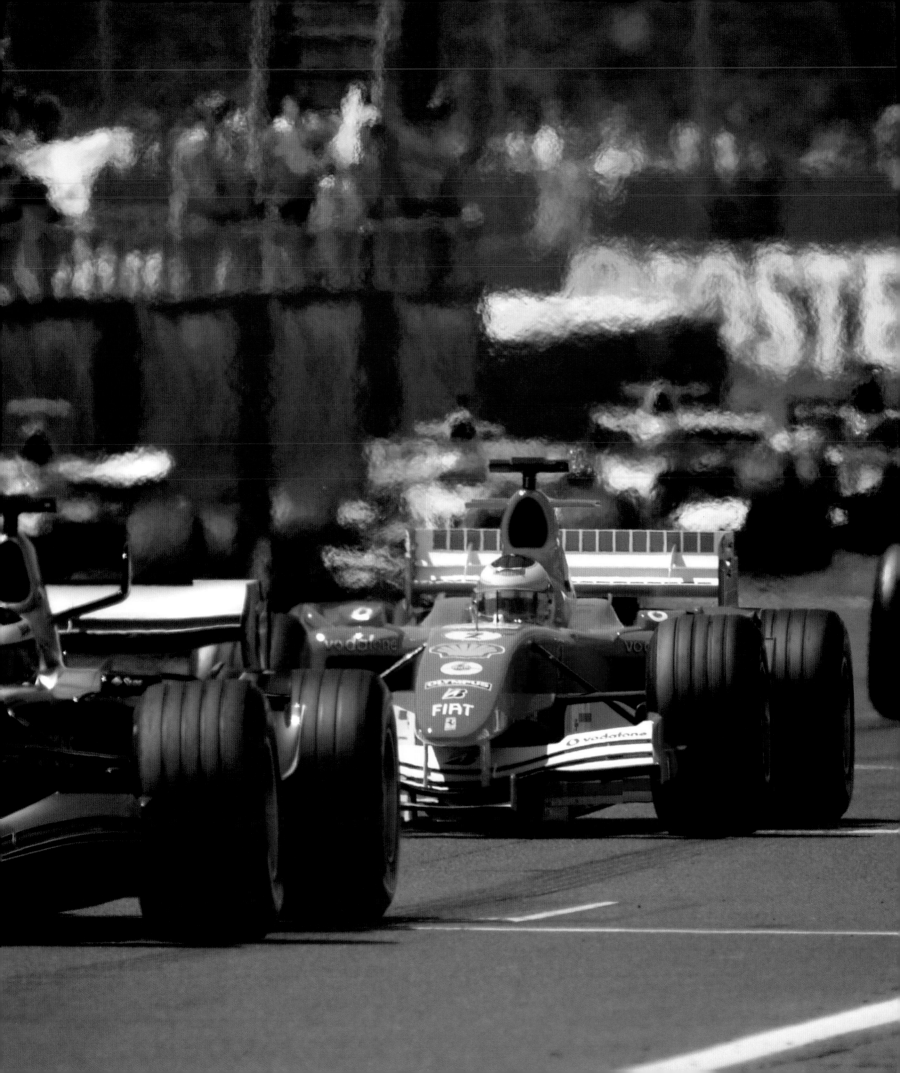

GO!
The Ferraris of Barrichello and Schumacher set off in pursuit of Juan Pablo Montoya's McLaren at the start of the 2005 British Grand Prix.

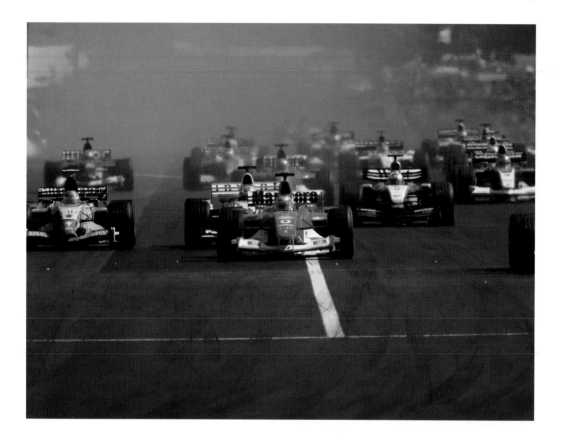

FRANTIC

The opening moments of any grand prix are the most risky. Running in close company, drivers jockey for position as they seek to grab whatever advantage they can. The pack streaks off the line in Hungary (left). Barrichello hangs on to second place, despite running wide at the exit of the first corner in Barcelona (below left). Schumacher attempts to avoid flying debris in Turkey (right), while a more difficult situation arises at the Nürburgring (below right) as Juan Pablo Montoya, having tangled with Mark Webber's Williams, spins his McLaren in front of Barrichello and Schumacher, and triggers an incident involving eight cars.

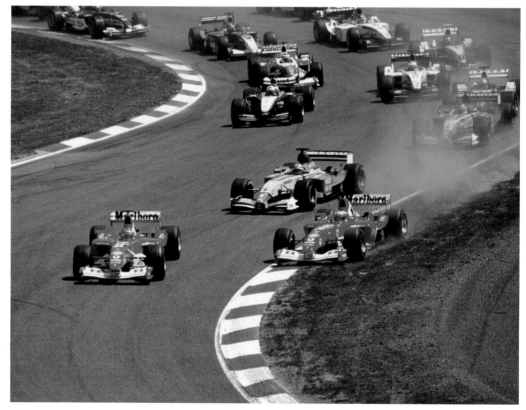

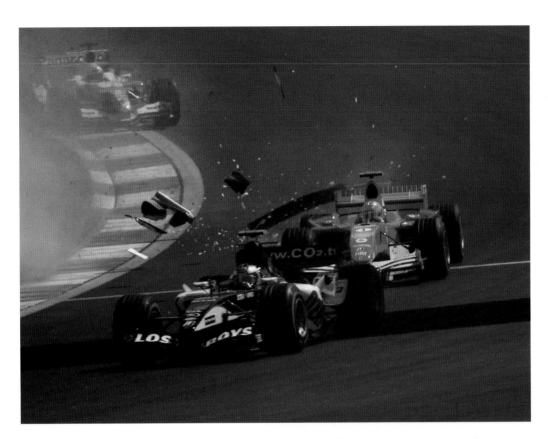

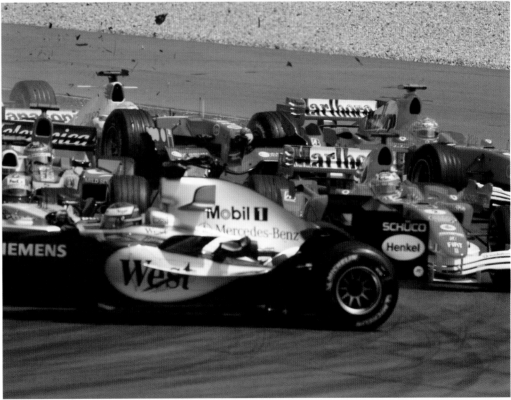

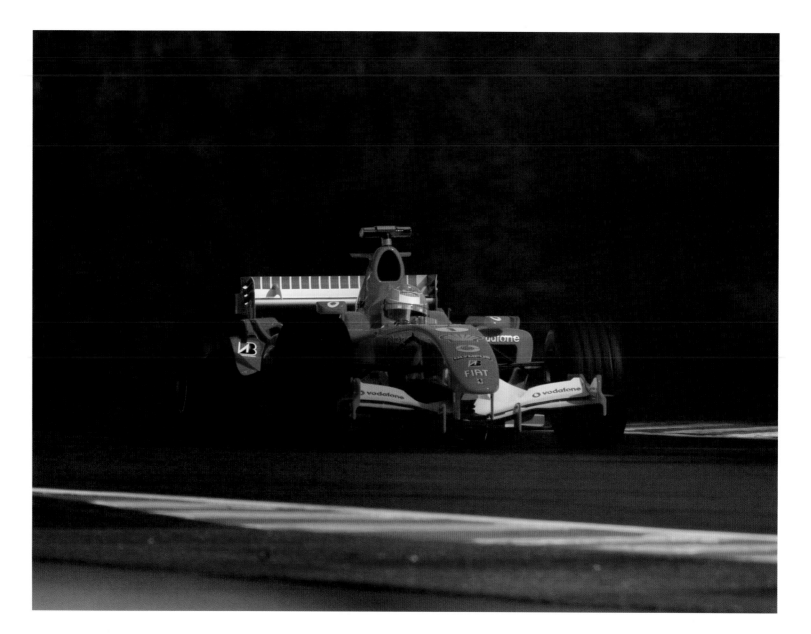

SEEN AROUND THE WORLD
F1 is considered to be the best advertising medium on a global basis. Schumacher carries Ferrari's colours through the awesome Eau Rouge corner at Spa-Francorchamps in Belgium (above), into the Swimming Pool complex at Monaco (above right), and past more than 120,000 spectators at Suzuka in Japan.

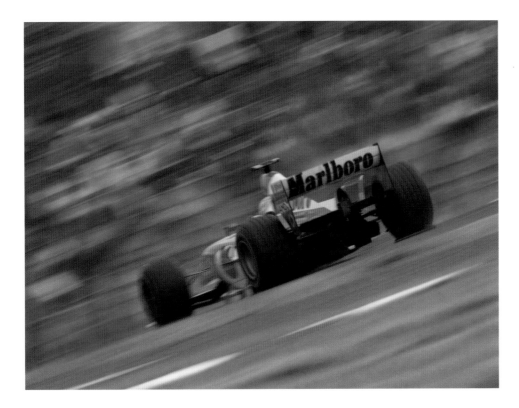

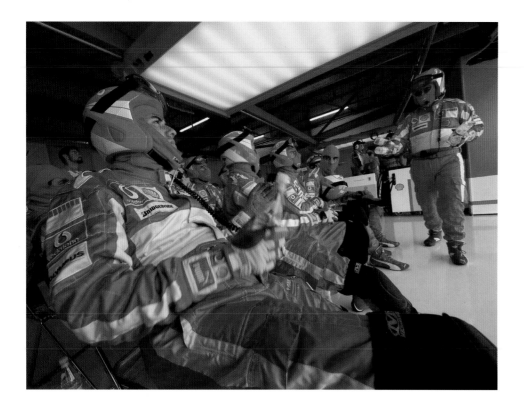

TEAMWORK

For safety reasons, during the race mechanics are allowed onto the pit lane only shortly before their car is due to stop. The crew therefore spends the vast majority of the race watching its drivers' progress on the monitors, while adrenalin builds in anticipation of at least one stop – maybe as many as three – for fuel and tyres for each driver. The crew remains dressed and ready for action at all times, the flameproof overalls and balaclava proving less than ideal in a hot climate. The call from the Ferrari management at the pit wall triggers instant action (below left) as tyres are removed from their blankets and rushed into position (above right), while the fuel rigs and hoses are made ready (below right). The car will be stationary for only about ten seconds at the most, but they know that the race can be won or lost during those vital moments.

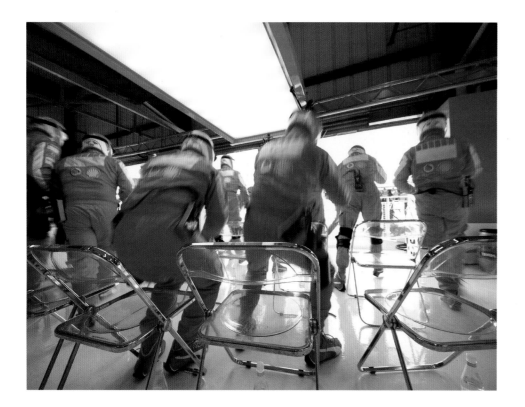

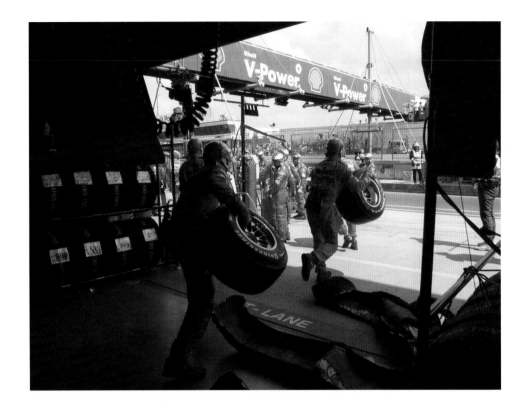

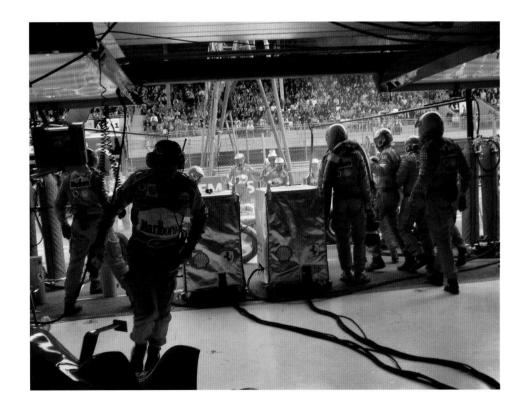

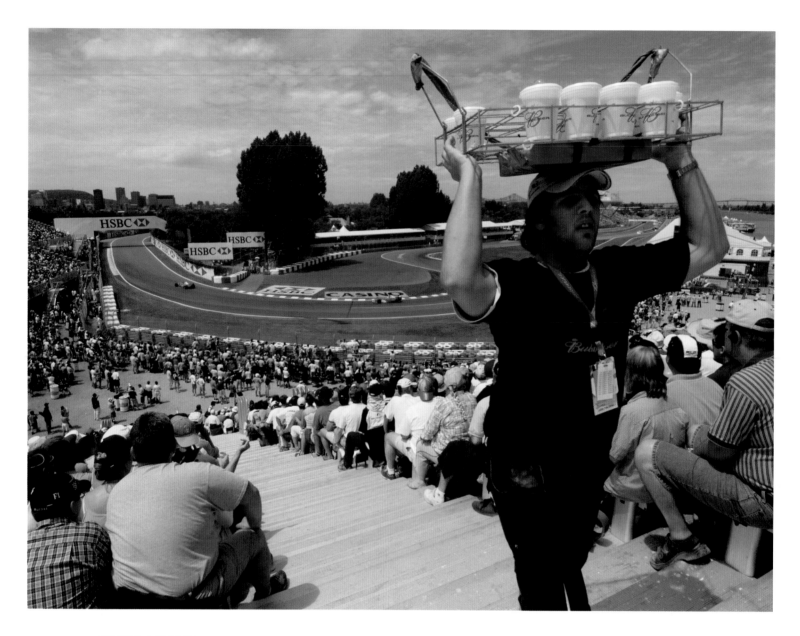

FEEDING A PASSION
Formula 1 is food and drink to
enthusiasts the world over, be
it in the packed grandstands
surrounding Turns One and Two
at Montreal (above), or in the
more grandiose surroundings
of the Swimming Pool Chicane
at Monaco (right).

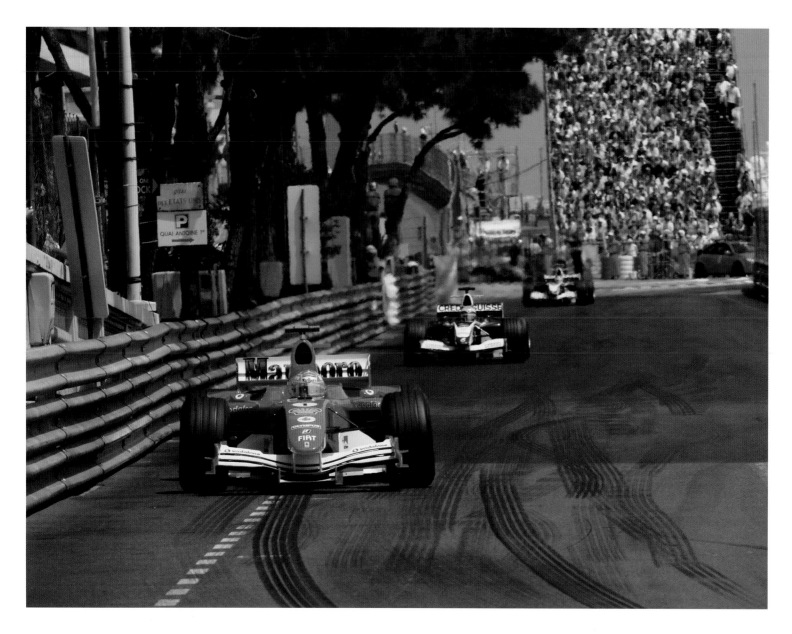

WINNING HABIT
Michael Schumacher has won
Monaco (above) five times. He
has the same number of wins
at Barcelona (right).

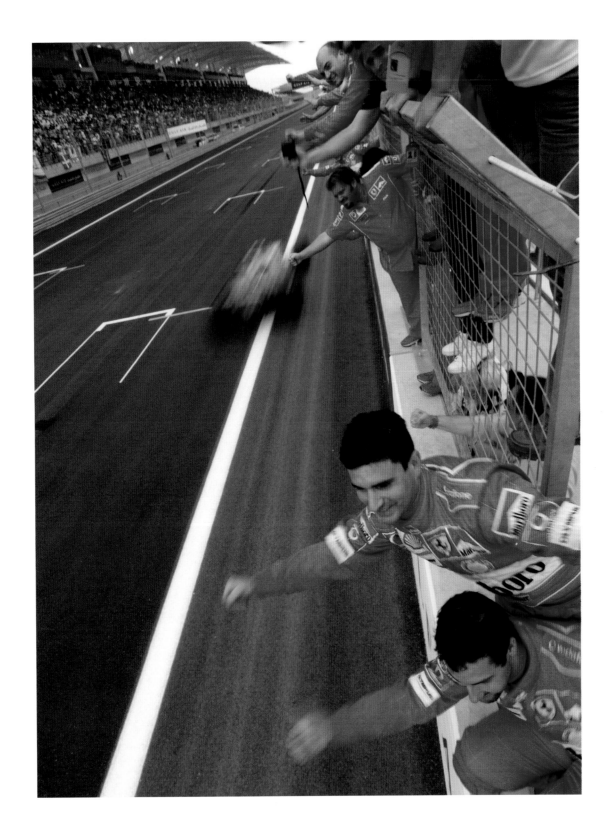

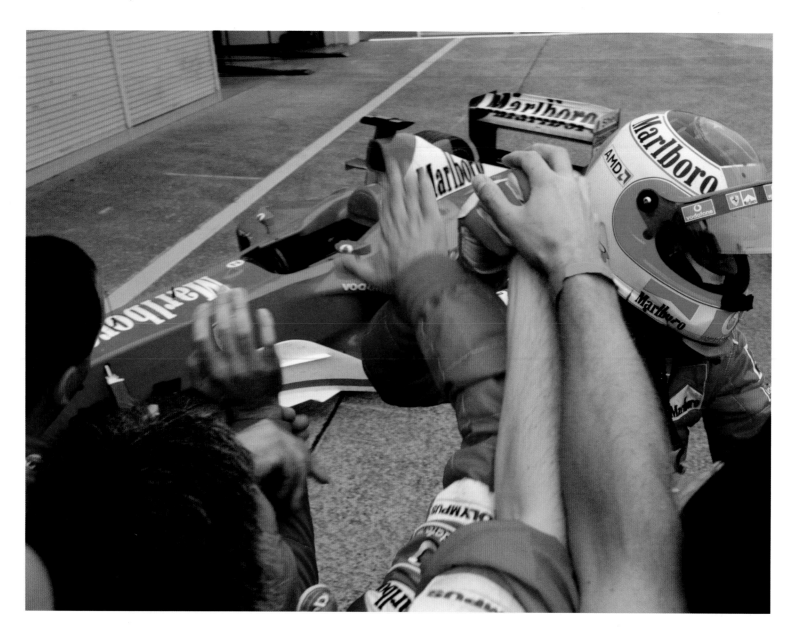

RESULT!
Rubens Barrichello, having just stepped from his winning car at the end of the 2003 Japanese Grand Prix, greets his mechanics as they line the fence at *parc fermé* in Suzuka.

COMING THROUGH!
Sometimes the route from track to *parc fermé* at the end of the race takes the winner along the length of the pit lane. This is the case in Melbourne, as a jubilant Michael Schumacher eases his way past the Ferrari pit to receive the plaudits from his team (right).

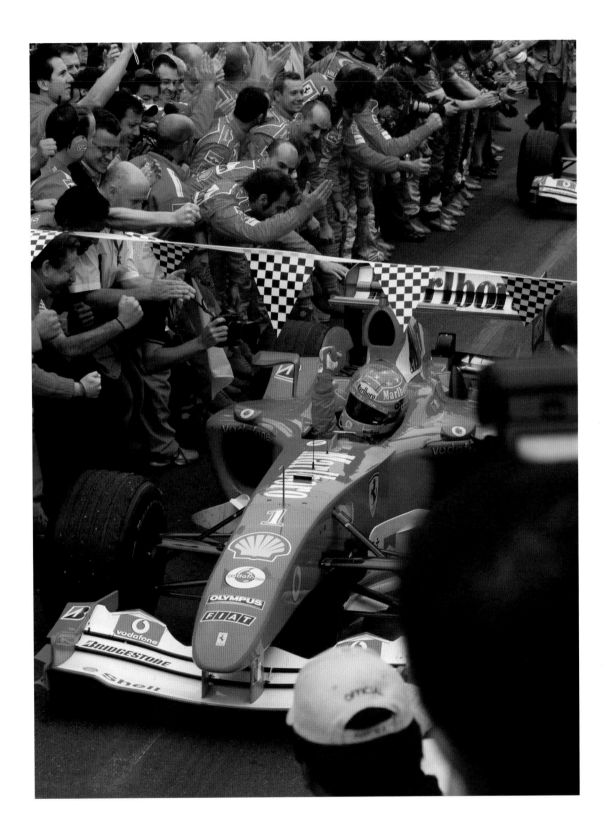

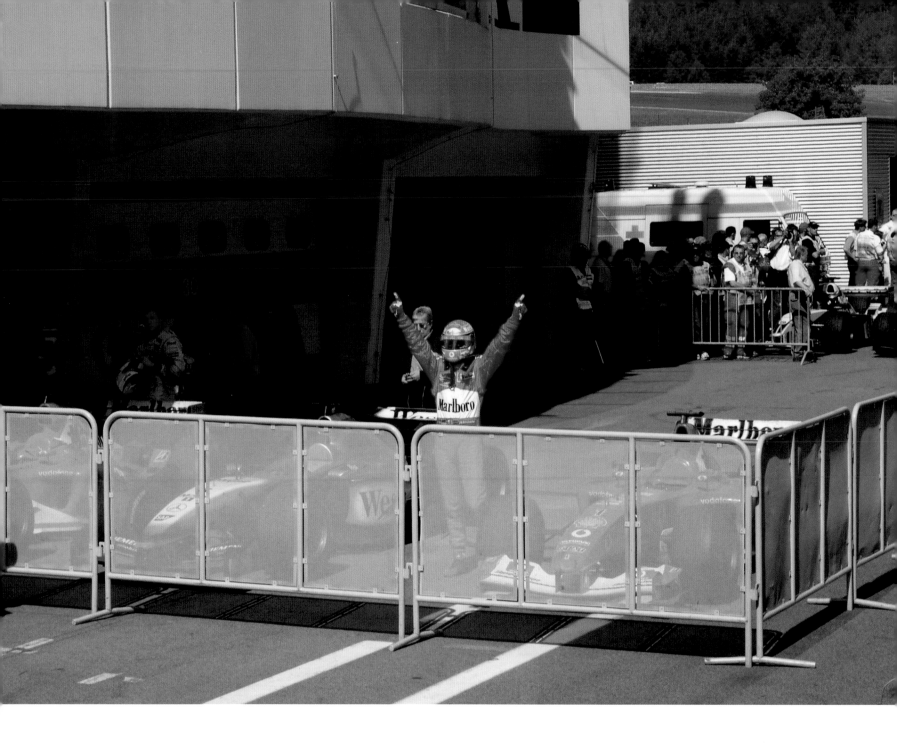

WINNER'S ENCLOSURE

Parc fermé is sacrosanct. With the exception of the drivers, no one is allowed in until the cars have been weighed and checked. Michael Schumacher greets his team from a distance in Austria (above), stands on his car for a better view from the Winner's Circle at Indianapolis (right), and leaps into the arms of Ross Brawn in Canada (far right). Ferrari's technical director was granted permission to enter because he was to join Schumacher on the podium to receive the trophy on behalf of the winning team.

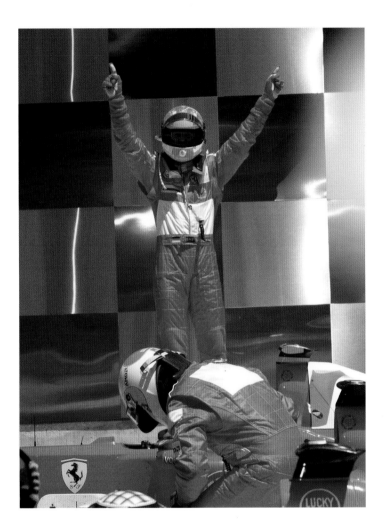

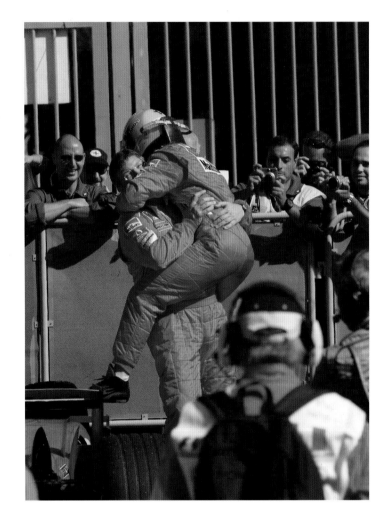

CHAMPAGNE MOMENT
Schumacher lets the bubbly rip in Hungary in 2004 to celebrate Ferrari's 14th constructors' championship, the title sealed by Schumacher and Barrichello, who started from the front and were never headed throughout the 70-lap race.

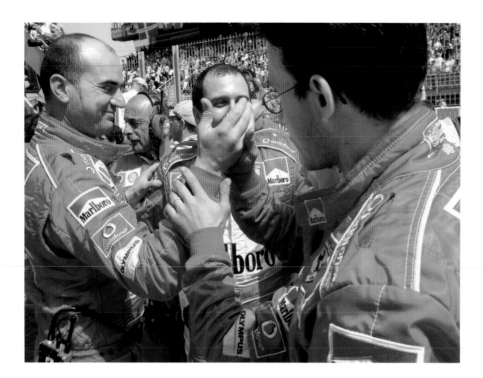

NEVER OVER UNTIL IT'S OVER
Anyone who has been in motor racing for more than five minutes knows just how cruel the sport can be. A victory that had seemed certain for more than an hour can be lost within sight of the flag. Once the winning car has crossed the line, the sense of relief is sudden and all-consuming as a weekend's tension is released. There is no better feeling for mechanics who have worked long hours and thought of nothing but their team. It makes the hardship and dedication worthwhile.

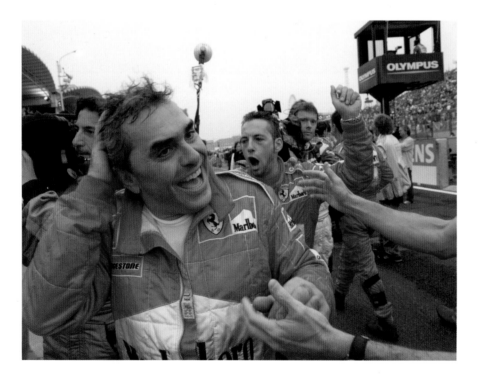

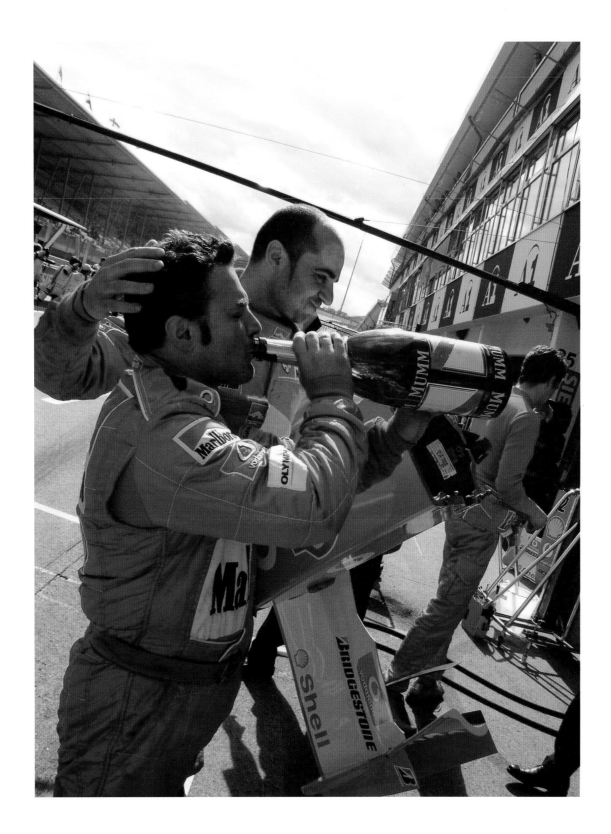

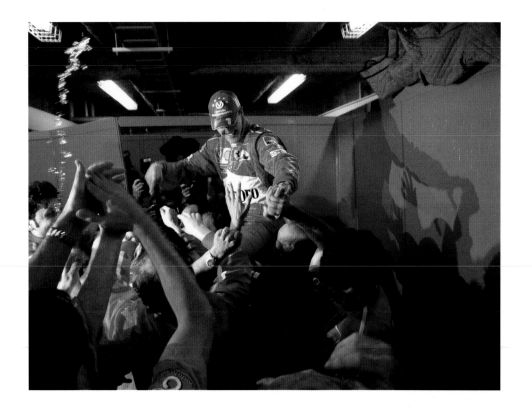

MUTUAL RESPECT

It can be as long as 30 minutes before the winning driver is reunited with his team. Having moved straight from *parc fermé* to the podium, he will be ushered into the television studio and will then attend the winner's press conference in the media centre and further television interviews in the paddock. Then he is free to return to the garage. The crew will be thrilled that their man has used to the maximum the equipment on which they have lavished such care and attention. Equally, the driver will be aware that his competitive and reliable car has been due solely to the diligence and dedication of those waiting to greet him with open arms. It is a sincere moment of mutual gratitude and respect.

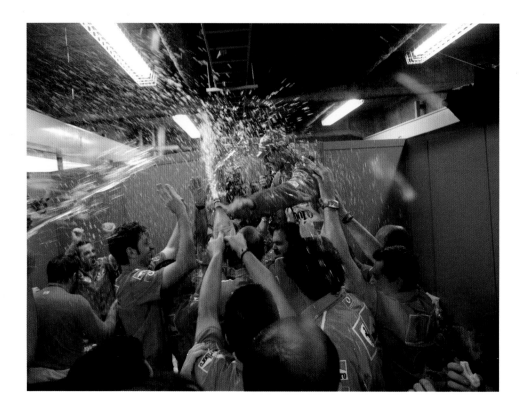

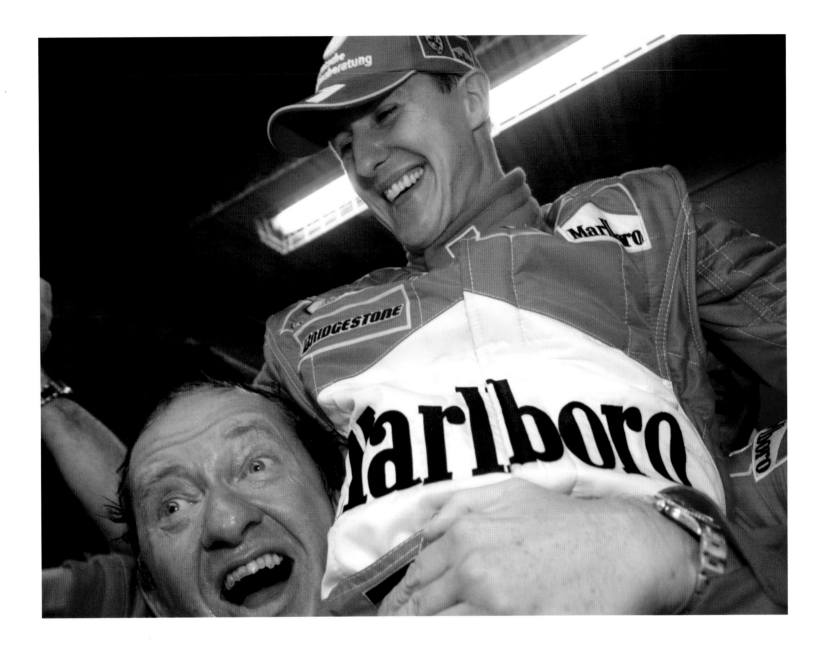

STAIRWAY FOR THE STARS
While Rubens Barrichello
removes his helmet, Michael
Schumacher is already on his
way to the podium after a Ferrari
one–two in Melbourne in 2004.

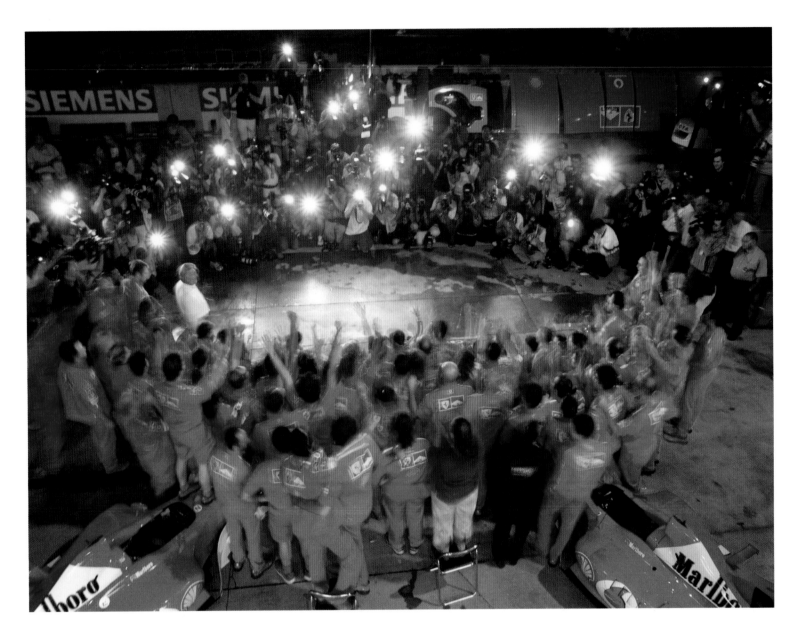

PHOTO CALL
Darkness descends quickly
in Japan, but the final round
of the 2003 season requires a
post-race photograph, not least
because Michael Schumacher
has just won a record sixth
world championship. The driver
is united with his team in the
paddock at Suzuka, as the
flashlights pop and cameras
record another important moment
in the history of Scuderia Ferrari.

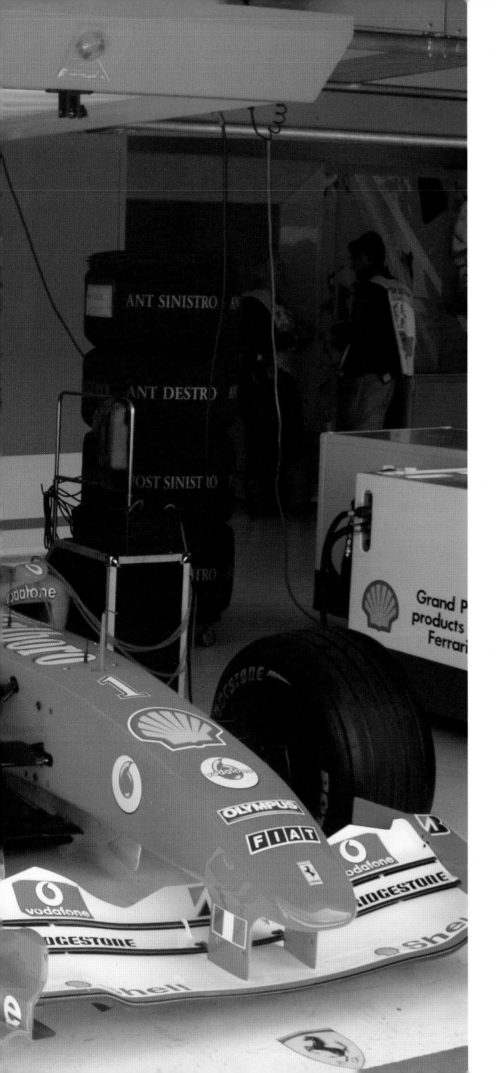

FAMILY

PHOTO OPPORTUNITY
Few grown men, no matter
what their status, will pass
up the opportunity to pose
proudly alongside a Ferrari
Formula 1 car.

Rory Byrne designed the F1 car that, in 2000, brought Ferrari its first world drivers' championship in 21 years. No one could question the South African's flair and talent. Arguably his biggest mistake that year was to drive his Ferrari road car to work in Maranello on the morning after the championship had been won 10,000km (6,000 miles) away in Japan.

Byrne rarely travelled to the races, preferring instead to liaise with Ross Brawn, the team's technical director, by email and telephone while he stayed at the factory working on next year's car. Byrne was thrilled when news came through from Suzuka in the early hours of Sunday 8 October that Michael Schumacher had finally won the title after so many near misses. He decided to drive from home to check his emails and read the race debriefs from Suzuka, and figured he would enjoy the moment even more by bringing his Ferrari Modena 360 to work.

The 5km (3-mile) journey took the best part of an hour. Even then, Byrne was lucky to reach his office.

Most of the population of Maranello had been awake all night, waiting for the start of the race and following it to its joyous conclusion at around 6am. Schumacher had brought Ferrari its first title since Jody Scheckter in 1979. The wait had merely massaged and accelerated the sense of joy that accompanied the energetic ringing of chapel bells in the centre of town.

Byrne, a quiet, modest man who likes to keep a low profile, was barely within sight of the factory when someone recognized him.

More than 50 people surrounded the car, one man getting on his knees and kissing the Prancing Horse symbol on the bonnet. Nothing would do but for Byrne to climb out and receive the gratitude and congratulations of his well wishers.

"Everyone wanted to shake my hand," said Byrne. "More and more people came over – all of them passionate Ferrari fans – and in the end, I simply couldn't move. It was unbelievable. I had to get the police to escort me to work because otherwise I would not have been able to get through the gates.

"I don't believe you'll find anything like this with any other race team. That's because Ferrari is part of the local community. In fact, on days like that, you really believe it *is* the community."

Maranello is the hub of a family that has spread to every corner of the globe. The Ferrari Owners' Club provides a formal register of owners proud to sit behind a steering wheel with the famous black horse at its centre. The club organizes trips to grands prix, offers lavish and expensive Ferrari memorabilia, and provides an opportunity to enjoy a sneak preview of new road cars before they are unveiled to the media.

Passionate fans sit up all night to share the success as the red cars race in a far-off land.

A website – exclusive to the Ferrari Owners' Club, of course – massages the sense of belonging by publishing photographs of famous visitors to Maranello. Social strata seem to be left at the main gate as monarchs, pop idols, actors, and sports people happily pose alongside the latest gleaming product from the Ferrari production line. You will see the regal countenance of the King of Morocco on the same page as an N.B.A. basketball star; the Crown Prince of Bahrain sharing a common passion with Eric Clapton or Nicholas Cage; a Malaysian ambassador just falling short of wearing a Ferrari cap, unlike a beaming Jennifer Capriati as the tennis star stands alongside a Modena 360 after a lap of Fiorano.

Part of the ritual might include a visit to the Cavallino, the long-established restaurant directly opposite the factory and the place where Enzo Ferrari would regularly enjoy a quiet corner. On more public occasions, he used the Cavallino to host meetings of team bosses and hold press conferences. All of these have been recorded and, as you would expect, proudly displayed on the whitewashed walls alongside photographs of drivers past and present: the perfect backdrop as red-jacketed waiters bustle between tables bedecked in yellow. This is the gloss specially prepared for the broader reaches of Ferrari's association with its clients and fans.

The true definition of Ferrari family lies over the bridge, half a mile down the road. Tucked out of view and with no outward sign of allegiance, the Montana is favoured by the team for exactly that reason. Run by Rosella – referred to by Michael Schumacher as his second mother – this functional and typically Italian restaurant serves as a bolt hole. Of course, Rosella could not resist displaying her Ferrari loyalty at some point; autographs, photographs, posters, and driver overalls bedeck the wooden walls. But, in this establishment, for red waistcoats read starched white aprons. If the Cavallino is Ferrari's posh front parlour, then this is the family living room at the rear.

Nigel Stepney is a regular visitor to the Montana. He may be English, but the former mechanic with Lotus holds the important title of team coordinator after more than a decade with Ferrari. It took a couple of years for Stepney to become assimilated into the team, understand the ethos, and feel an integral part of this special family. Along the way, he learned about the unique culture that prevails in Maranello and within the team. Stepney says that the racing team may not necessarily have the best 150 people working in Formula 1 but that it has "150 bloody good people who can all work together."

The inference is that employing a collection of the most talented and prolific personnel would lead to a clash of egos whereas, within the *Gestione Sportiva* at Maranello, people have nothing but respect for each other. Every man and woman has their job and carries it out without standing on anyone's toes.

That respect stretches from Michael Schumacher to the man putting the shine on the factory floor. And it spreads beyond the factory gates to the passionate fans sitting up all night to share the success or heartbreak as those beautiful red cars race in some far-off land. Typical family. Typical Ferrari.

WAIT FOR IT! WAIT FOR IT!
Mechanics and engineers,
having rushed to the pit wall
at Indianapolis, wait for the
victorious Ferrari to emerge
from the final corner.

FATHER FIGURE
Luca di Montezemolo
acknowledges the crowd
as the Ferrari president
emerges from the garage
at Monza (left).

PRONE POSITION
As the early-morning
sun rises over Monza in
September, a dedicated
Ferrari fan claims his place
by the fence (above).

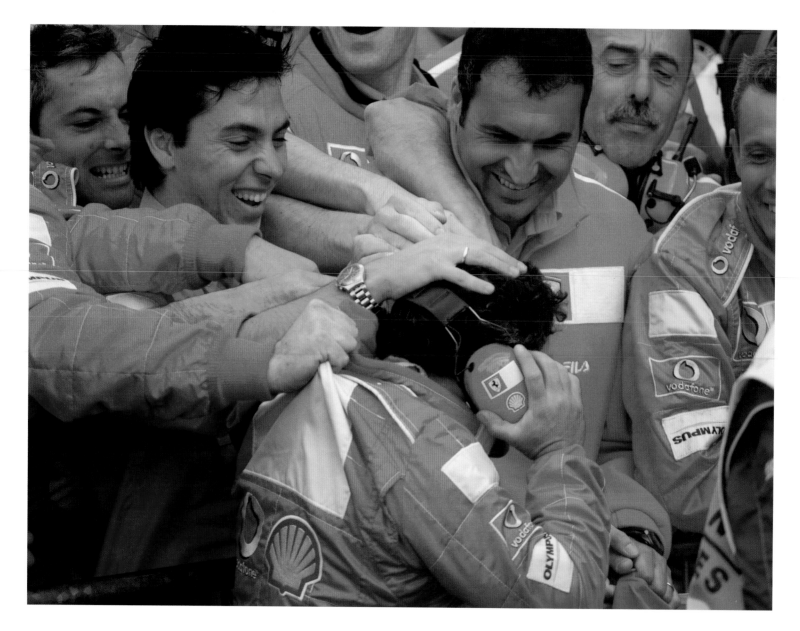

IN IT TOGETHER

The spirit of togetherness
within the Ferrari race team
extends from preparing to
pose for a team photograph
(above), to the portable office
in China (above right), and to
the scene in any garage as
mechanics and engineers check
progress on the monitors (right).

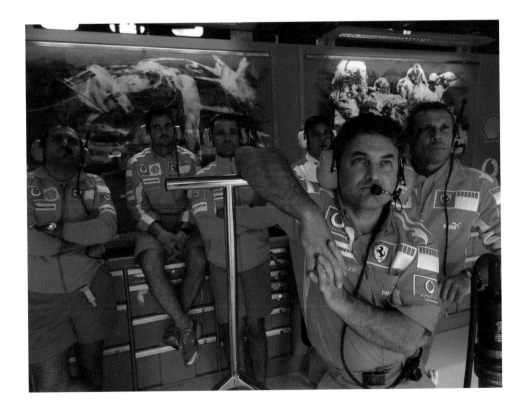

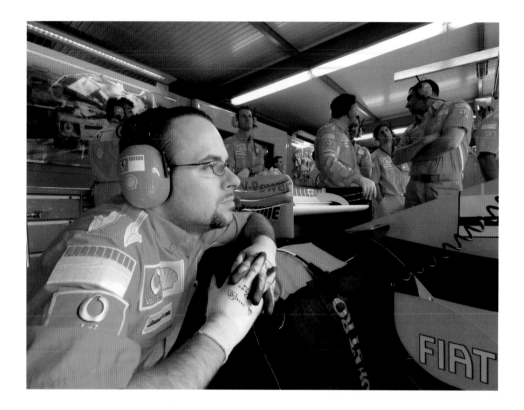

READY FOR THE OFF
A mechanic crouches by the right-rear tyre, poised to remove the electric blanket once the signal has been given by the car's number one mechanic.

SILENT FITNESS
Balbir Singh protects his ears as an engine fires up in the Ferrari garage. Schumacher's fitness guru does not have the benefit of the headsets worn by the mechanics, but he does have his driver's ear on matters of diet and training.

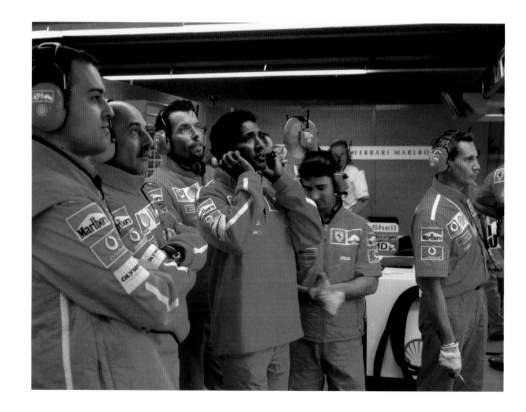

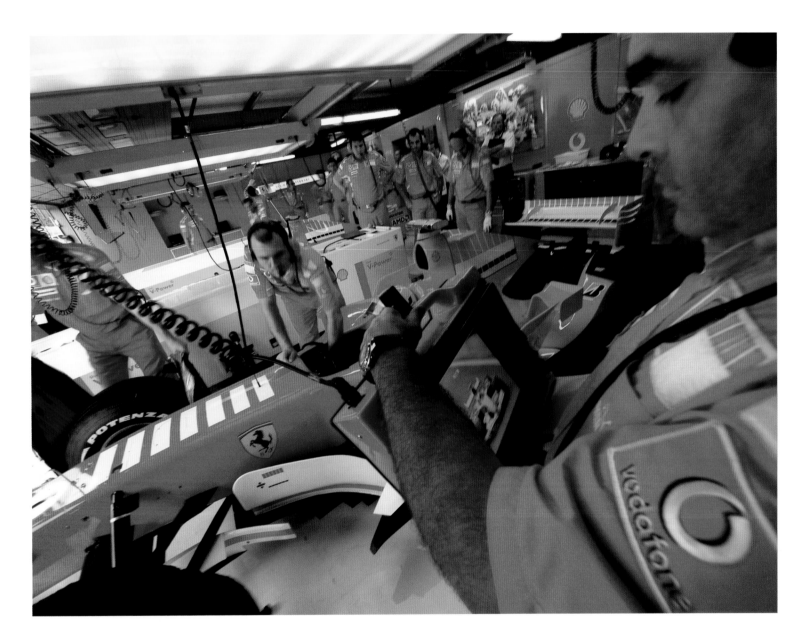

COVERING EVERY ANGLE
As Schumacher prepares to leave the garage, a mechanic uses a monitor to check Rubens Barrichello's on-track progress during practice.

"IT'S IN THERE SOMEWHERE"
Nothing is left to chance, as every
detail in and around the left-hand
sidepod is checked on the grid.

PRACTISING PERFECTION

It is 6pm on the eve of the British Grand Prix and the Ferrari team is hard at work honing its pit stop skills. When tyre changing takes places as well as refuelling, 24 people will be involved in dispatching the driver with fresh rubber and up to 90 litres of fuel. The team will rehearse the routine endlessly, looking to trim vital tenths of a second and, more importantly, to avoid the fumble which could cost a place and possibly a win. Even when perfection has come close, there is, as a mechanic (left) indicates, always the need to run through it two more times.

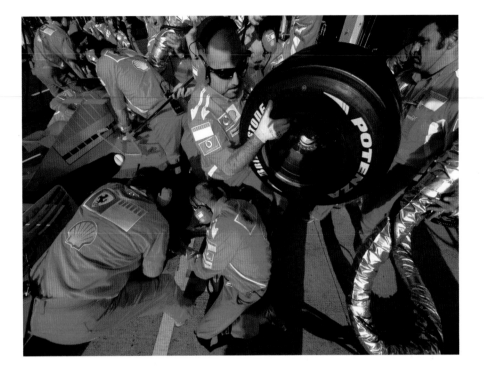

Next page

WORK IN PROGRESS

The television monitor, which drops into place in front of the driver when his car is in the garage, provides the only link between his progress on the track and the mechanics who have helped put him there. To a man, they will be mentally riding in the cockpit every inch of the way.

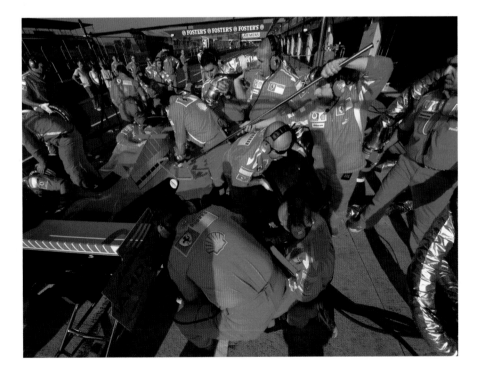

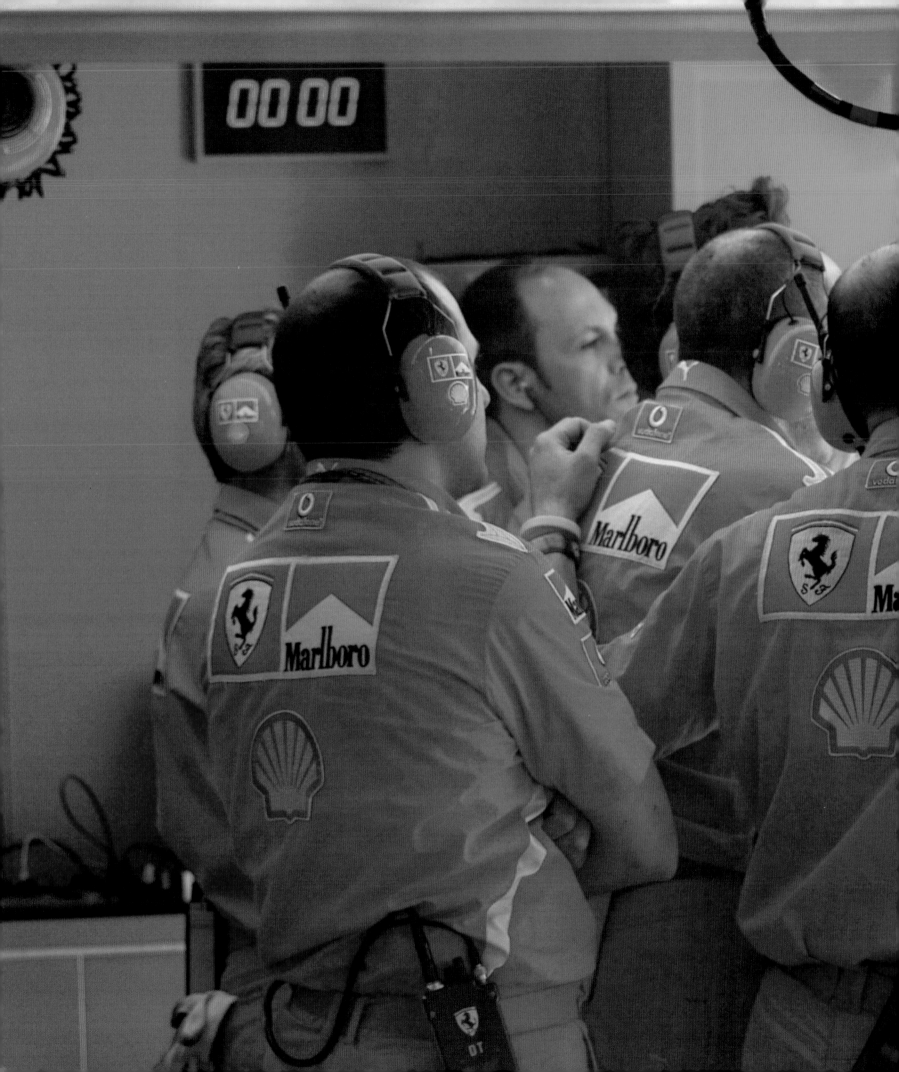

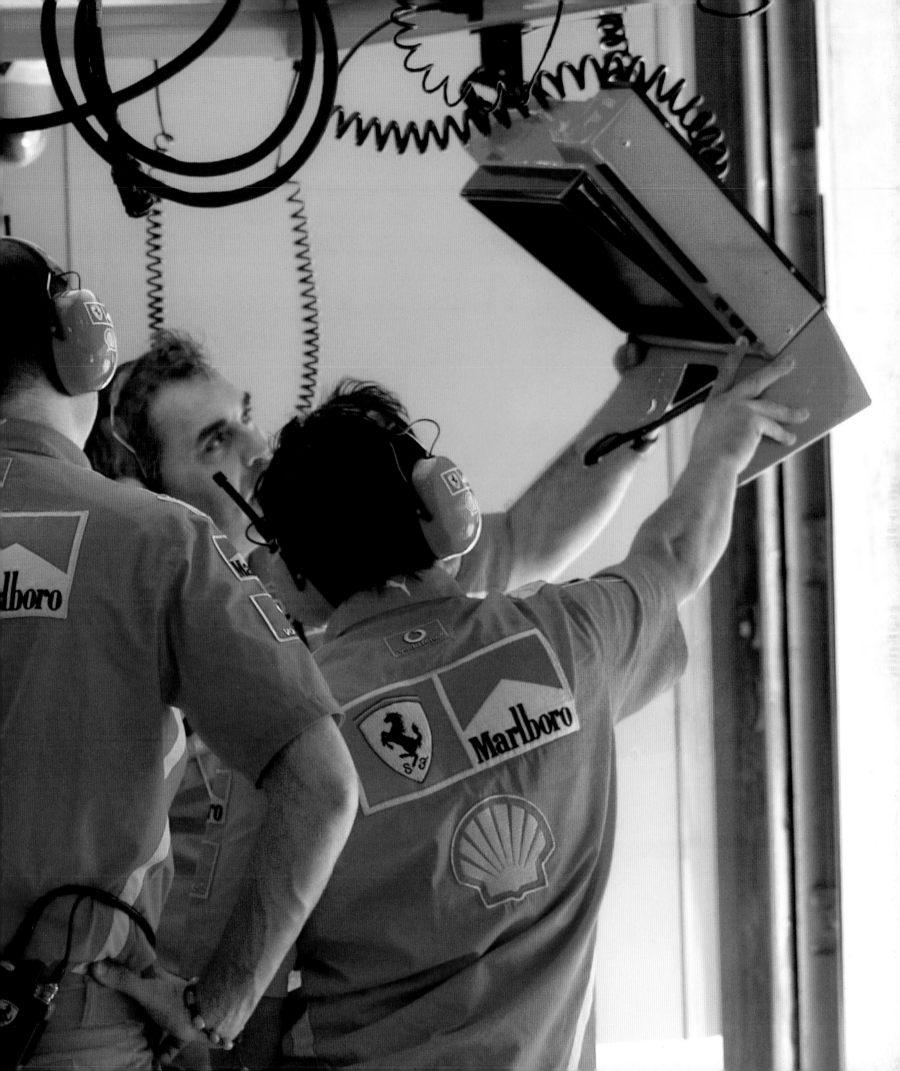

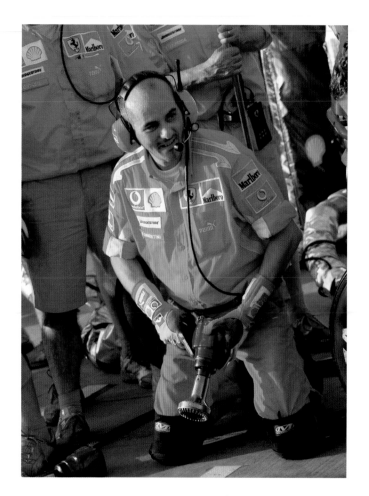

ON HIS MARK
The right-front "wheel nut man"
has his air gun ready for action
during pit stop practice (above).

BROTHERS IN ARMS
During the course of 19
grands prix, a mechanic
is likely to spend more
time with his work colleagues
than with his family (right).

TWO UP
Race fans, brandishing the
Ferrari sponsor's product,
arrive at Indianapolis.

UP CLOSE AND PERSONAL
Mechanics work closely with
their driver, even as he waits
in the cockpit. Once finished,
Barrichello acknowledges
everyone who has played
a part, including the tyre man
(far right) as the wheels are
loaded onto the trolley.

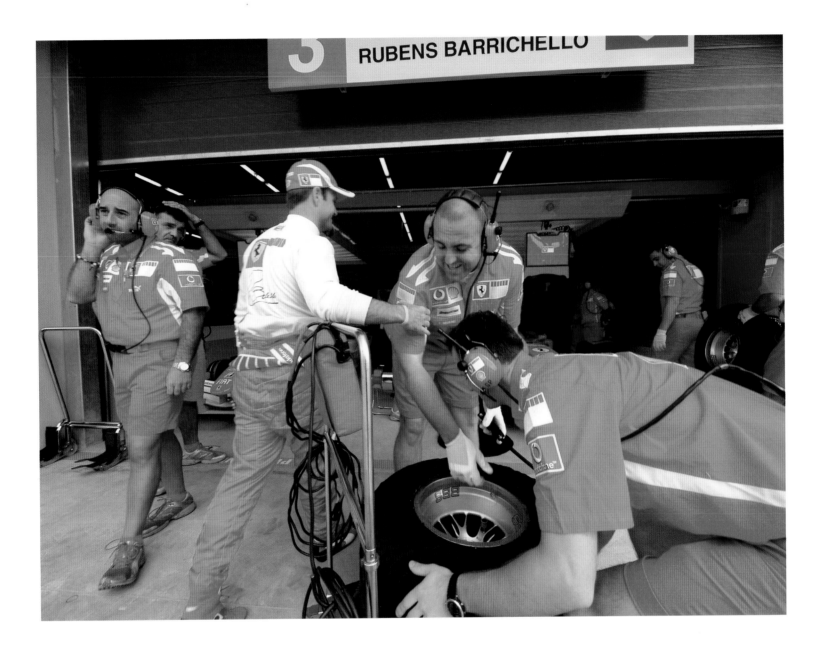

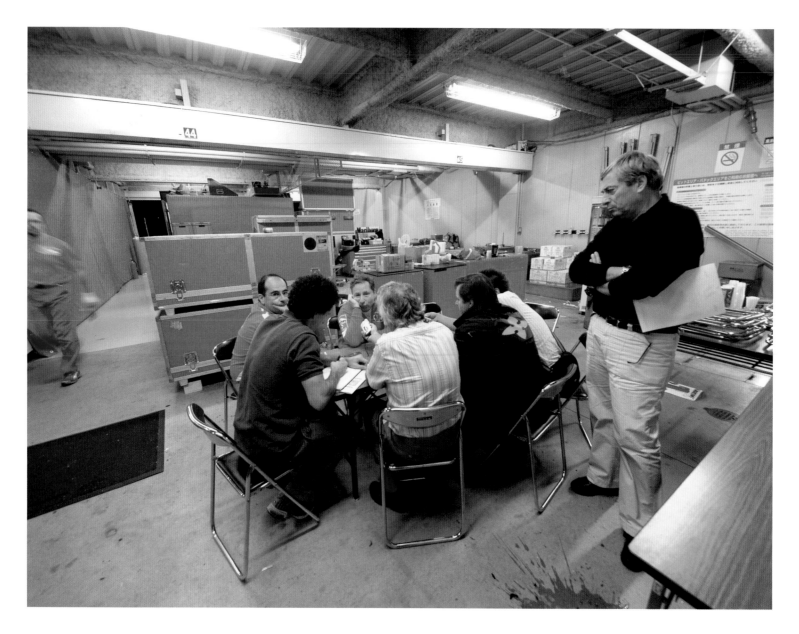

INSIDE TRACK
Jean Todt, with Ferrari's
press officer Luca Colajanni
on his right, gives a post-race
briefing to members of the
media in Japan.

TALKING A GOOD RACE

The team will hold three or four briefings each day, including after the race, win or lose. In the interests of both secrecy and clarity, headsets are used as tactics, tyre choices, and other critical details are discussed and decisions reached. Inside the elaborate team headquarters in Shanghai, Ross Brawn sits at the head of the table (below), flanked on his right by Gabriele Delli Colli and Rubens Barrichello. Michael Schumacher sits opposite with his engineer Chris Dyer.

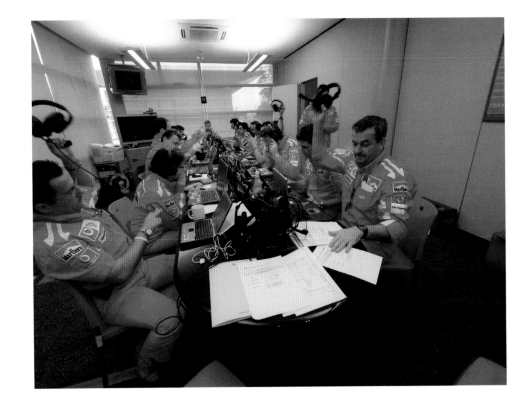

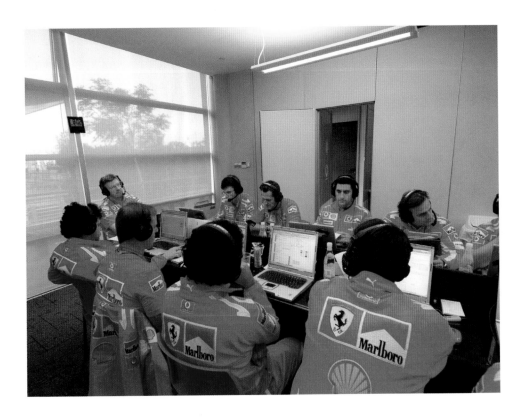

REASON TO BE HAPPY
The giant screen at Indianapolis shows that Rubens Barrichello has just put Ferrari on pole. North America has long been a stronghold of Prancing Horse supporters.

SIMPLY RED
The red flag bearing the familiar yellow shield is universal Ferrari language, from Monza (above) to Indianapolis (above right). Some supporters like to wear Ferrari colours by any means available (right).

PIT STOP
The truck crew stops for
refreshment en route to
a grand prix.

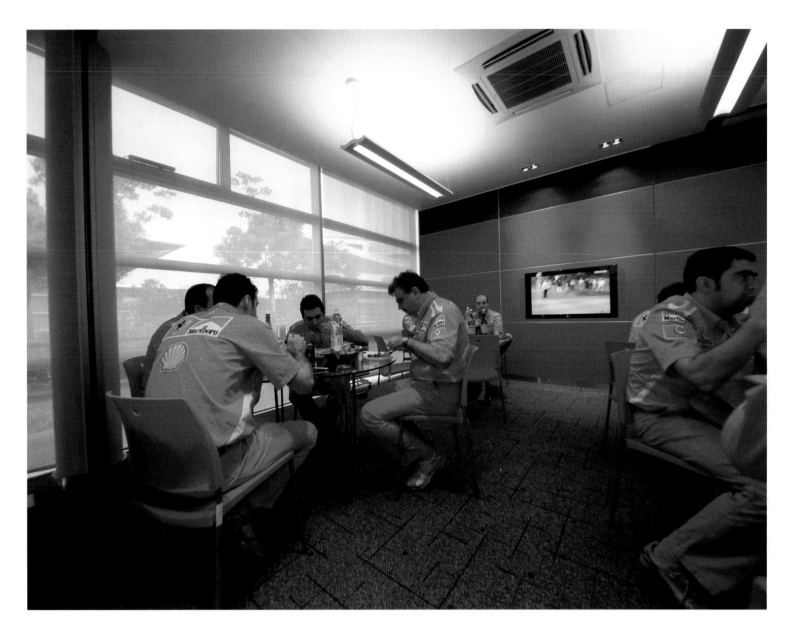

WRONG SPORT
A televised golf tournament
holds no interest for the team
as it enjoys lunch at the
Shanghai track.

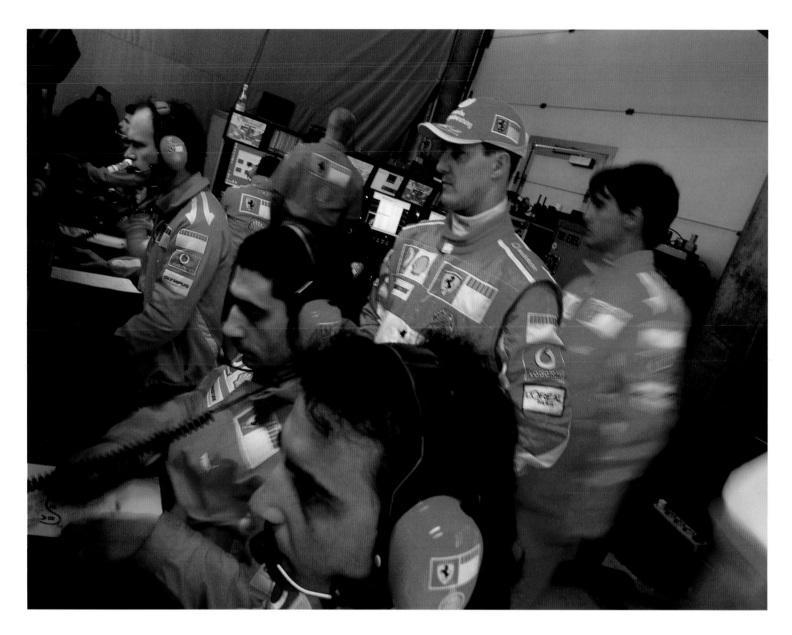

EYEING EACH OTHER
Schumacher checks rivals'
progress on the screens at
the back of the garage at
Magny-Cours (above), while
Barrichello joins Jean Todt during
practice at Silverstone (right).

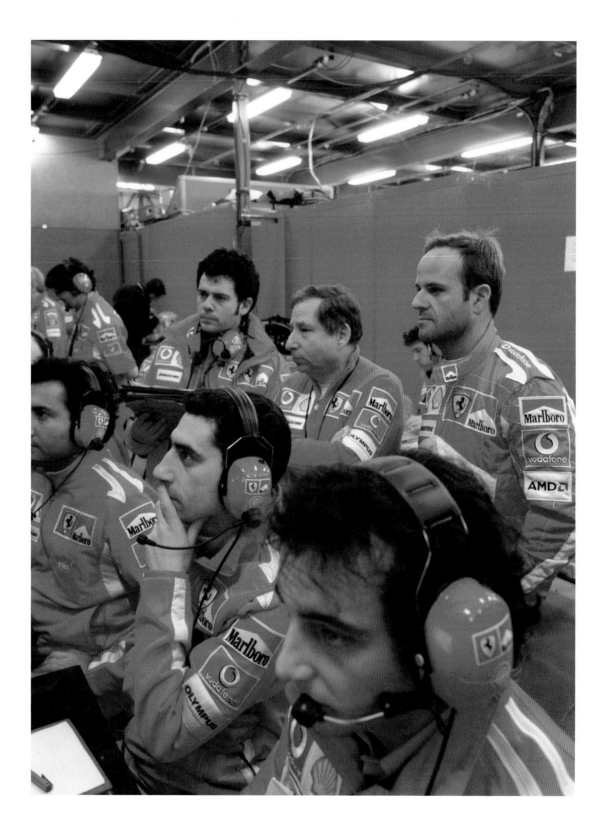

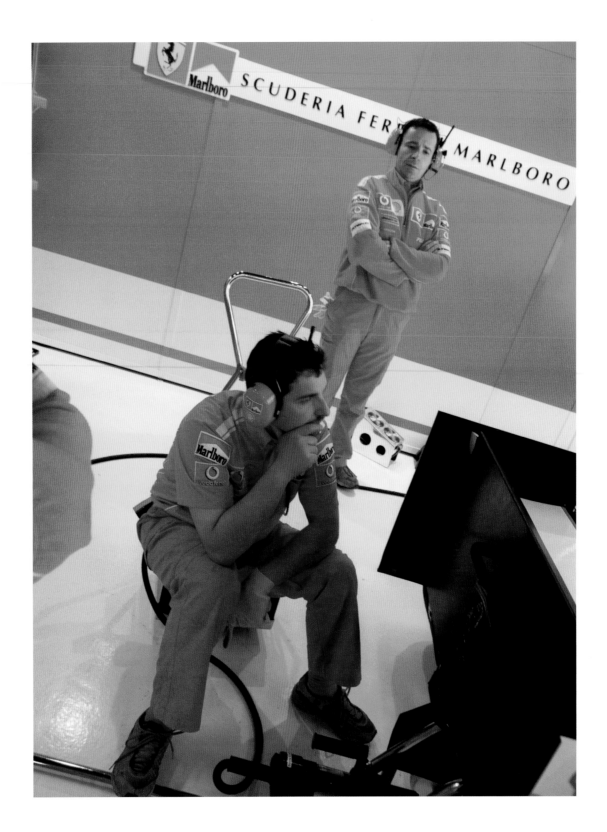

WHAT NEXT?

For some, there is a certain amount of sitting around during practice (left), while for others the waiting and thinking begins once the track action ends. Discussion takes place by the covered engines inside the Silverstone garage (right). Not far away, Ross Brawn, Jean Todt, and Nigel Stepney consider the latest problem after practice for the British Grand Prix (below right).

DUE RESPECT

To welcome their man home, mechanics squeeze through a gap and hang over the protection screens that line the pit wall (above). The scene then shifts to the area beneath the podium (right), where the team gathers to share the moment victory is confirmed with the presentation of yet another trophy.

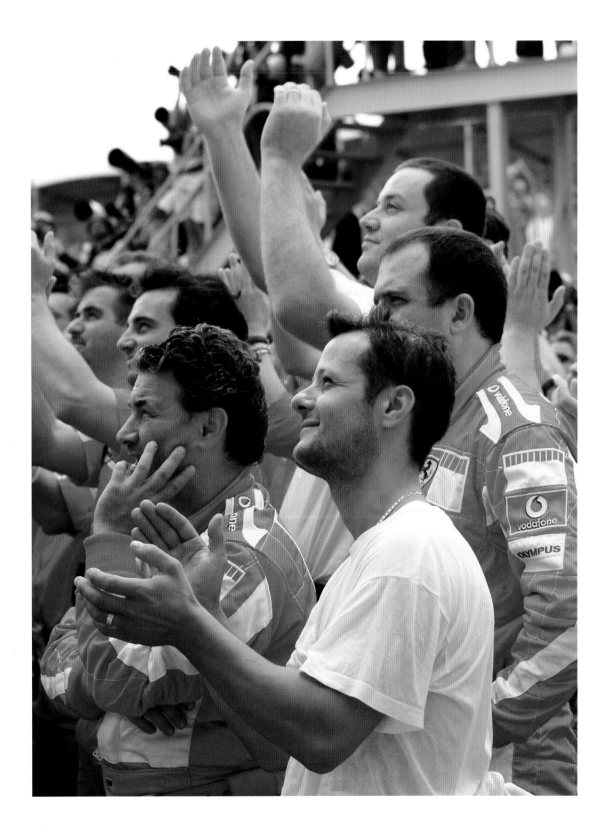

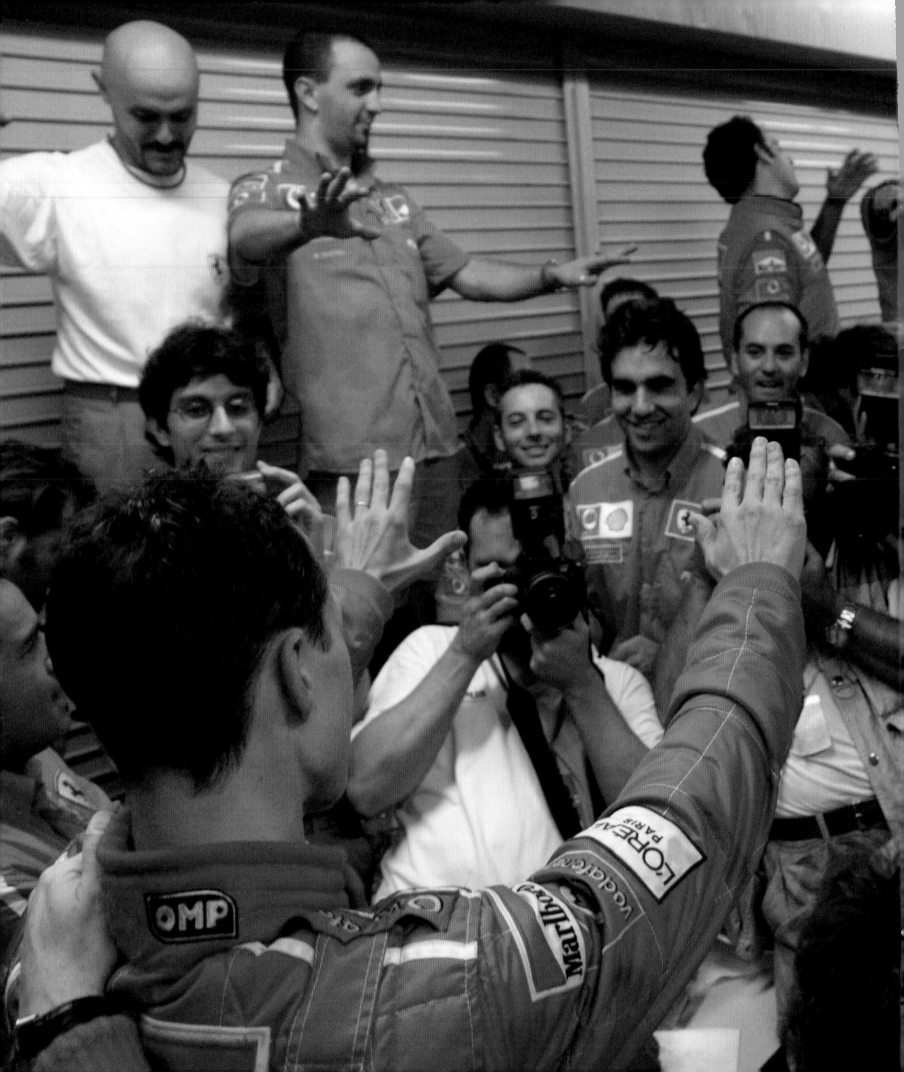

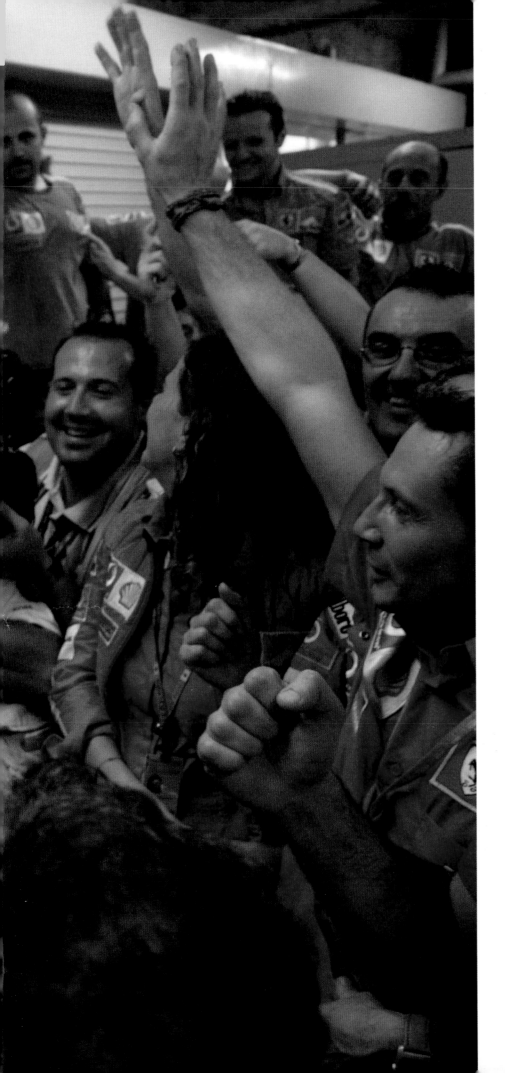

PRIVATE MOMENT
With the garage shutters drawn closed, Michael Schumacher calls for quiet in the excited aftermath of a victory in Japan. It is a strictly personal occasion, as Schumacher thanks everyone in the Ferrari family for the work they have done.

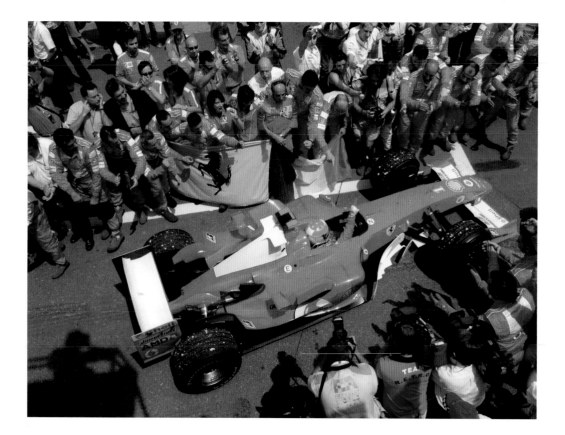

WHAT IT'S ALL ABOUT
The successful end of a long weekend as the team celebrates the return of its cars (above and top right) and prepares to savour the moment of victory. Jean Todt leads the way (far right) as he gives a clenched fist salute beneath the podium at Monza.

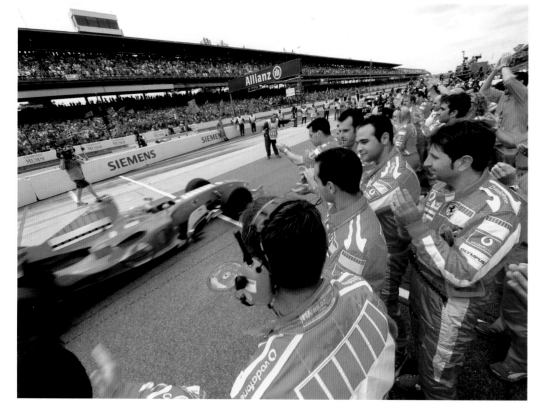

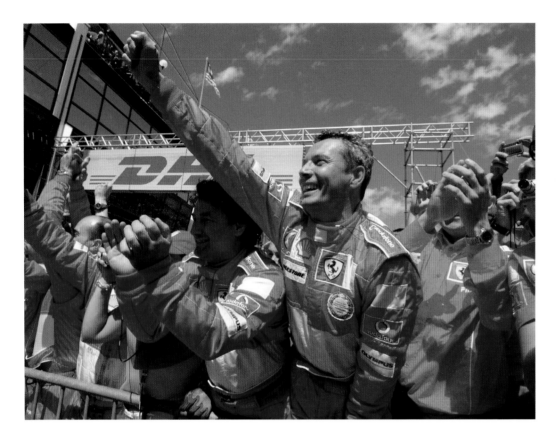

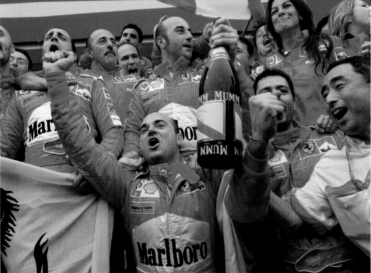

THIS ONE'S FOR YOU
Before leaving the podium at
the end of yet another victory
celebration, Michael Schumacher
remembers his mechanics and
carefully drops what is left of the
winner's champagne into eager
hands waiting below (right).
Unlike their driver, who has
followed the ritual of spraying
champagne, the team members
can be relied upon to use the
bubbly for its intended purpose
as the celebrations continue and
the Ferrari family is united in this
special and meaningful way.

INDEX

JON NICHOLSON: THE PHOTOGRAPHER (RIGHT)

MAURICE HAMILTON: THE AUTHOR (CENTRE)

Maurice Hamilton would like to thank
Luca Colajanni and Eric Silbermann
for their help

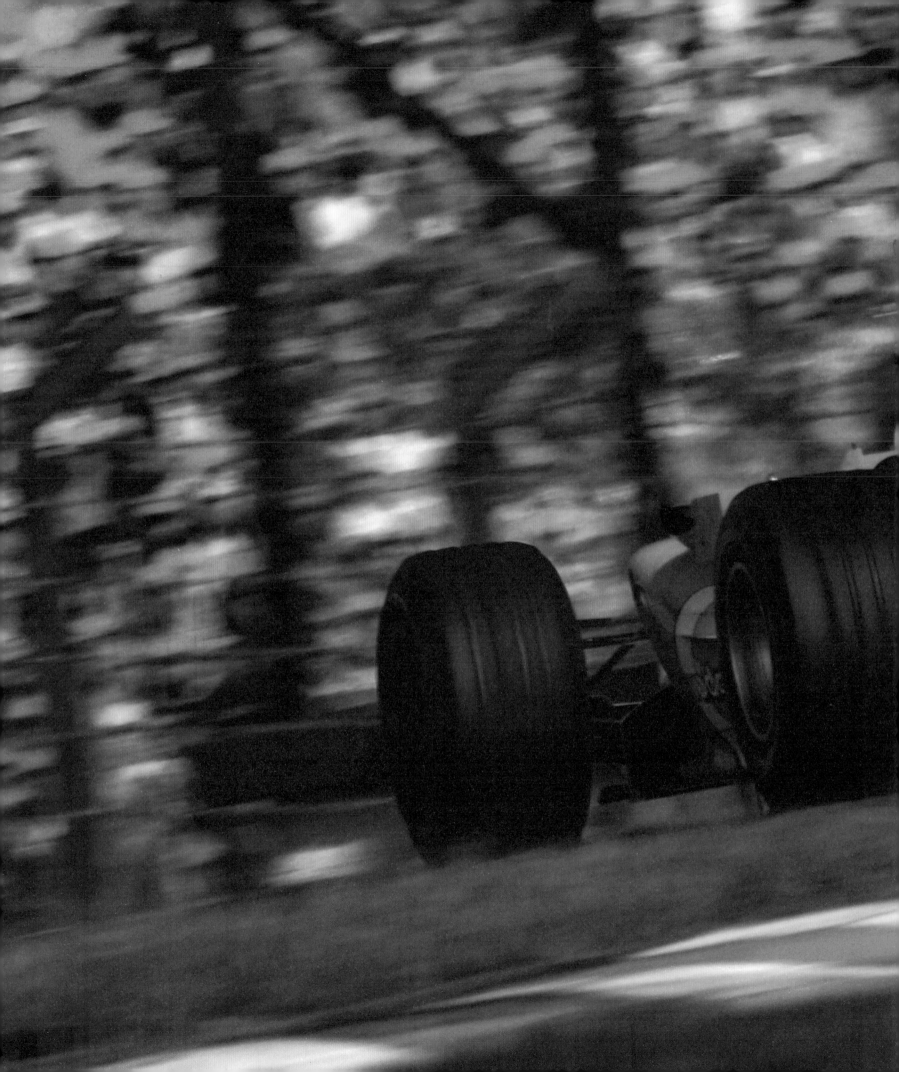